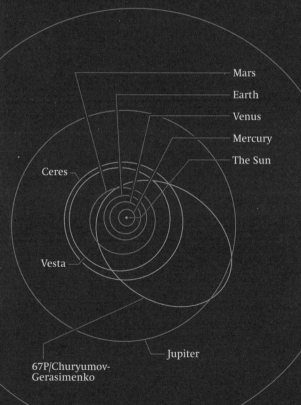

Pluto

Saturn

Mars

Earth

Venus

Mercury

The Sun

Ceres

Vesta

Jupiter

67P/Churyumov-
Gerasimenko

THE PLANETS

PHOTOGRAPHS FROM THE ARCHIVES OF NASA

PREFACE *by* BILL NYE

TEXT *by* NIRMALA NATARAJ

CHRONICLE BOOKS

SAN FRANCISCO

Library of Congress Cataloging-in-Publication Data

Names: Nataraj, Nirmala. | Nye, Bill. | United States. National Aeronautics
 and Space Administration.
Title: The planets : photographs from the archives of NASA / preface by Bill
 Nye ; text by Nirmala Nataraj.
Description: San Francisco : Chronicle Books, [2017] | Includes
 bibliographical references.
Identifiers: LCCN 2016046135 | ISBN 9781452159362
Subjects: LCSH: Planets – Pictorial works. | Solar system – Pictorial works.
Classification: LCC QB501.2 .N38 2017 | DDC 523.4 – dc23 LC record available
at https://lccn.loc.gov/2016046135

Manufactured in China

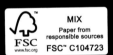

MIX
Paper from
responsible sources
FSC
www.fsc.org
FSC™ C104723

BOOK DESIGN AND IMAGE RESEARCH BY Neil Egan

10 9 8 7 6 5 4 3 2 1

Chronicle Books LLC
680 Second Street
San Francisco, California 94107
www.chroniclebooks.com

[*front cover*]

SATURN AND TITAN

Saturn's largest moon, Titan, is shown against the giant planet in
this image captured by *Cassini*'s wide-angle camera in 2012. This
natural color mosaic was created by combining six images taken
through red, green, and blue spectral filters.

CONTENTS

YOU'RE AN EXPLORER

by Bill Nye

WELCOME, space explorer! I hope by the time you read this part of the book, you've already spent a good bit of time admiring the pictures. They are astonishing. You are looking at images with a clarity and sharpness that our ancestors probably couldn't even imagine, let alone capture. After all, it wasn't until quite recently, in the course of human affairs, that anyone fully grasped what it means to live upon a spherical planet gravitationally suspended in the stark blackness of space. It was only in the last sixty years that humans could conceive, design, build, launch, and fly spacecraft above other celestial bodies. And although astronomers of 600 years ago had an excellent sense of how big our Earth is, it wasn't until the last few decades that we could see our neighboring celestial bodies up close, as you can right here in your hands.

Your journey begins right here as you turn these pages. With each page, you'll make a discovery. You can see with utter clarity the similarities between the inner terrestrial planets. Marvel at the ancient traumas of Mercury. Try counting the craters of impacts in an area the size of your palm. Those meteoric collisions took place millennia ago, mostly. But those perfect rings and mounds are eerie reminders of how much damage a primordial rock could do, if one were to arrive unwelcome and unannounced here on Earth. Move beyond the Sun, and Venus is revealed in a way that very, very few humans have heretofore ever seen. Fly out farther and relax your gaze on scenes from the very surface of Mars. With some thought and attention to detail, try imagining a route for our next rover's expedition as we search for life on the red planet. Such a discovery, of Martian microbes, say, would change the course of human history.

As you make your way further into the book you'll find yourself farther from the Sun. The gas giants loom large in your lap. You can marvel at the magnificent storms of Jupiter and the astonishing hexagonal vortex of Saturn. And the rings! Saturn's rings are wide like the brim of a state trooper's hat—wide and flat. Uranus's are very thin and were completely unknown when I was born. Just think what else is out there for humankind to discover. I like to believe that these photos will carry your imagination to places that no one else has ever considered.

This book reminds us of two questions that all of us ask at some point in our lives—two ideas that we find so compelling that space agencies around the world pursue the answers with rockets and probes and imagers to the far reaches of our solar system: Where did we come from? And, are we alone out here in the cosmos, way out here, suspended on an arm of the Milky Way? To find your own answers to these universal questions, save the best for last and look at our Earth from space as astronauts do. It will change you. Read on, explorer!

[*opposite*]

SWIRLS IN THE GULF OF ST. LAWRENCE

An astronaut aboard the International Space Station (ISS) in 2016 captured this remarkable image of swirling eddies in the Gulf of St. Lawrence in eastern North America. The swirls form as a complex network of flows come together in the shallow waters off the coast of Prince Edward Island. These currents are made visible here by the particular angle of the Sun reflecting off the water.

OUR SOLAR SYSTEM

THE ORIGINS of our solar system remain shrouded in mystery. To this day, scientists scratch their heads over the matter of how our cosmic neighborhood was formed.

We know a few things. To begin with, our solar system was fully up and running around 4.568 billion years ago. Before that it only existed as a formless potential in the midst of a cloud of cold gas and dust — a solar nebula — that was many light-years in diameter.

Although we don't know exactly what precipitated the formation of our solar system, some scientists surmise that a supernova explosion in the vicinity impacted the solar nebula, causing it to collapse. This episode created dense, gravity-rich areas, where matter was sucked into countless pockets of gas and dust. These areas became cradles that nurtured the formation of stars, including our Sun.

In the pocket where our Sun was born, material from the solar nebula accreted into a ball at the center, while other matter dispersed in a disk that settled around the embryonic Sun. It's likely that the Sun began as a T Tauri star — a new star in which nucleosynthesis (the process during which elements heavier than helium are created through fusion) has not yet begun. After about fifty million years, the temperatures and pressures were high enough to incite fusion (the process during which hydrogen is converted into helium, and tremendous amounts of heat and energy are released). That's when our Sun as we know it was born.

The changes didn't end there. Material orbiting the Sun continued to collide, sometimes forming larger objects or splitting off into smaller bits of cosmic debris. Most planets began as wayward particles of dust that came together over time.

Today, aside from our eight planets — Mercury, Venus, Earth, Mars, Jupiter, Saturn, Uranus, and Neptune — the solar system is home to a diverse family of celestial bodies: dwarf planets, asteroids, and the comet-rich Kuiper Belt that exists just beyond Neptune.

THE ORIGIN OF THE PLANETS

The planets started out as infinitesimal grains of dust in the disk around the new Sun. Through small collisions, the grains accumulated into balls of matter called planetesimals, which were about a mile in diameter and sizeable enough to attract other planetesimals through gravity. Collision speeds had to be low enough so that the objects could continue to grow rather than break apart. This process of accretion and collision took place for between ten and one hundred million years.

As some planetesimals merged, others exploded into nothingness. At the end of this long evolution, only eight of the objects remained stable: These are the planets we know today. As the force of gravity pulled the hot, molten material of each planet inward toward its center, each object became spherical in shape. However, the spinning of a planet causes it to counteract the force of gravity, creating a bulge at the equator — meaning that none of the planets in our solar system are perfectly spherical.

As the planets continued to orbit around the Sun, the Sun sent out steady streams of solar winds. The winds, which are made up of minute particles and energy, were strong enough to strip the planets closest to the Sun — Mercury, Venus, Earth, and Mars — of much of their gas. In addition, temperatures closer to the Sun were too high for such gases as water and methane to condense, meaning that only materials with a higher melting point and density could form. Thus, these planets, known as the terrestrial planets, became rich in rocks and metals.

In contrast, the four outer planets — Jupiter, Saturn, Uranus, and Neptune, which are known as the Jovian planets — were far enough from the Sun that their ice and gases could not be blown away by the solar winds. Thus, these planets grew to comprise more gases, primarily hydrogen and helium, than their siblings, the four inner planets. The early Jovian planets also featured accretion disks similar to the one around the Sun. Jupiter itself has a mini solar system of sixty-seven moons orbiting it.

The region between the inner and outer planets is full of bits of cosmic debris in the form of millions of asteroids — leftover remnants of rock, ice, and metals from the solar system's formation, which some scientists believe are the vestiges of an early planet that disintegrated long ago. Astronomers believe that no planets formed in this liminal space because Jupiter's gravity precluded the development of a planet-size object. (In fact, Jupiter is eleven times the size of Earth and more than twice as massive as all the planets of the solar system combined — massive enough to have almost become a star.)

Just beyond the orbit of Neptune – the farthest planet from the Sun – in the coldest areas of the solar nebula, icy planetesimals remain, but they only grew to a few kilometers in size. Unable to attract surrounding gas, they are known as Kuiper Belt objects (KBOS) and span 279 to 465 billion miles (450 to 750 billion kilometers). Also beyond Neptune is Pluto – a former planet that was downgraded to the status of a dwarf planet in 2006. Pluto is low density like Jovian planets but small like terrestrial planets.

WHAT CONSTITUTES A PLANET?

The exact definition of a planet is the subject of debate and evolves as new discoveries are made. Astronomers generally agree that a planet is a body that orbits a star and that it must be large enough so that gravity contorts its mass into a spherical shape. (In contrast, asteroids and comets tend to be irregularly shaped.)

While many astronomers don't view Pluto or other Kuiper Belt objects as true planets, others believe that any KBO as massive as Pluto should be considered a true planet.

In 2006, the International Astronomical Union revealed a new classification scheme for objects in the solar system. These include small bodies (such as asteroids and comets), planets, dwarf planets, and protoplanets (celestial objects that are smaller than moons and dwarf planets but large enough to attract other objects and particles within their gravitational field; it is believed that protoplanets form in the early development of a solar system and often grow into regular-size planets). Astronomers are discovering that such objects might be more abundant in our solar system than we previously believed. In 2005, a team of astronomers discovered an object in the farthest reaches of the solar system, about three times as far from our Sun as Pluto, with its own moon. They named this dwarf planet Eris.

More recent missions to the outer solar system have revealed evidence that our system contains hundreds of dwarf planets – including Varuna, Quaoar, Makemake, and Haumea. Many of these are in the Kuiper Belt, while others, like Eris, have enormous elliptical orbits that take them even farther beyond the known solar system. Because we can't verify the actual sizes or shapes of these objects, which are simply too far beyond the reach of our instruments to measure, we cannot definitively know if they are actual dwarf planets.

Astronomers have also scoured the skies in search of hidden true planets that might be lurking beyond Neptune. In fact, the notion of a mysterious Planet X that orbits far outside the known bounds of the solar system has inspired astronomers to systematically search for distant objects. So far, the search has rendered no empirical evidence of a Planet X, but a small group of astronomers suggests that indirect evidence of a massive planet exists, which they have nicknamed Planet Nine.

Although, like many dwarf planets, Planet Nine has not been seen, it has been detected through its gravitational effects. Many Kuiper Belt objects that are closely clustered together suggest the influence of a massive giant in the region beyond Neptune. Unlike Eris and Pluto, Planet Nine could boast a mass ten times that of Earth. It is believed to orbit twenty times farther from the Sun than Neptune and to take between ten and twenty thousand Earth years to make one full revolution around the Sun.

In 2015, NASA's New Horizons mission, the first mission to Pluto and the Kuiper Belt, conducted a six-month reconnaissance flyby study of Pluto and the surrounding area. The mission's discoveries have pointed to the possibility that the neat and elegant map of the solar system we currently follow may not be the most accurate depiction of our celestial neighborhood. In fact, increasing evidence of Planet Nine may be the first indicator that there is far more lurking in our solar system than we once believed.

THE SOLAR SYSTEM'S MOONS

Moons orbit around planets and are usually solid objects with little to no atmosphere. Similar to how planets formed, many moons likely evolved from disks of gas and dust whirling around the planets in their early formation. While moons tend to orbit their planets closely, several of the outer planets have irregular moons that orbit comparatively far beyond them.

To date, astronomers have confirmed the existence of 145 moons around the eight planets, while another twenty-seven or so moons still await confirmation. These moons don't include the eight moons orbiting five of the dwarf planets (Ceres, Pluto, Haumea, Makemake, and Eris) or the diminutive satellites that revolve around some asteroids.

Among the terrestrial planets, Mercury and Venus have no moons, Earth has one, and Mars has two. Meanwhile, the Jovian planets, with their formidable gravitational pulls, have a huge number of moons: Counting both confirmed and still-to-be-confirmed moons, scientists have found that Jupiter has 67, Saturn has 62, Uranus has 27, and Neptune has 13.

Moons come in a variety of shapes and sizes. The moons of Mars – Phobos and Deimos – are lumpy rather than spherical. Jupiter is host to the solar system's largest moon, Ganymede.

In fact, Ganymede is 8 percent larger than the smallest planet, Mercury, but with only 45 percent of that planet's mass. Saturn's largest moon, Titan, is also larger than Mercury. As far as the smallest moons are concerned, a number of them are much smaller than the dwarf planet Pluto. At 7 miles (11.3 kilometers) in diameter, Mars's moon Deimos is considered the smallest moon, although *Cassini* has discovered the presence of tiny shepherd moons orbiting Saturn, as well as others that have yet to be named and confirmed around the other gas giants in the solar system. Additionally, "moonlets" are the tiny satellites that might orbit a moon (and in some cases, an asteroid); many of the objects that are part of a planetary ring are also considered moonlets.

Our Moon itself is roughly a quarter of the size of Earth. A number of rock and soil samples gathered by astronauts during lunar missions have provided insight into the Moon's formation. The prevailing theory is that the Moon is the descendant of a small protoplanet that collided with Earth 4.5 billion years ago. While some of the protoplanet's material merged with the liquid core of the Earth, the rest of the material rocketed back out into space, eventually cooling and solidifying into our planet's sole moon. Initially, the Moon orbited at a closer distance to the Earth; today, it moves away from us at the rate of approximately 1.34 inches (3.4 centimeters) per year. It is believed that the Moon couldn't have formed at a distance closer than 3 Earth radii (i.e., 12,400 miles or 20,000 kilometers) because it would have been torn apart by the Earth's tidal forces. Because the rate of the Moon moving away is influenced by fluctuations in continental drift and oceanic movement, it is constantly changing – and currently, is actually slowing down.

THE HISTORY OF PLANETARY DISCOVERY

Humans once universally believed that the heavens held extraordinary sway over earthly affairs, and some still do. In ancient civilizations, astrology and astronomy developed side by side in an attempt to understand how our lives were influenced by celestial events, such as by lunar and solar eclipses and planetary conjunctions – when two celestial bodies have the same ecliptic longitude in the sky and appear to be close together.

The word *planet* is derived from the Greek for "wanderer." The earliest written records we know of (from 1600 BCE in ancient Babylon) were observations of planets and their orbits, times of eclipses, and other astronomical data. Early Chinese, Mesoamerican, and northern European cultures also observed the planets as special. For one thing, they are the only objects, other than comets and asteroids, that appear to move in the sky, to dim and brighten along their path, and to remain consistently tied to the path of the Sun.

Although Mercury, Venus, Mars, Jupiter, and Saturn have been known and observed since ancient times (and accordingly, granted supernatural powers by many cultures), it wasn't until the era of Galileo and Copernicus that the heliocentric (Sun-centered) model of the solar system was developed. In the late sixteenth century, Galileo used a telescope to observe Jupiter's moons and proved that objects revolve not just around the Earth but around other celestial bodies.

Only two of our solar system's eight official planets were "discovered" by observers. The other six are easily detectable by the naked eye. In 1781 CE, Sir William Herschel discovered Uranus. He also catalogued more than eight hundred double stars and twenty-five hundred nebulae, and he was the first scientist to delineate the spiral structure of the Milky Way Galaxy.

John Couch Adams, an English astronomer and mathematician, predicted the existence of Neptune in 1843. Then, in 1846, German astronomer Johann Gottfried Galle confirmed Neptune's existence, based on calculations by French mathematician Urbain Jean Joseph Le Verrier.

Although Pluto is no longer considered a planet, its discovery by astronomer Clyde Tombaugh in 1930 received great fanfare among astronomers and armchair cosmologists alike.

SOLAR SYSTEM MISSIONS

Since 1959, dozens of NASA spacecraft have launched on missions to capture information about both the inner and outer planets.

A number of missions to Mars – including the Mars rovers Opportunity and Curiosity, the MAVEN mission (far above the planet's surface), the *Odyssey Orbiter*, and the *Reconnaissance Orbiter* – have collected vital information about the red planet.

The *Dawn* spacecraft has undertaken vital in-depth studies of the asteroid belt between the inner and outer planets, where the dwarf planet Ceres has been observed in depth.

Nine missions have researched Jupiter, while four have flown by Saturn. *Voyager 2* has ventured as far as Uranus and Neptune. And *Ulysses* and *New Horizons* flew past the outer planets en route to a long orbit around the Sun.

Many of these unmanned missions were, or are, in it for the long haul. *Galileo* orbited Jupiter for eight years, and *Juno* entered orbit around the giant planet in 2016. *Cassini* has been orbiting Saturn and its moons since 2004, rendering some of the most stunning photographs of the solar system and revealing new details about planetary objects, such as evidence of an ocean on Saturn's moon Enceladus. The space probe will eventually crash into Saturn in 2017. This is a precaution to avoid "contaminating" either Enceladus or Saturn's other massive moon, Titan, in case either possesses life.

Launched in 1977, *Voyager 1* and *2* are NASA's longest-running missions. They explored the outer solar system before making their lengthy passage into interstellar space. In 2017, *Voyager 2* was roughly two-thirds of the way through the heliosphere, which is the enormous magnetic bubble that holds our solar system, the ever-unfurling stream of solar winds, and the Sun's entire magnetic field. Although it has no destination in particular, its instruments are still hard at work and are expected to pick up even more data until we lose transmission of the probe's radio signals around 2020. If the spacecraft continues its journey without interruption, in 296,000 years it is expected to pass the star Sirius, which is 8.6 light-years from Earth.

BEYOND THE SOLAR SYSTEM

Any traces of the early solar nebula from which our solar system was born are long gone, but astronomers can observe other star systems in different phases of formation to understand what might have happened in our early solar system.

Based on observations of other stars, scientists estimate that five billion years from now, our Sun will probably expand to monstrous proportions and transform into a red giant—a dying star in the final throes of evolution. When this happens, most of the terrestrial planets, including Earth, will be destroyed. After another hundred million years, the Sun will no longer generate energy and will shrink down to a dense white dwarf the size of a planet.

The impending death of our solar system is so far away it seems inconceivable. Though none of us will have to worry about facing the end of our planetary neighborhood, astronomers are working to identify habitable planets in other star systems. Since 1998, more than two thousand extrasolar planets have been discovered, and more than seven hundred have been confirmed. Many of them have been detected because of their gravitational effects on parent stars rather than through direct observation.

In 2009, NASA sent a telescope to orbit the Sun in search of potentially habitable extrasolar planets (those with liquid water at the surface) near the constellations Cygnus and Lyra. Within the first two years, the telescope discovered seventeen planets with conditions believed capable of developing life. However, most of the extrasolar planets that have been discovered are gas giants with unbearable temperatures.

Discovering extrasolar planets is extremely challenging; aside from being so far away, they are millions of times dimmer than the stars they orbit. But an upcoming launch may reveal new information: the James Webb Space Telescope—an international collaboration among NASA, the European Space Agency, and the Canadian Space Agency—is a large infrared telescope with a 21.3-foot (6.5-meter) primary mirror for the observation of celestial phenomena. The Webb Telescope will be launched into space in October 2018, and it will be the world's primary space observatory for the next decade. Its aims are ambitious: to study each phase of the universe's history, as well as the development of other solar systems that may reveal signs of life. The James Webb Telescope will be able to offer us even more detailed information about the atmospheres of extrasolar planets—and, perhaps more relevant to us, those mysterious objects contained within our own solar system.

In the more than half a century since NASA was founded, the space agency has sent more than one thousand missions into space. These missions—manned and unmanned—have captured millions of photographs, which have revealed remarkable formations and shed new light on some of modern astronomy's greatest mysteries. This book collects some of the most stunning imagery from the archives of NASA. It highlights the eight planets and their moons—starting with Mercury, closest to the Sun, and moving outward—but it also includes other significant bodies, such as the Sun itself, Pluto, Ceres, giant asteroids, and more. The following pages present a visual tour of the solar system, revealing the planets, their moons, and the celestial bodies of our cosmic neighborhood as you've never seen them before.

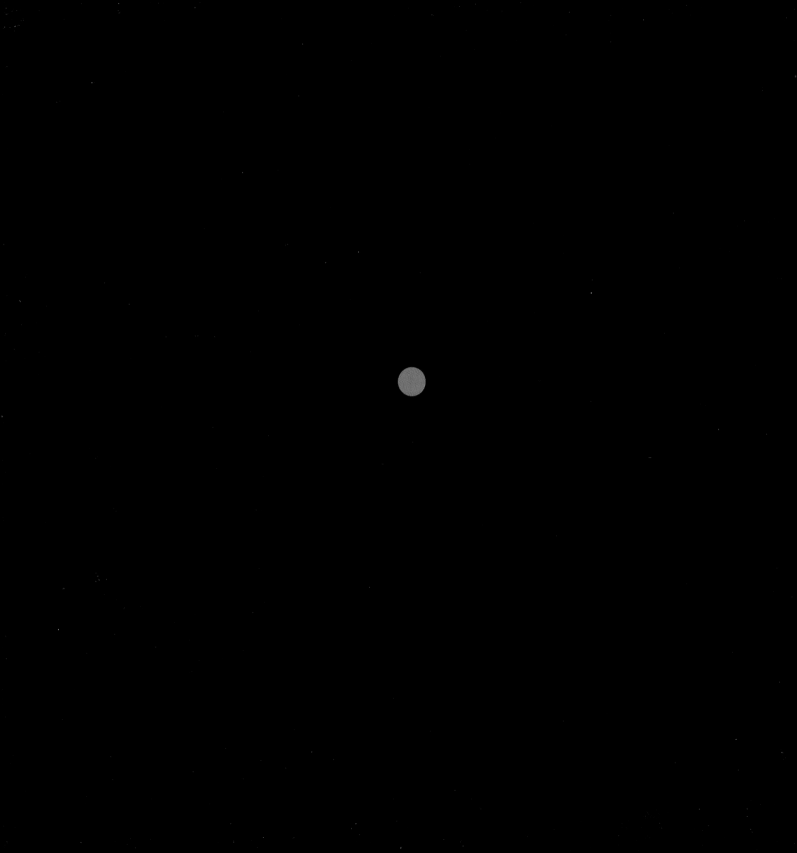

MERCURY

[*opposite*]

FLYBY MOSAIC OF MERCURY

The first probe to orbit Mercury was the NASA spacecraft *MESSENGER*, an acronym that stands for Mercury Surface, Space Environment, Geochemistry, and Ranging. *MESSENGER*'s orbit around the sun-scorched planet began in 2011 and ended in 2015, when it crashed into Mercury's surface. Over the course of several years, *MESSENGER* captured more than two hundred thousand photographs of Mercury, leading to several discoveries, from the evidence of ice on the planet and the detection of lava flows (which occurred early in the planet's history) to an inexplicably offset magnetic field. This high-resolution mosaic of images comes from *MESSENGER*'s first flyby of Mercury in 2008, before it went into orbit around the planet. Initially, *MESSENGER* was launched aboard a rocket to study the planet's geology and chemical composition.

[*following spread*]

MOSAIC OF MERCURY'S LIMB

This view is of Mercury's southern hemispheric limb, which refers to the edge of a planetary disk, where the atmosphere of the planet meets the limitless darkness of space. The October 2012 composite image comes from *MESSENGER*'s Mercury Dual Imaging System (MDIS) and its "limb imaging campaign." Once a week, MDIS photographed Mercury's limb, allowing scientists to acquire valuable information about Mercury's shape and topography. Here, we see a number of prominent, shadowy impact craters on the planet's surface, made more dramatic by the angle of the Sun.

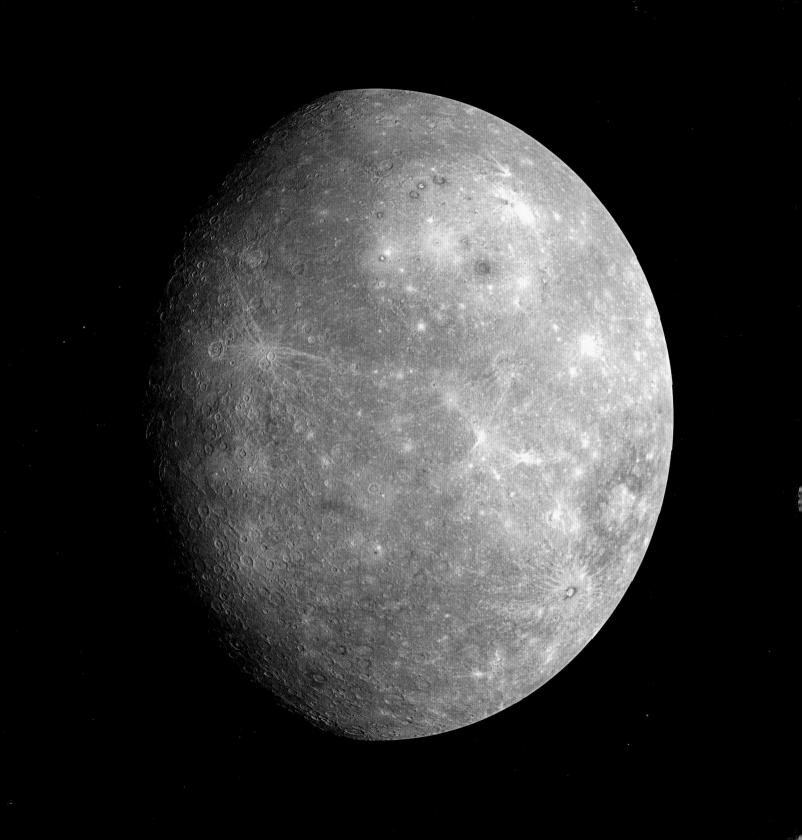

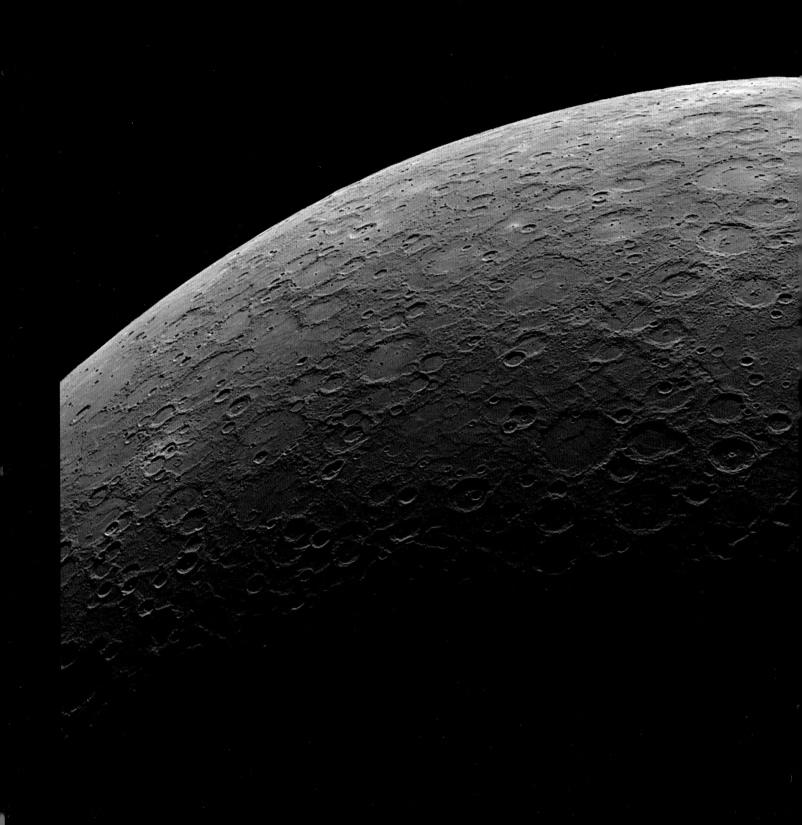

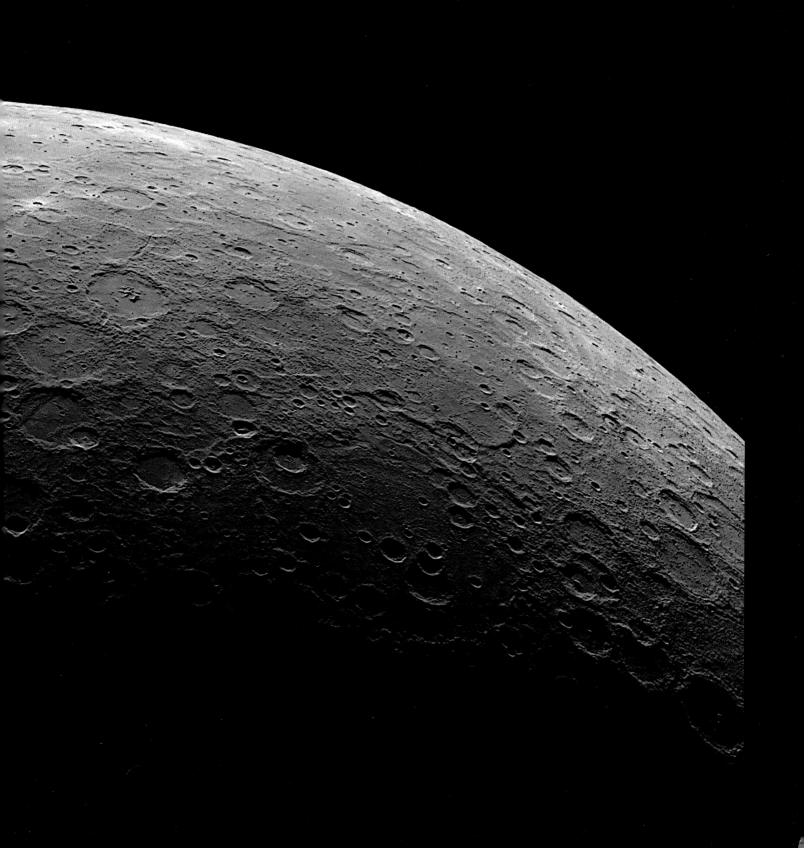

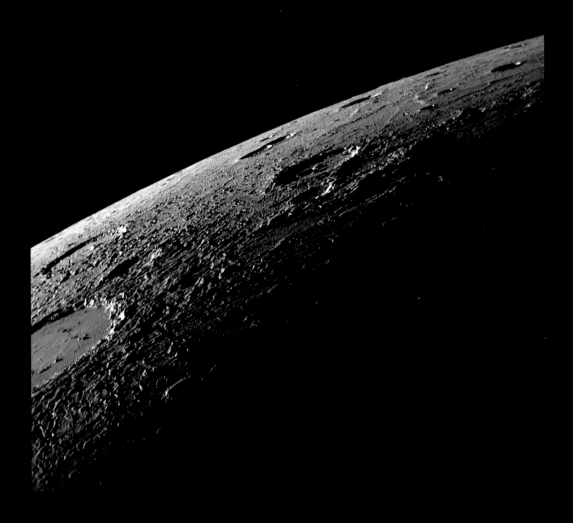

[*above*]

MERCURY'S NORTHERN CRATERS

This image shows the cratered northern portion of
Mercury. It was captured by *MESSENGER* in 2008
during the spacecraft's second flyby of the planet.

[*opposite*]

GLOBAL MOSAIC OF MERCURY

This 2011 global mosaic of Mercury was taken by the *MESSENGER*
spacecraft. A global mosaic presents a "map" of the entire surface of
a celestial body using a number of images. Toward the bottom of the
planet, you can see Debussy, a "rayed" impact crater that displays
the radial streaks made up of material that was thrust out during the
impact event. The bright lines around the crater indicate its geological
newness.

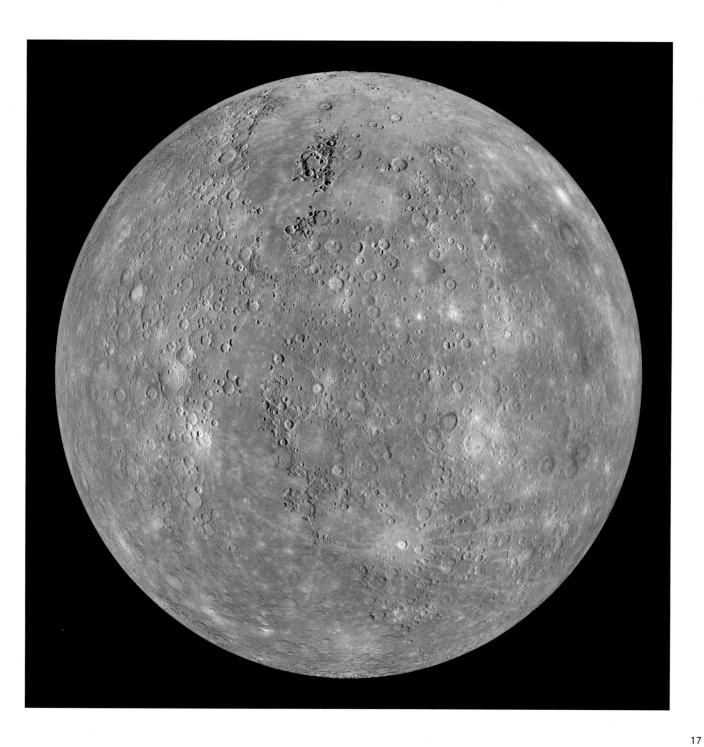

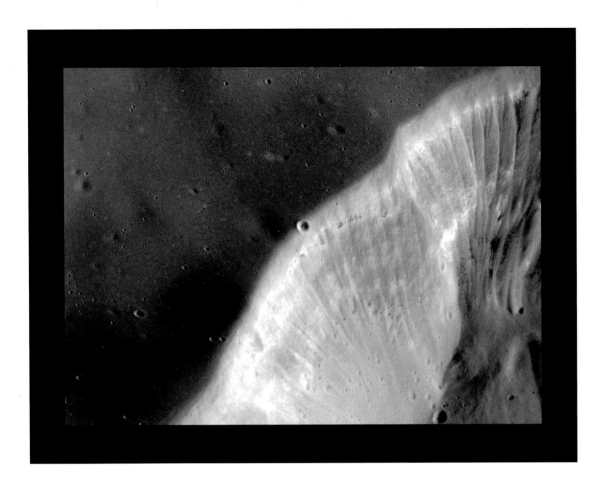

[above]

A VOLCANIC VENT
ON MERCURY

This photo was taken by the Narrow Angle Camera
of the MDIS on *MESSENGER*. The photo shows a
volcanic vent wall with a fluted surface caused by
landslides.

[opposite]

KUIPER CRATER

This image mosaic was captured by the *Mariner 10*
spacecraft, which took more than seven thousand
photographs of Mercury in September 1974 and
March 1975. The center left of the image features
the first recognizable characteristic on the surface of
the planet: a small rayed impact crater named after
Mariner 10 team member Gerard Kuiper.

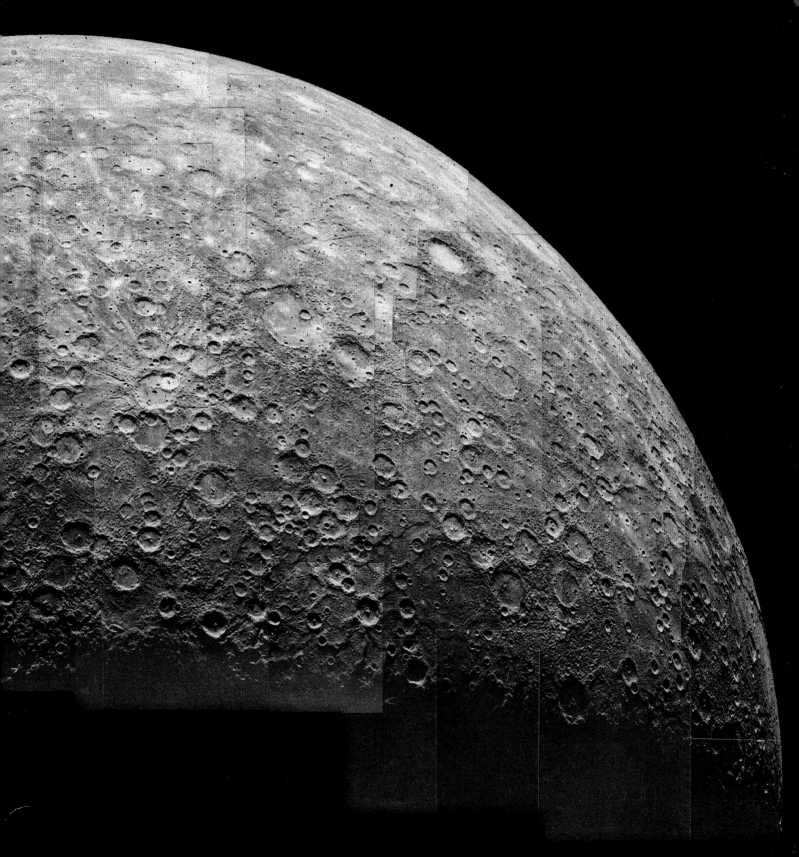

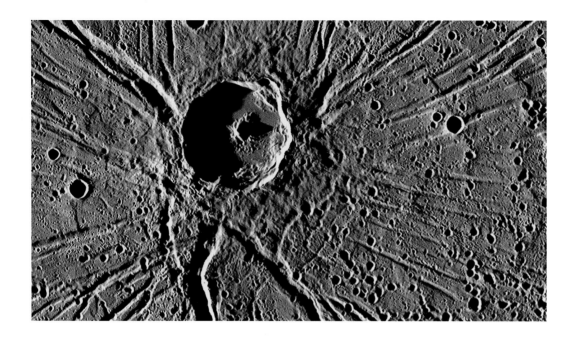

[above]

APOLLODORUS CRATER

In 2008, *MESSENGER*'s first Mercury flyby gave us this view of the crater Apollodorus and its tentacular rays. The spacecraft's team nicknamed the crater "the spider."

[opposite]

CALORIS BASIN MOSAIC

This 2014, color-enhanced mosaic from *MESSENGER* shows Mercury's Caloris Basin at the center of the image. This impact crater is the largest feature on the planet's surface. The topographical form of the Caloris Basin features lava floods (in orange), as well as low-reflectance material (in blue) that is most likely from material originally in the basin floor. The thickness of the orange volcanic layer is approximately 1.6 to 2.2 miles (2.5 to 3.5 kilometers). The Caloris Basin contains the massive Apollodorus Crater (in the center of the image) and is surrounded by several concentric ridges in comparatively smooth plains – most likely the result of secondary volcanic activity after the first impact.

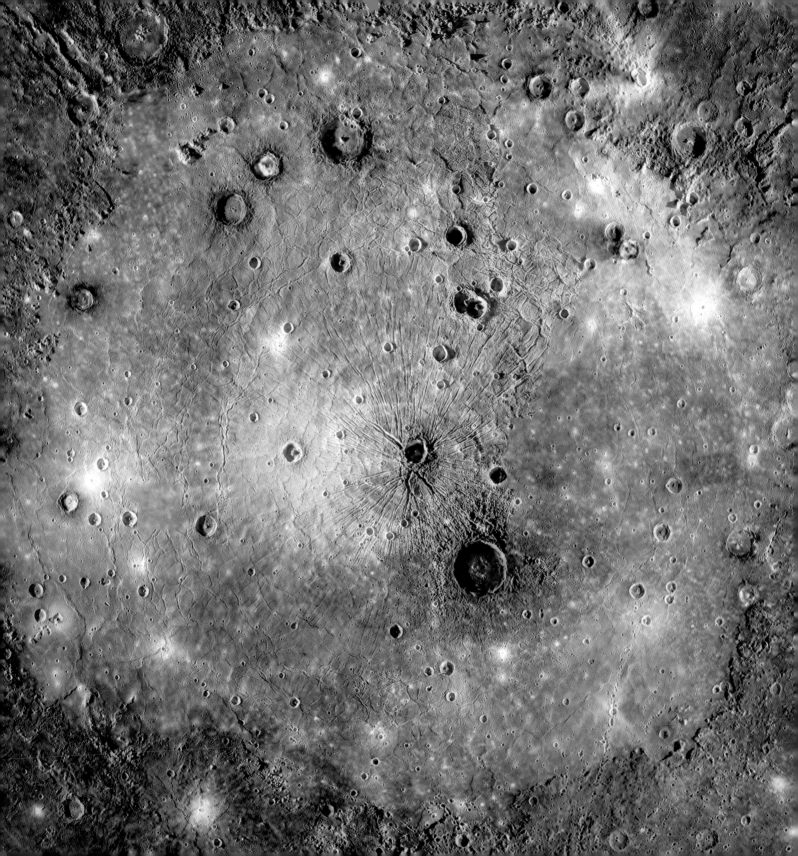

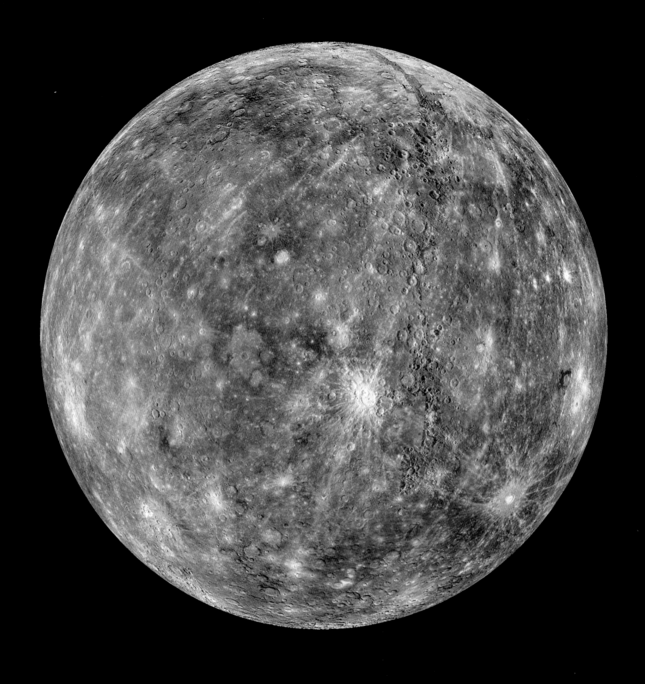

[*opposite*]

A COLORFUL MAP OF MERCURY

This image of Mercury comes from a series of composites that were part of *MESSENGER*'s color base map imaging campaign. The variety of colors here depicts the chemical, physiological, and mineralogical diversity on the surface of the planet. Mercury is the smallest planet in our solar system and the second densest of all the planets (bested only by Earth). Its enormous, metallic, molten liquid core has a radius of 1,100 to 1,200 miles (1,770 to 1,930 kilometers). Mercury's predominantly iron core generates an active magnetic field that constantly interacts with the Sun's solar wind and contributes to the planet's thin atmosphere.

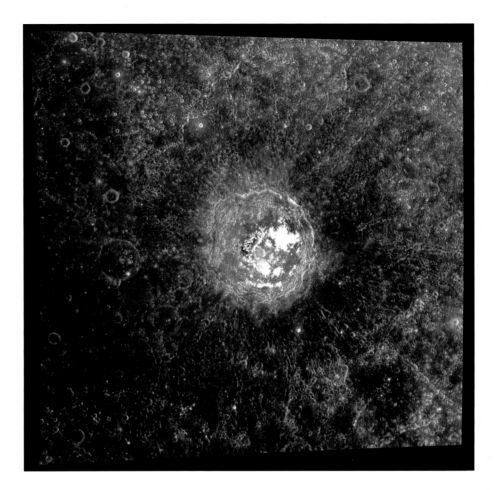

[*above*]

TYAGARAJA CRATER

This 2013, color-enhanced *MESSENGER* image reveals Mercury's Tyagaraja Crater, an enormous formation that encompasses mysterious "hollows" believed to have been created by powerful solar winds. The bright white areas within the crater are the hollows, while the reddish dot at the center of the crater is probably material around a pyroclastic vent – an area of fast-moving gas gliding across the ground at high velocities. The darker material around the hollows is low-reflectance material from the crater floor.

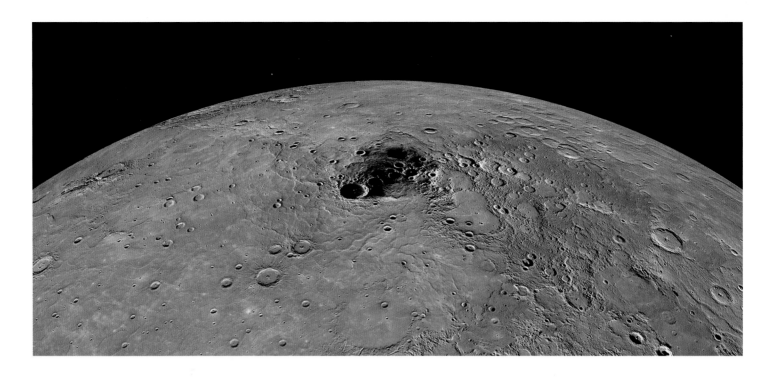

MERCURY'S NORTH POLE

Mercury's north pole appears in this orthographic projection (a two-dimensional rendering of a three-dimensional space, using parallel lines to project a sphere onto a plane) of the planet's global mosaic. This *MESSENGER* image shows what the pole would look like if it were fully sunlit, which it never is, since the planet's almost-vertical spin axis keeps the poles from receiving much direct sunlight.

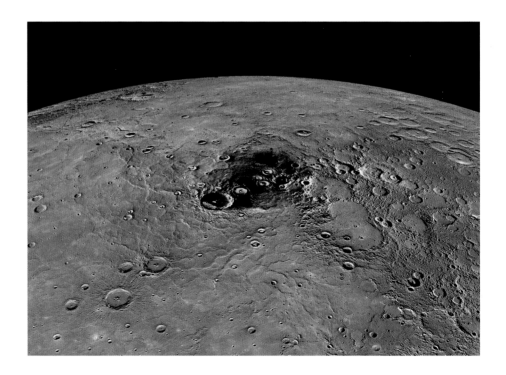

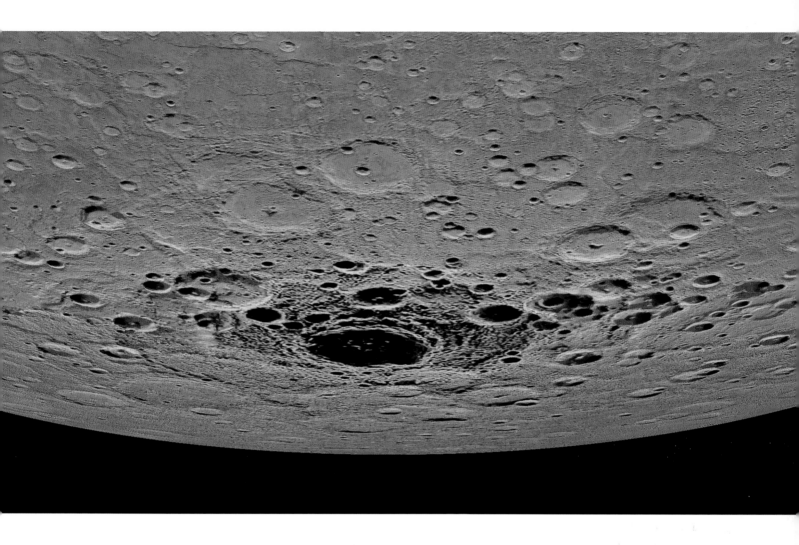

[*opposite, bottom*]

WATER ICE CRATERS

The yellow areas in Mercury's north pole region indicate craters that may hold deposits of water ice, as revealed by Earth-based radar observations and new data from a *MESSENGER* flyby in 2015.

[*above*]

MERCURY'S SOUTH POLE

This orthographic projection of Mercury's south pole is illuminated to show the approximate degree to which areas are lit by the Sun. The black areas are in permanent shadow, and the largest shaded area in the center is the crater Chao Meng-Fu.

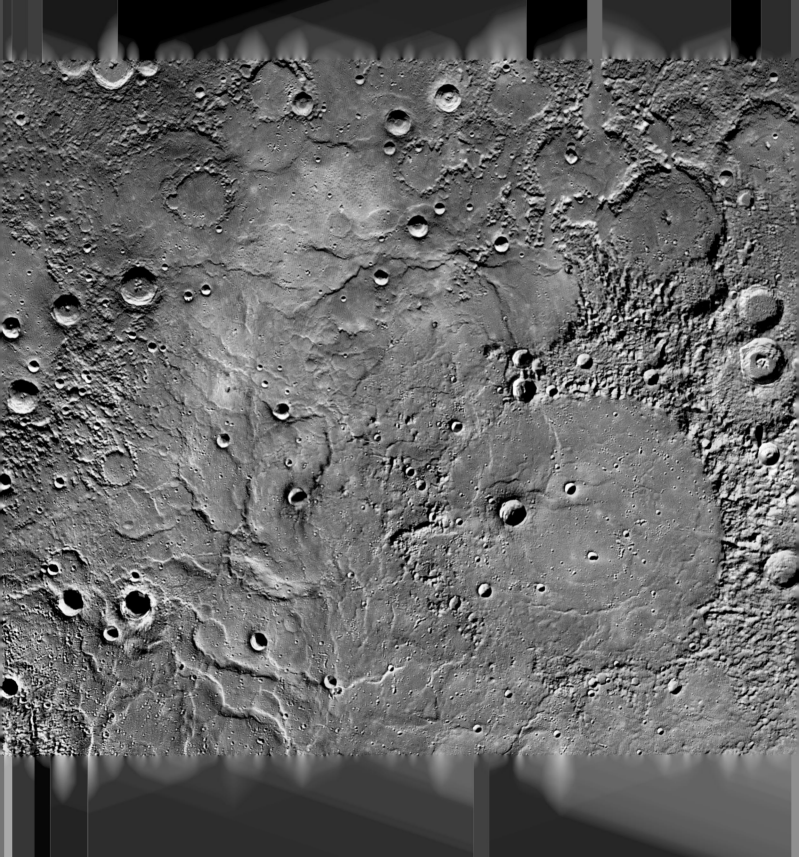

MERCURY'S VOLCANIC PLAINS

This enhanced-color *MESSENGER* image
shows Mercury's epic volcanic plains
in the planet's northern hemisphere.
In the bottom right of the image is the
Mendelssohn impact basin, which is
181 miles (291 kilometers) in diameter.
The large wrinkled ridges indicate cooled
lava flows, while the circular rims in the
bottom left region are impact craters
that were eventually submerged by lava.
Near the top of the image, the bright
orange area is a pyroclastic vent with
fast-moving gas emulsions.

CALORIS BASIN

This vibrant, enhanced-color mosaic
from 2011, taken during *MESSENGER*'s
year-long primary mission, shows
the northwest area of the Caloris
Basin, with craters (in blue) set within
volcanic plains (in orange).

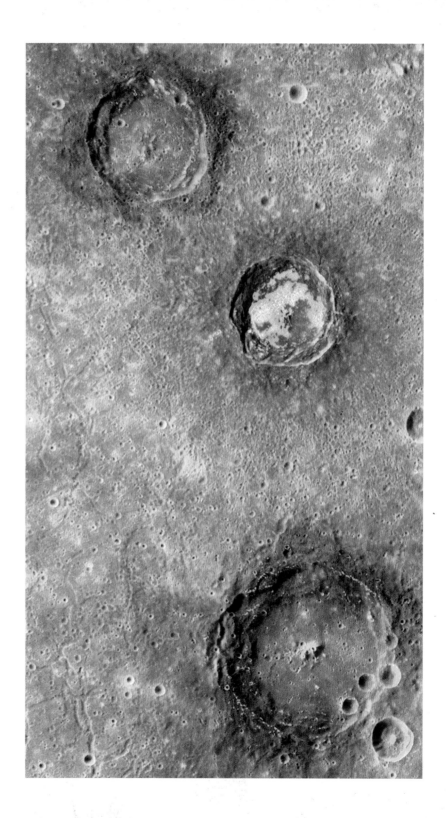

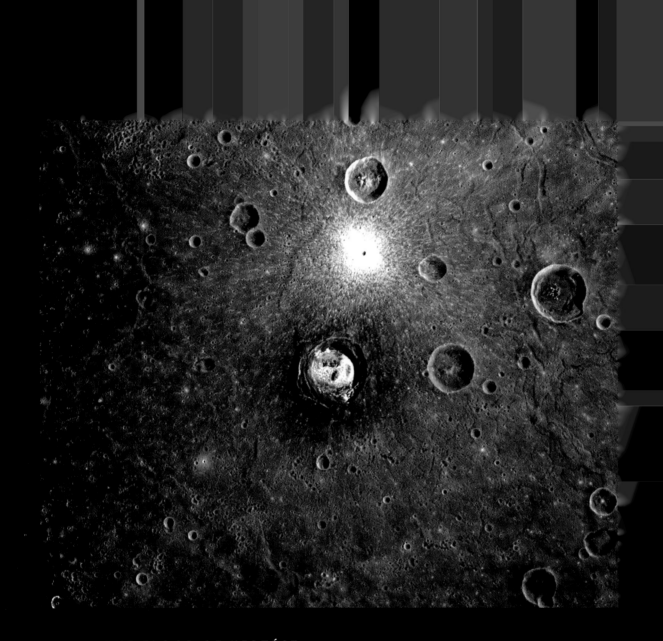

THE FLOOR OF KERTÉSZ

This color-enhanced, 2013 *MESSENGER* image features a series of bright, irregular hollows in the floor of Kertész, a crater in the western region of Mercury's enormous Caloris Basin. Although scientists initially believed that the reflective hollows were water ice (similar to the water ice deposits in the craters close to the planet's poles), it has been theorized that these are actually regions where rocks evaporate due to the high daytime temperatures on the surface of the planet at most latitudes.

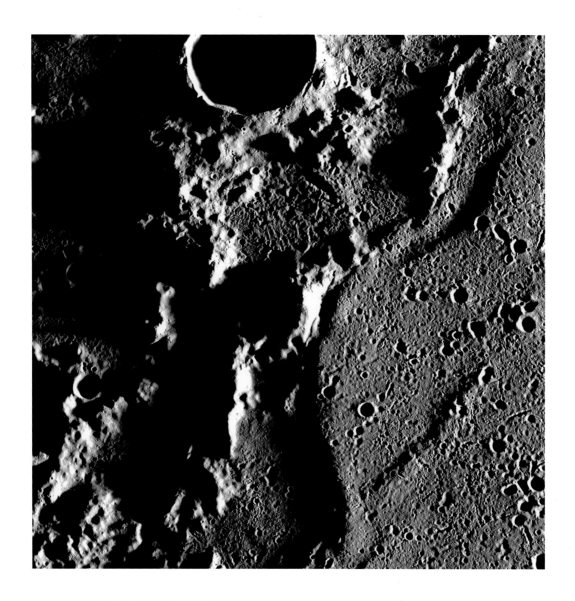

GOETHE BASIN

This *MESSENGER* image of Mercury's Goethe impact basin was taken
when the Sun sat low on the planet's horizon, which resulted in
dramatic shadows and a stark depiction of the surrounding topography.

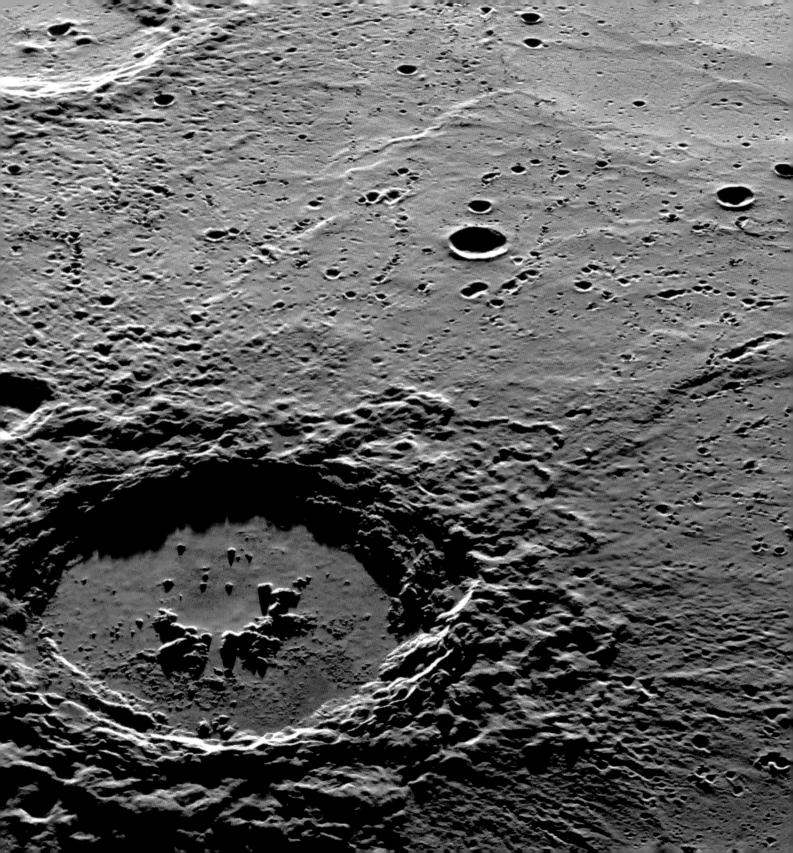

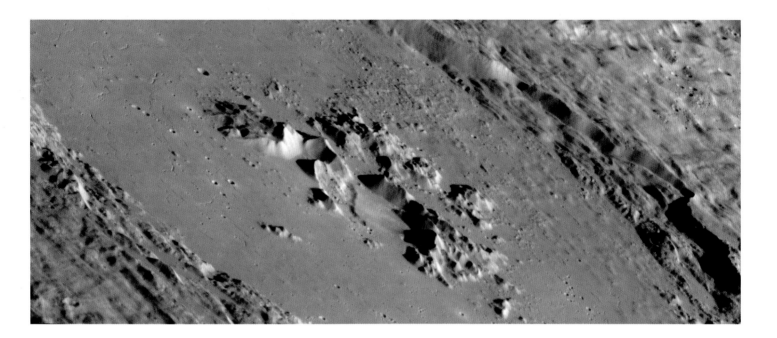

[*opposite*]

HOKUSAI CRATER

In the foreground of this 2013 *MESSENGER* image, the large impact crater Hokusai extends across Mercury's surface. One of the youngest large craters on the planet, many of Hokusai's rays still span over 1,000 kilometers.

[*above*]

ABEDIN CRATER

This 2015 mosaic made up of *MESSENGER* images shows the floor of the Abedin Crater, which is covered in rock that melted during the impact event. As the molten rock cooled, it formed visible cracks.

[*right*]

VAN EYCK CRATER

This 2014 *MESSENGER* image features the complex topography of the Van Eyck Crater. Scientists believe that the crater was formed during the formative years of the solar system by the same meteorite impact that created the Caloris Basin, the single largest feature on Mercury's surface.

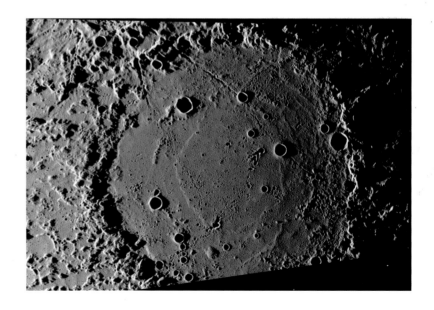

VENUS

VENUS TRANSIT

Here, Venus's silhouette can be seen in the top right corner as the planet transits across the face of the Sun. The image was captured by the Solar Dynamics Observatory (SDO) on June 5 and 6, 2012. It marks an event that only happens twice within an eight-year span every 105 or 121 years; the next transit will occur in 2117.

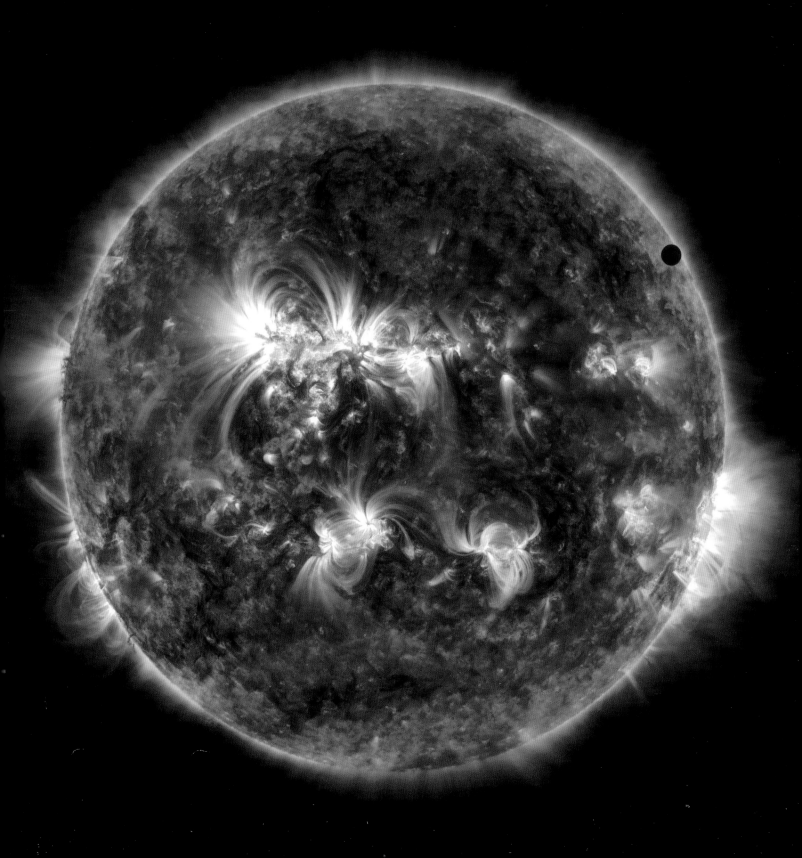

36

[*above*]

A RARE TRANSIT

The solar-observing-satellite Hinode captured this glorious,
and rare, view of Venus transiting the Sun in 2012.

[*opposite*]

A CLOSER LOOK AT THE VENUS TRANSIT

Venus's 2012 transit is featured in this rare view. Until 2004, when the first in this pair of transits
occurred, no living person had seen a transit of Venus around the Sun with their own eyes; only vague
sketches and grainy old photos offered a record of the event. Transit timings were more challenging in
the days before telescopes, when poor weather and the natural haziness of Venus's atmosphere made
it difficult for scientists to make proper calculations. In fact, precise timing of transits didn't occur
until the late 1800s, when cameras could accurately measure the size of the solar system.

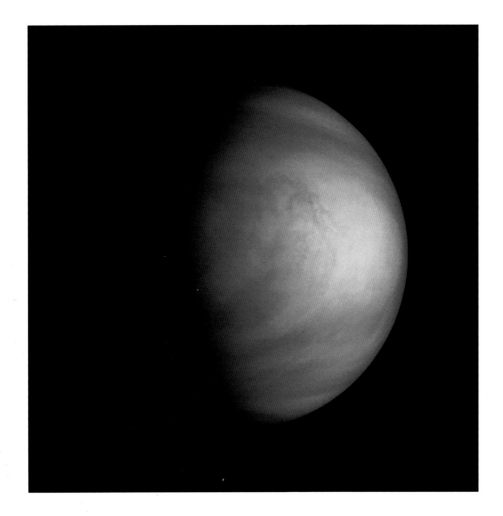

[*above*]

SULFURIC ACID CLOUDS

The Galileo spacecraft captured this image through a violet filter on February 14, 1990, which reveals the sulfuric acid clouds high in Venus's atmosphere.

[*opposite*]

CLOUDS ON VENUS

This 2007 image of Venus's clouds was snapped by the *MESSENGER* Dual Imaging System cameras as the spacecraft approached the planet.

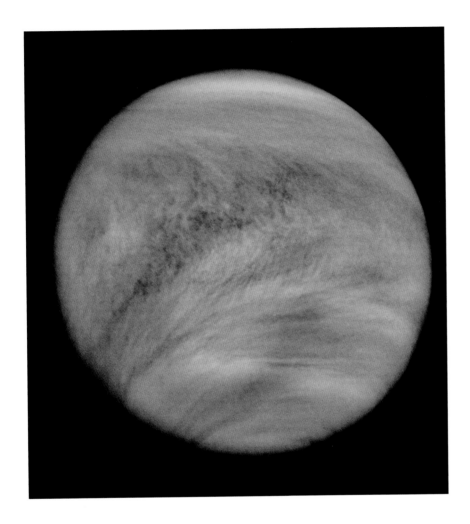

[*above*]

THE CLOUDS OF VENUS

This image of Venus's murky orange cloud tops was captured by the Pioneer Venus Orbiter in ultraviolet light in 1979.

[*opposite*]

SIF MONS

Magellan captured this image of lava flows from the large Venusian volcano Sif Mons. Scientists believe that the dark plains in the background formed from volcanic eruptions.

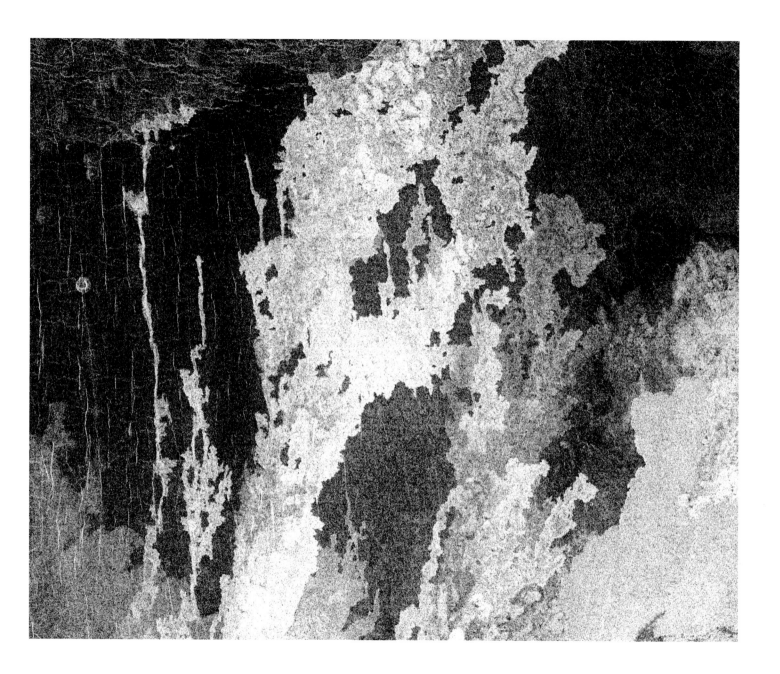

A GLOBAL VIEW OF VENUS

This global mosaic of Venus comes from a 1996 image taken by the *Magellan* spacecraft, with color simulations based on earlier Soviet *Venera 13* and *14* spacecraft images. *Magellan* went into orbit around Venus in 1990 and began a rigorous mapping phase, gathering information across an area 16 miles (26 kilometers) wide and 10,000 miles (16,100 kilometers) long. In particular, *Magellan* scientists were seeking information regarding the age of the planet's surface, the chemical composition of surface minerals, the dominant geological processes, the shape of Venus's surface, the planet's erosion processes, how interior processes contributed to surface features, and the ever-present question of whether or not running water ever existed on the planet's surface.

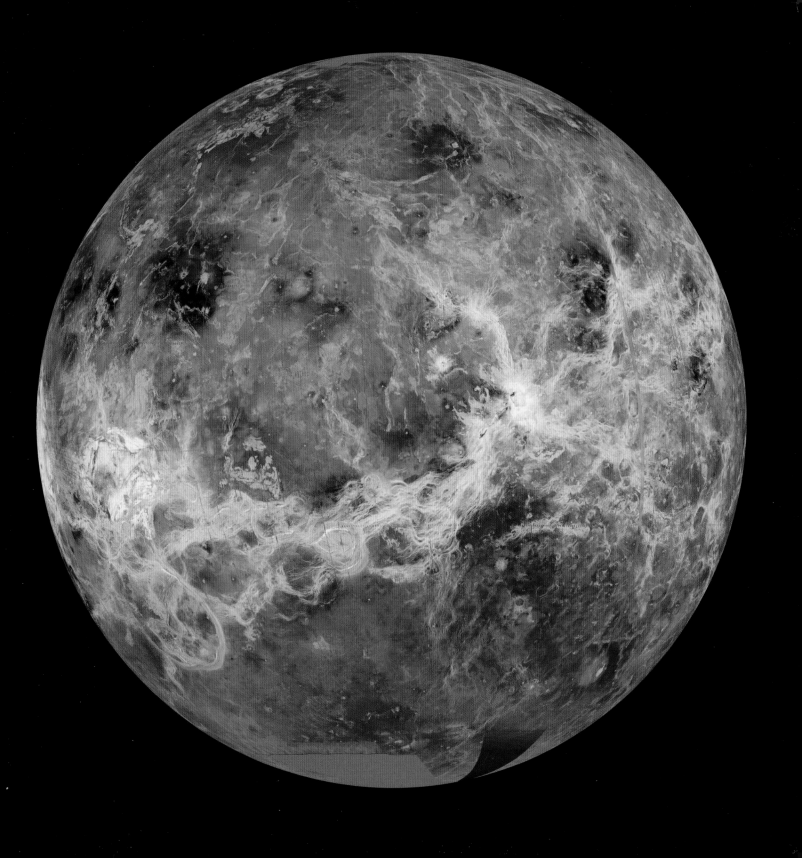

[*opposite*]

TESSERAE

This image was generated by radar data collected in 1992 during the second cycle of the *Magellan* mission. The bright highlands, also known as tesserae, jut up from the plains and are the older landforms. The tesserae are thought to be thick material from the planet's crust, and they make up roughly 15 percent of Venus's surface.

[*following spread, left*]

SAPAS MONS

This three-dimensional, computer-generated image comes from a 1992 video created by the *Magellan* mission and produced by JPL's Multimission Image Processing Laboratory and the Solar System Visualization project. It features Sapas Mons, a large volcano in the equatorial Atla Regio area of Venus. The simulated colors are based on images taken by the Soviet *Venera 13* and *14* spacecraft.

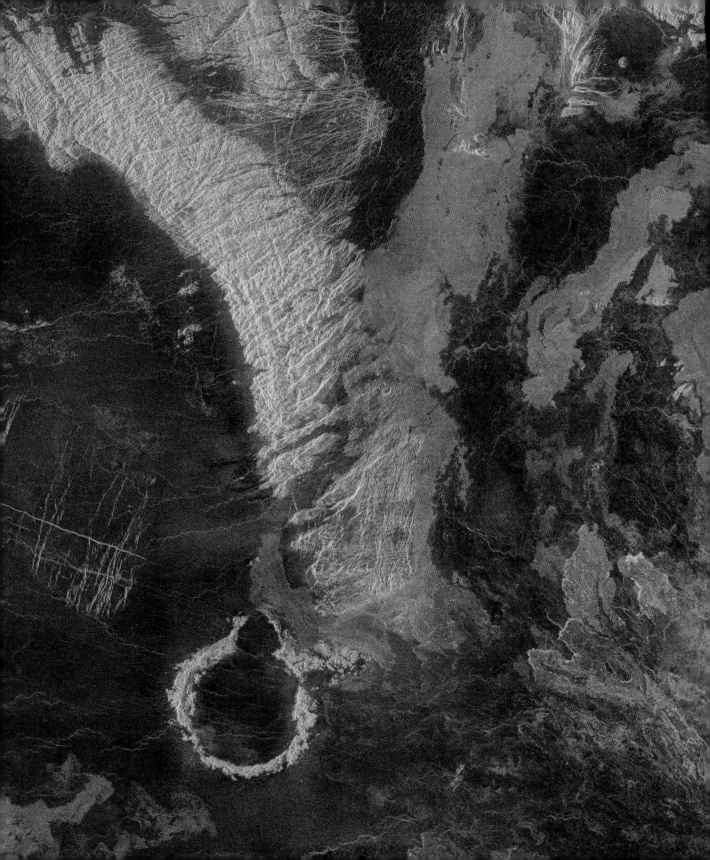

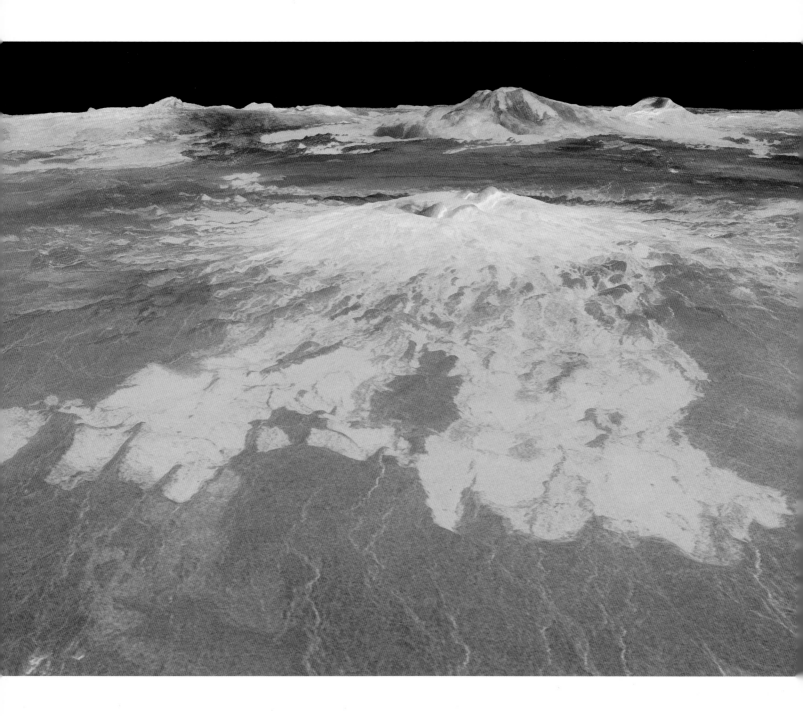

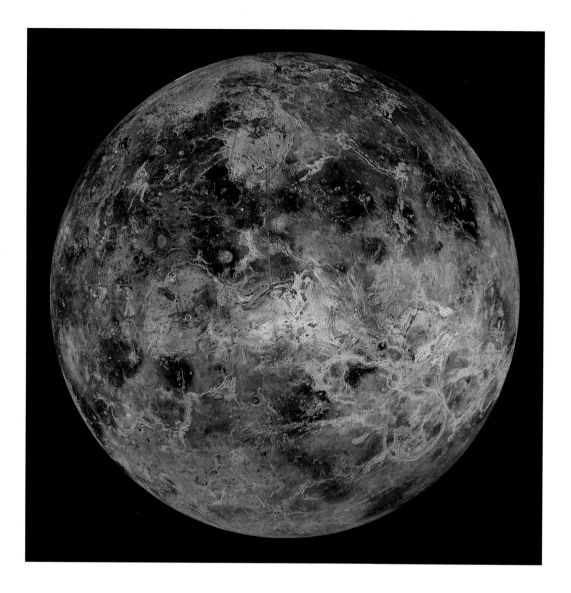

[*above*]

A HEMISPHERIC VIEW OF VENUS

This color-enhanced map of Venus is the compilation of radar investigations of the planet over the course of almost a decade, which ultimately led to the *Magellan* spacecraft mission of 1990–94. The *Magellan* images captured over 98 percent of Venus, but in this map, gaps in coverage were provided by Earth-based images from the Arecibo Observatory, a radio telescope in Puerto Rico. The color itself represents contrast in the elevation and chemical composition of features on the planet's surface.

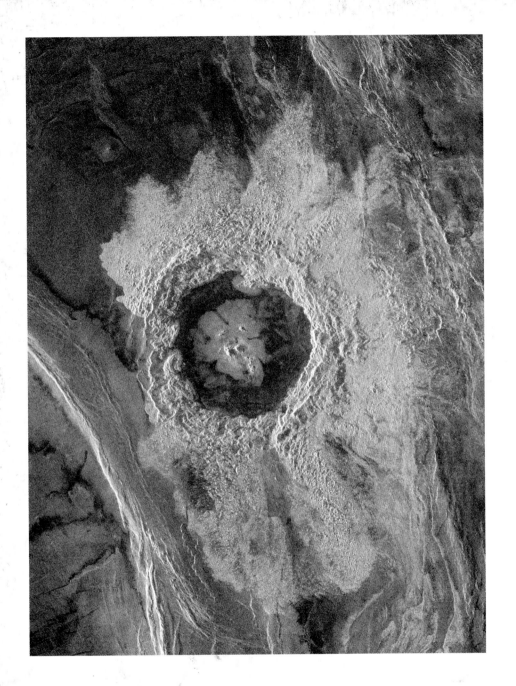

DICKINSON CRATER

This 1996 image from *Magellan* reveals the Dickinson Crater, which is 43 miles (69 kilometers) in diameter and contains lava flows that are believed to be the result of volcanic ejections during the impact event.

LAVA FLOWS ON SAPAS MONS

This false-color 1991 *Magellan* image of Sapas Mons encompasses an area that is roughly 404 miles (650 kilometers) wide. It shows a number of bright lava flows that are believed to have erupted alongside the volcano rather than from the summit.

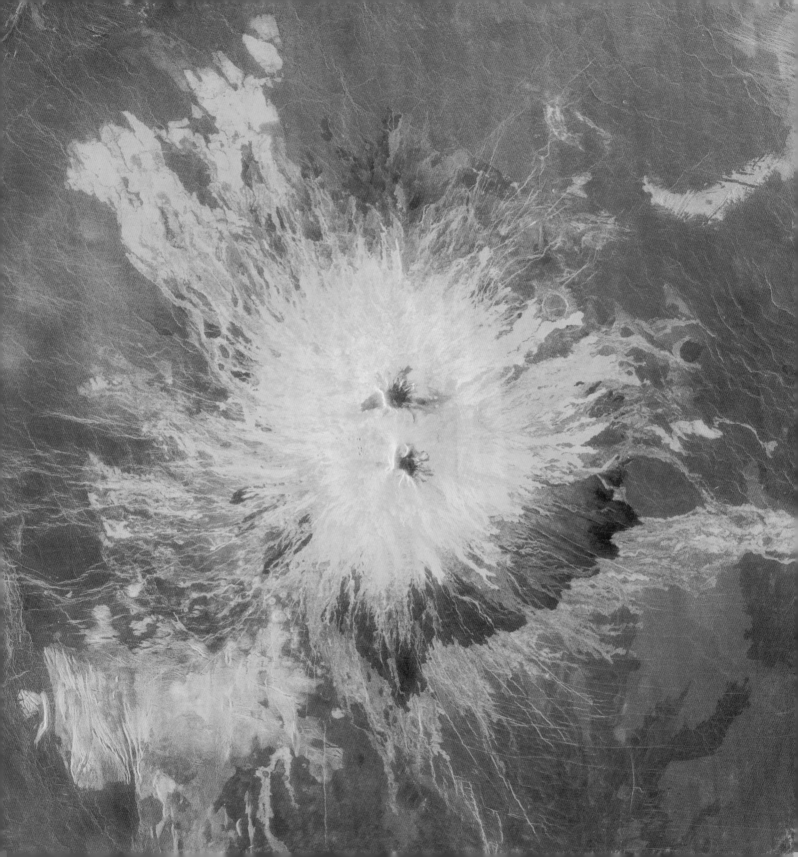

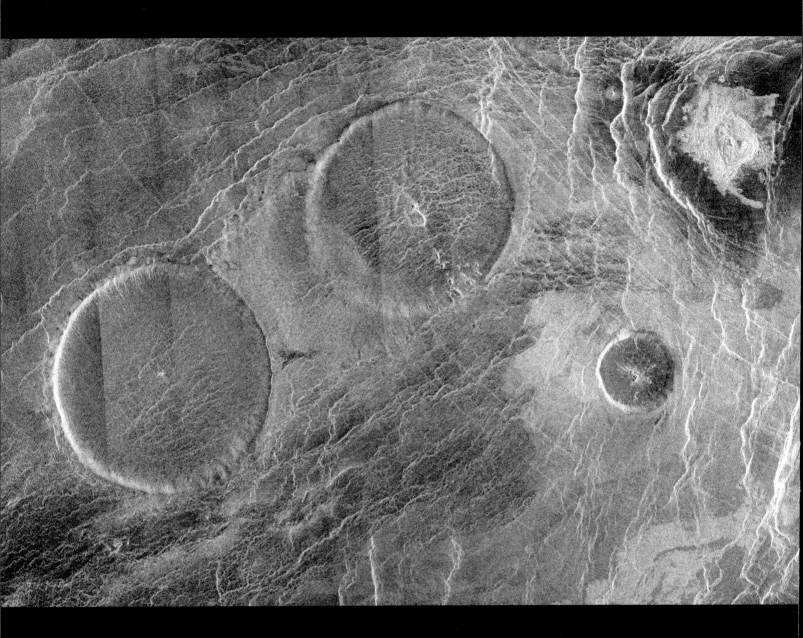

EISTLA REGION OF VENUS

This mosaic image from *Magellan* shows the Eistla region of Venus, which contains "pancake" domes that are the result of thick pools of lava cooling and reforming.

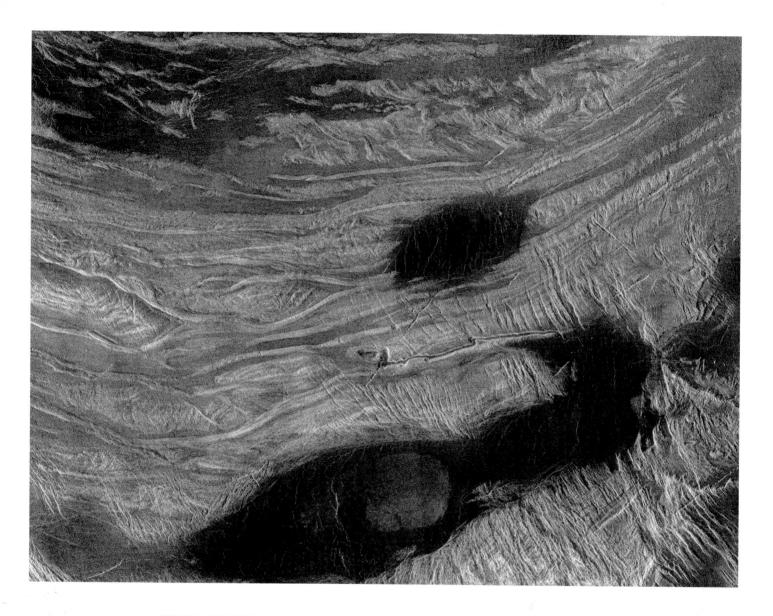

OVDA REGIO

This 1990 *Magellan* image shows us the northern boundary of the equatorial Ovda Regio, which is a central part of Aphrodite Terra, the most massive of three continent-size highland regions. These highlands are characterized by enormous curving ridges and low-lying areas that are more rugged in appearance. The large, dark areas pictured here are believed to be basins formed by intense tectonic activity and subsequently filled with lava flows. The featured ridges, which run east-west along the plane of the photo, are approximately 5 to 9 miles (8 to 15 kilometers) wide and 20 to 40 miles (32 to 64 kilometers) long.

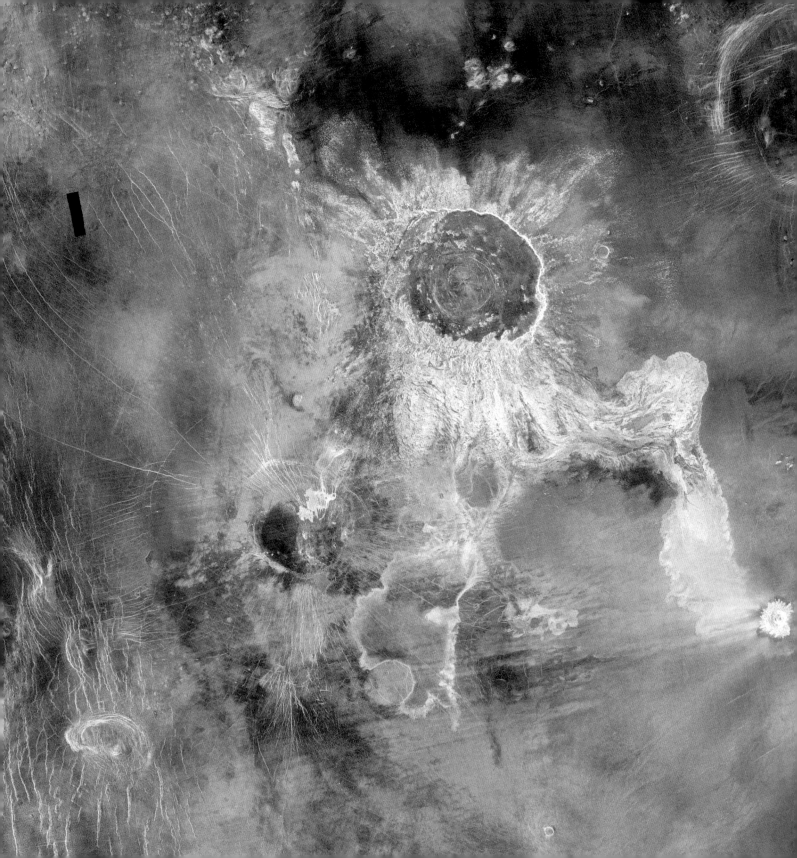

ISABELLA CRATER

This *Magellan* radar image reveals Isabella, Venus's second-largest impact crater, with a radius of 108 miles (175 kilometers). The fluid network of channels may have been formed from debris flows, which occur when clouds of hot gas and pieces of solid and melted rock are swept across the land during impact.

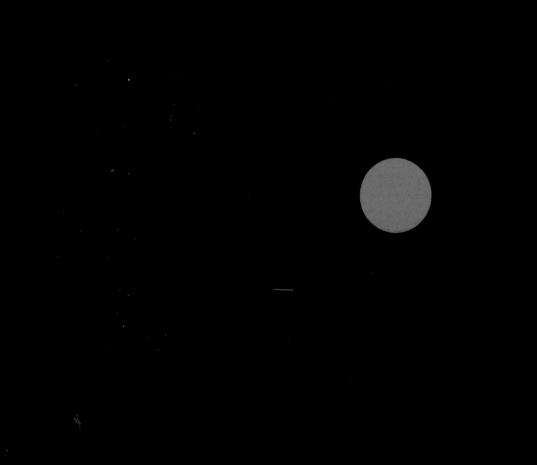

EARTH

LUNAR ORBIT

This image, captured during the 1969 Apollo 10 mission, is a high-angle view of the North American continent's west coast from approximately 100,000 miles (161,000 kilometers) away. Apollo 10 was the first crewed lunar flight to operate around the Moon, and its mission was to outline all aspects of a lunar landing (except for the actual landing). Although the emphasis was on verifying the behavior of lunar module systems in the Moon's environment, the astronauts on board were also responsible for capturing photographs of Earth while they were homeward bound.

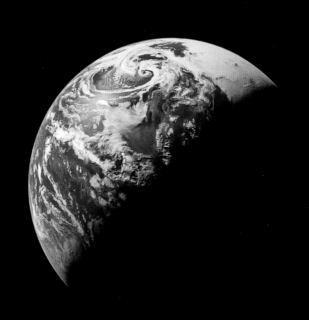

[*opposite*]

CLOUDS OVER THE SOUTH PACIFIC

This August 2016 photograph taken from the International Space Station reveals the coast of Chile, an area that tends to be rainy and cloudy year-round. The photograph provides an example of the "overview effect," the experience of awe, transformation, and interconnectedness that astronauts have described in their transit around Earth. Philosopher and space writer Frank White originally coined the term in the 1970s after flying across the country in an airplane. "Anyone living in a space settlement or living on the moon would always have an overview," White said. "They would see things that we know, but we don't experience, which is that the Earth is one system; that we're a part of that system; and that there's a certain unity and coherence to it all."

[*following spread*]

BLUE CARIBBEAN

This December 2014 image taken from the ISS features a panoramic view of the Caribbean Islands. The tip of Florida is visible in the top left, the Bahamas in the center, and a portion of Cuba in the bottom left.

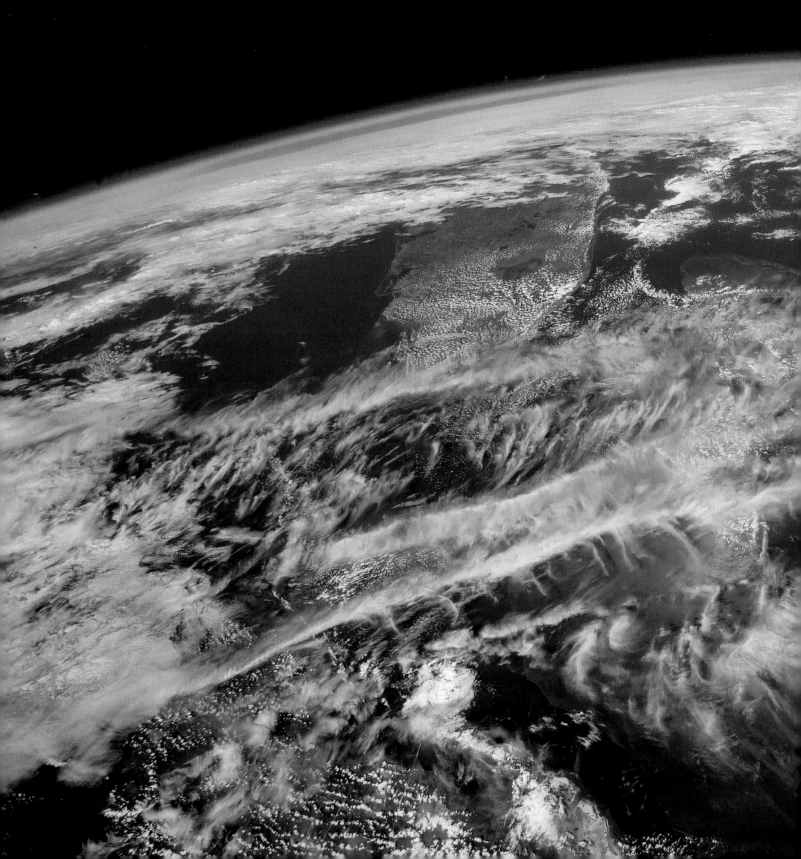

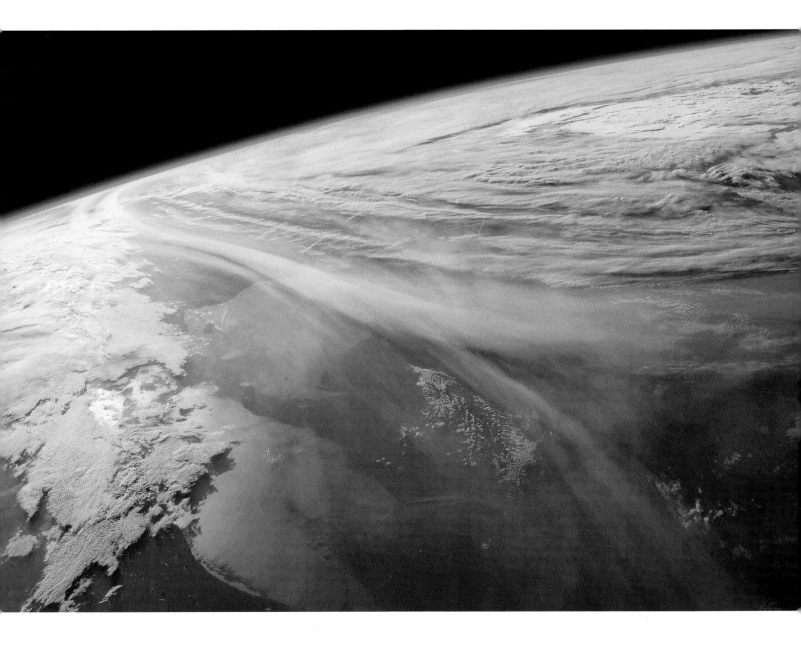

SPRING CLOUDS IN THE MIDWEST

Clouds and atmosperic currents were photographed from the International Space
Station on May 21, 2016, in orbit above the border between Minnesota and the Dakotas
in the Northern United States.

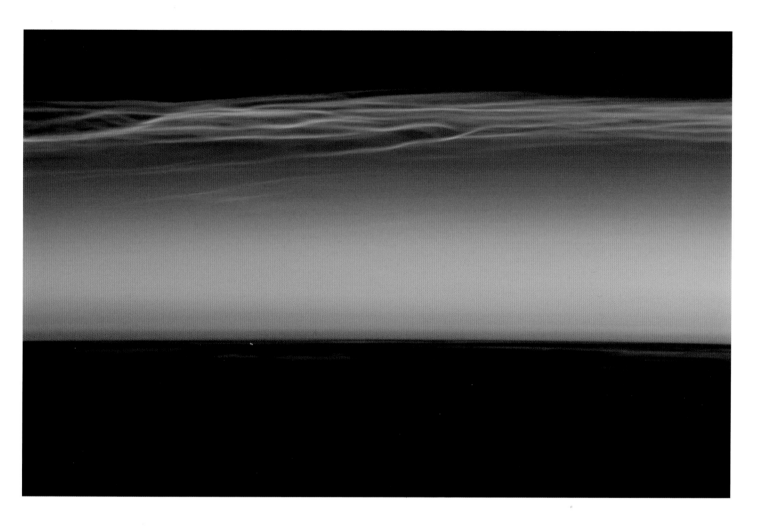

POLAR MESOSPHERIC CLOUDS

This vibrant image reveals noctilucent clouds, a night-shining, cloud-like phenomenon also known as polar mesospheric clouds. The image was taken in June 2012 from the ISS just as it transited over Tibet. During the late spring and early summer, noctilucent clouds are visible in both hemispheres – from the ground and in space. They often appear as bright filaments billowing out against the darkness of space. Scientists believe they are composed of ice crystals formed on meteoric dust particles. These clouds only form at low temperatures during the summer, a time when the coldest temperatures occur near the poles at the mesosphere. This is the layer of Earth's atmosphere that is directly above the stratosphere and below the mesopause, and it demarcates where atmospheric temperatures stop declining and instead rapidly increase. When the clouds are lit by the Sun after it is below the visible horizon (when night falls), they become luminous. In this image, the faint orange stratosphere appears as the lowest visible layer of the atmosphere, close to the horizon.

HURRICANE IVAN

NASA astronaut Edward M. Fincke captured this image in
September 2004 aboard the ISS as Hurricane Ivan raged in
the western Caribbean Sea with winds up to 160 miles
(257 kilometers) per hour. Fincke took the photo as the ISS
passed over the eye of the Category 5 storm; the hurricane had
veered off course, barely missing its predicted target, Jamaica.
The winds swept out over 174 miles (280 kilometers) from the
eye of the storm, covering almost the entire portion of Earth
pictured here. In the upper right corner, the solar arrays of the
ISS, which convert energy to electricity, are also visible.

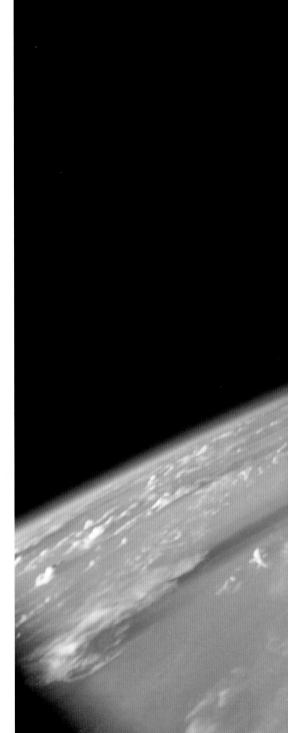

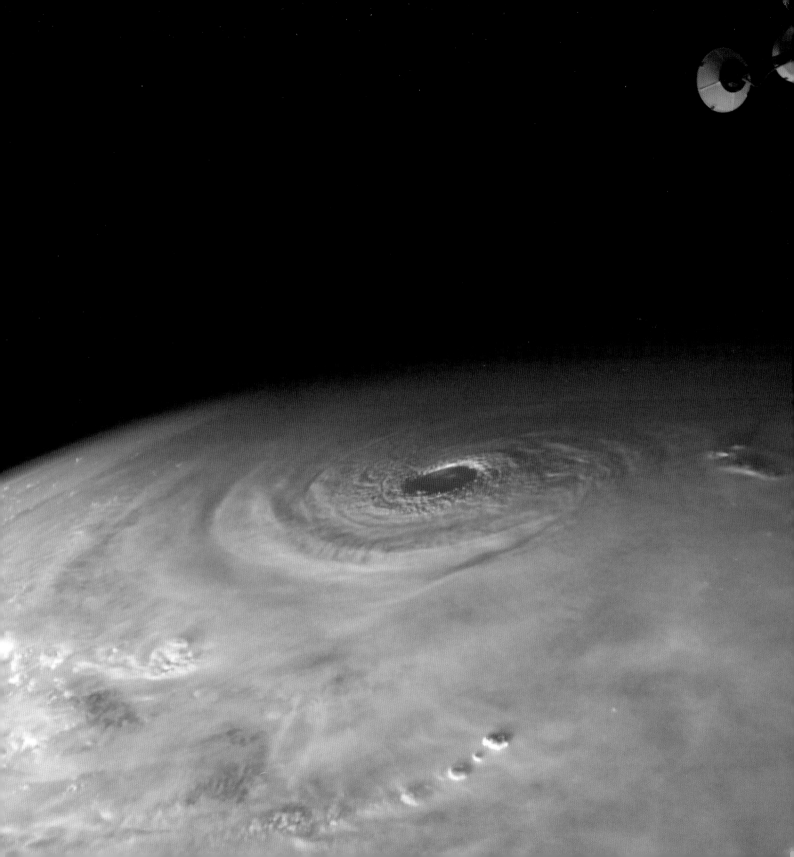

IBERIAN PENINSULA AT NIGHT

This spectacular International Space Station image reveals the illuminated nighttime landscape of the Iberian Peninsula. In the foreground, the brightest area along the coast is Lisbon, Portugal, and the glowing hotspot in the center of the peninsula is Madrid, Spain. The blurred areas are places where clouds obscure and scatter the light.

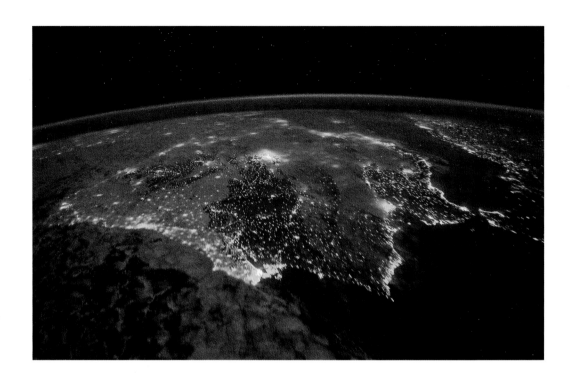

MORNING IN THE WESTERN UNITED STATES

This image of the western United States was taken by astronaut Scott Kelly from the ISS just as the Moon was beginning to rise over the horizon on the morning of August 10, 2015. During this mission, Kelly broke the record for the most time in space by a US astronaut. Between 1999 and 2016, he completed four space missions, including two short-term and two long-term missions. On March 1, 2016, he returned from a year-long mission aboard the ISS that included 340 consecutive days in space, bringing his total time in space to 520 days. Since then, Kelly's American record has been surpassed by NASA astronaut Jeff Williams, who has logged a total of 534 days in space.

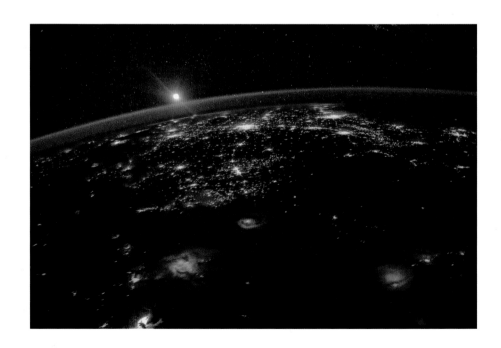

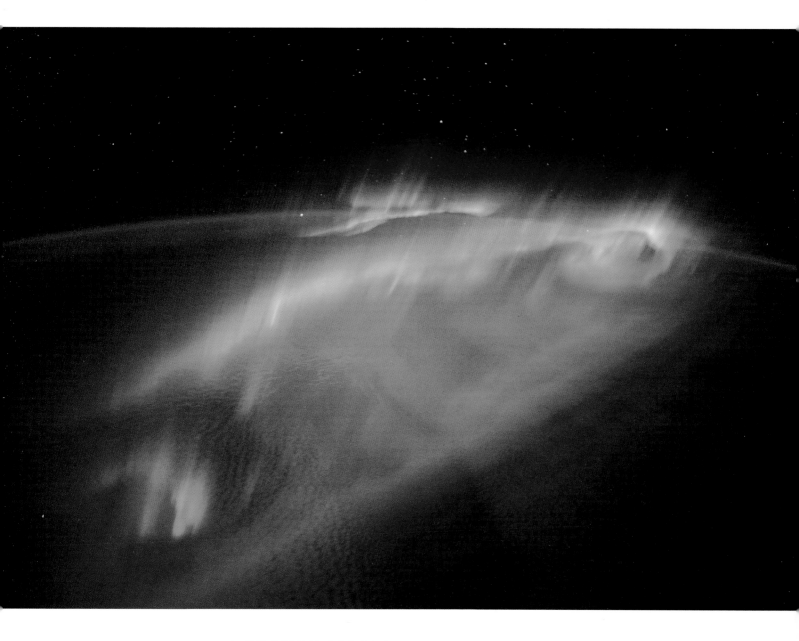

A GHOSTLY AURORA

European Space Agency astronaut Alexander Gerst took this photo from
200 miles (322 kilometers) above the Earth's surface aboard the ISS. On
August 29, 2014, Gerst posted the photo on social media with the note,
"Words can't describe how it feels flying through an #aurora."

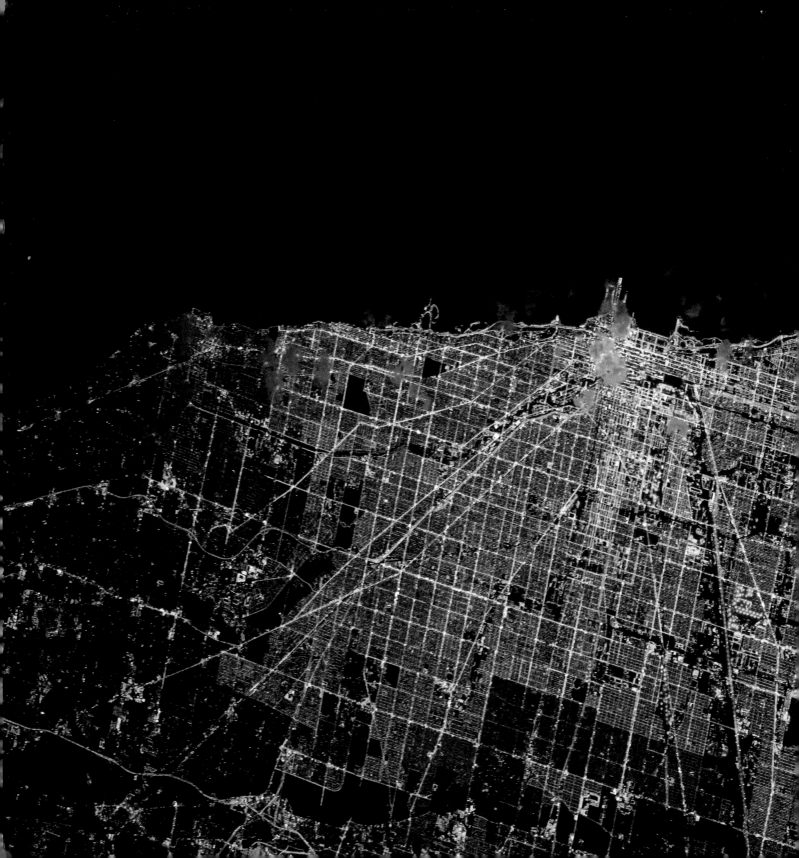

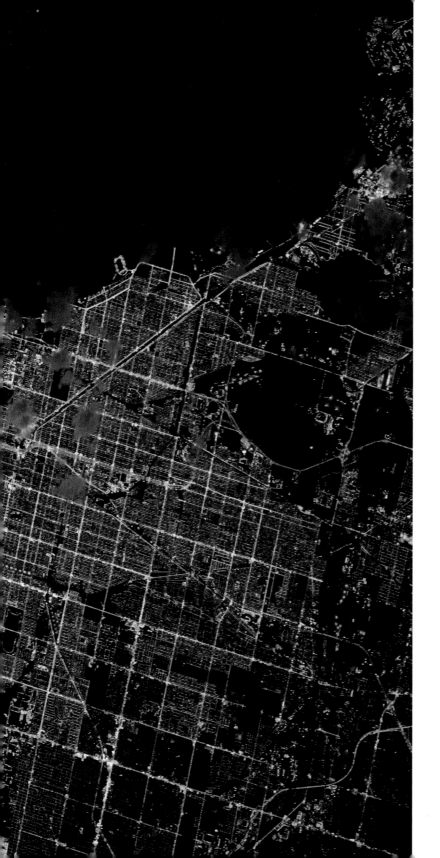

THE LIGHTS OF CHICAGO

In April 2016, NASA's Expedition 47 commander Tim Kopra captured this breathtaking view of Chicago at night from the International Space Station. Night views of the Earth from space help us to envision the distribution of the world's populations; the population of Chicago is approximately three million, while the surrounding metropolitan area harbors close to ten million. Because the surface of the Earth is shrouded in darkness, nighttime images require longer camera exposure times; however, the long exposures usually lead to motion blurring. This is slightly mitigated by a barn-door tracker, a camera mount that helps hold a city steady while the photo is captured, even as the ISS and Earth continue to rotate.

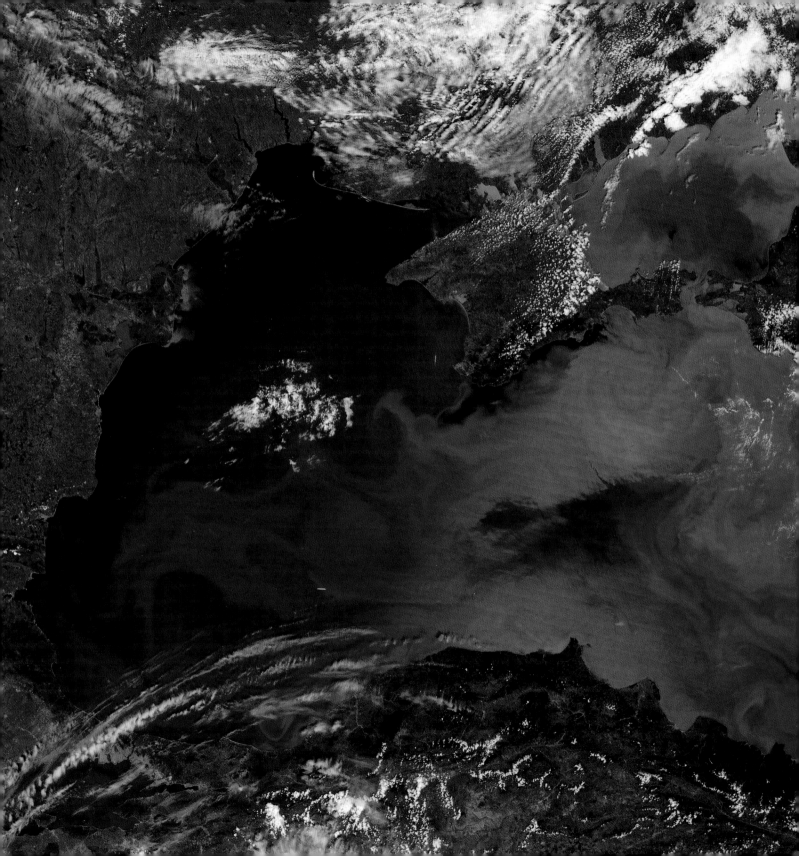

PHYTOPLANKTON IN THE BLACK SEA

NASA's *Terra* satellite, using its Moderate Resolution Imaging Spectroradiometer (MODIS), took this image of the Black Sea in 2012. The sea's rich blue-and-green color palette is the result of phytoplankton – microscopic photosynthesizing organisms such as algae – that spanned close to 168,500 square miles (436,400 square kilometers) and extended to the Sea of Azov in the upper right of the image (which is a duller tan-green because of sediment). Chlorophyll in the phytoplankton creates visible changes in satellite imagery as the light reflects off the surface of the phytoplankton-rich water in a different way.

GREAT SALT DESERT

Iran's Great Salt Desert, Dasht-e Kavir, is pictured in
this false-color composite image (in infrared, red, and
green wavelengths) taken by *Landsat 7*, which is part
of the longest-running program for satellite imagery
of Earth. The massive desert is filled with mud flats
and salt marshes. NASA's World Wind project allows
viewers to observe 3-D images taken by *Landsat 7*.

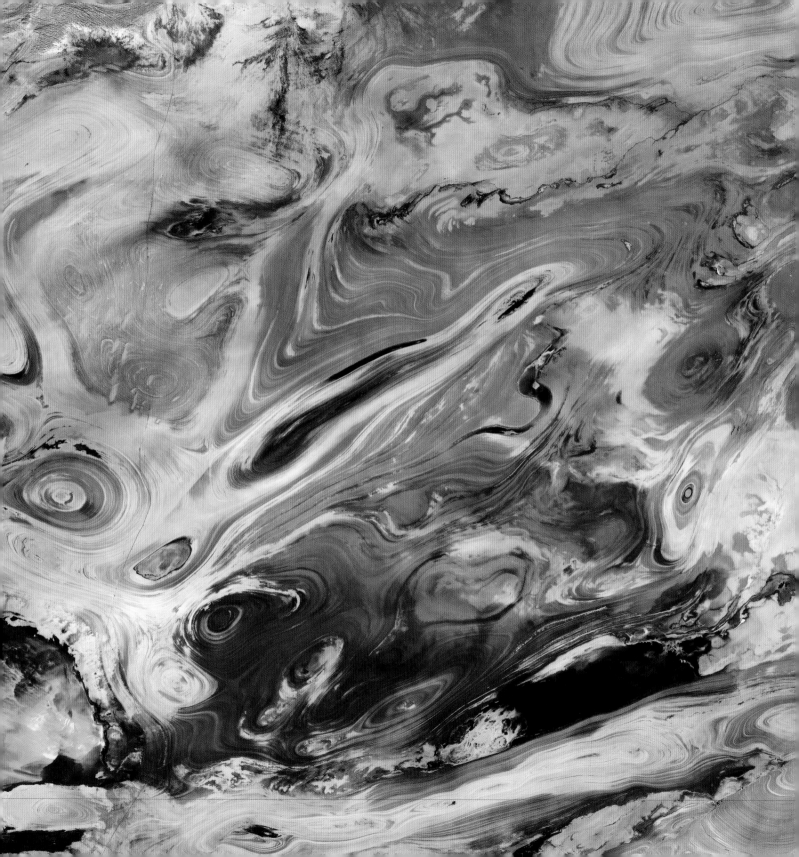

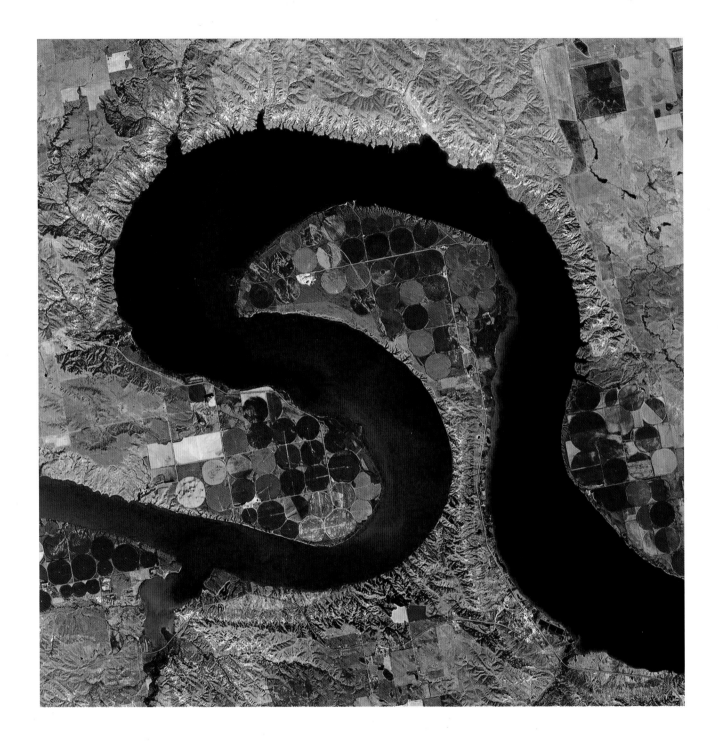

74

LAKE SHARPE

This 2009 image of Lake Sharpe was taken by ASTER, the Advanced Spaceborne Thermal Emission and Reflection Radiometer, which is one of the five Earth-observing instruments on the *Terra* satellite. Overseen by a joint US-Japan team, ASTER maps the Earth's evolving surface and monitors everything from glacial changes to coral reef degradation and thermal pollution. Lake Sharpe is actually a sinuous reservoir (created by Big Bend Dam) on the Missouri River in South Dakota. Scientists predict that, in the future, the Missouri River will directly bisect the narrow peninsula that defines the "big bend" in the image and carve a shorter path for itself.

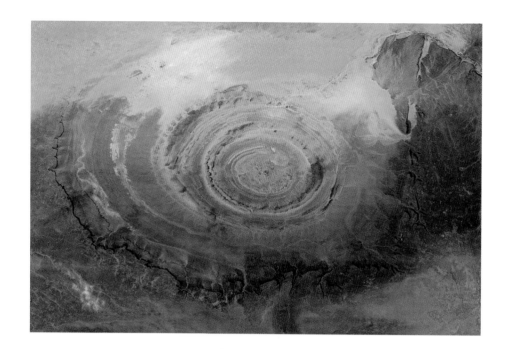

EARTH'S BULL'S-EYE

This picturesque view of the Richat Structure (also known as the "Eye of Africa" and "Earth's bull's-eye") was taken from the International Space Station. The Richat Structure is a circular anomaly in the middle of the Sahara Desert. The formation, which is 31 miles (50 kilometers) wide, is believed to be uplifted rock that's been carved out by erosion.

PENNSYLVANIA'S RIDGE AND VALLEY PROVINCE

The ISS captured this view in 2016. The photo shows the unique ridges of Pennsylvania's Ridge and Valley Province, an area characterized by long ridges separated by continuous valleys.

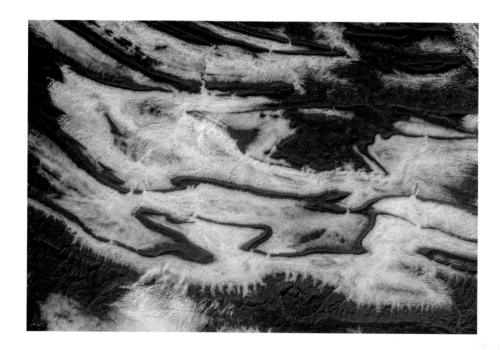

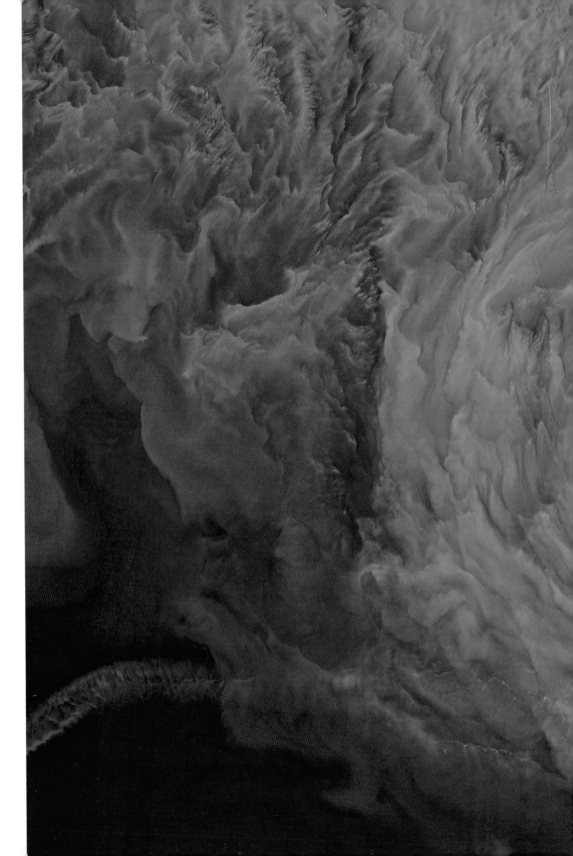

LINES IN THE CASPIAN SEA

The *Landsat 8* satellite captured this 2016 composite image of the Tyuleniy Archipelago (center-right in the photo) in the Caspian Sea. The image reveals a massive amount of lush vegetation on the ocean floor, marked by a subtle assortment of lines. Research suggests that many of the marks are the result of ice gouging, which occurs when floating ice banks glide into shallow regions and scrape across the seabed, producing long furrows as the ice moves.

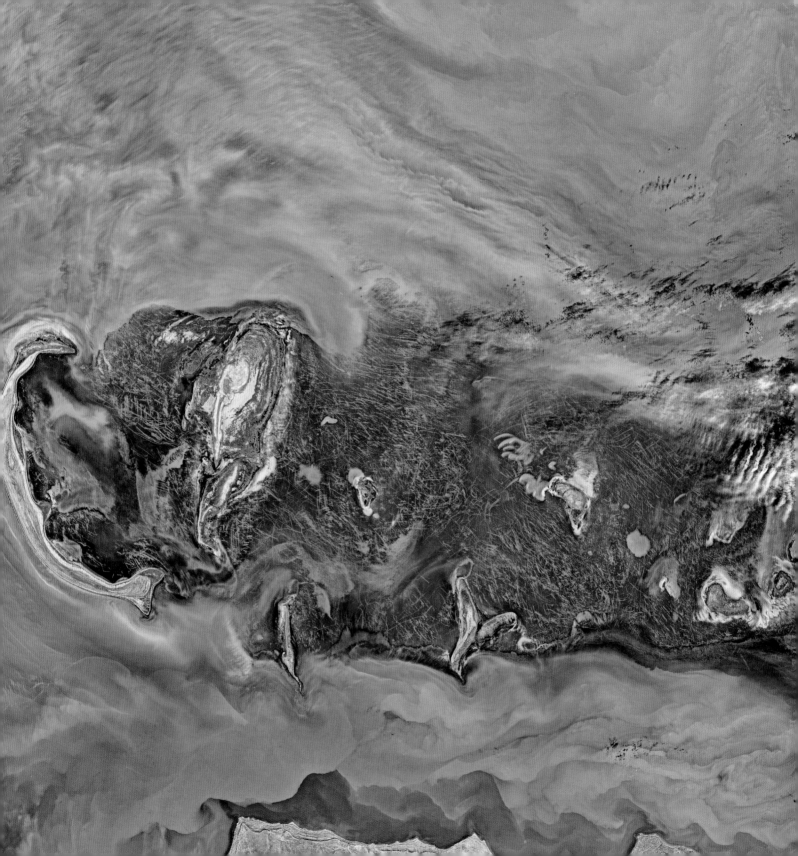

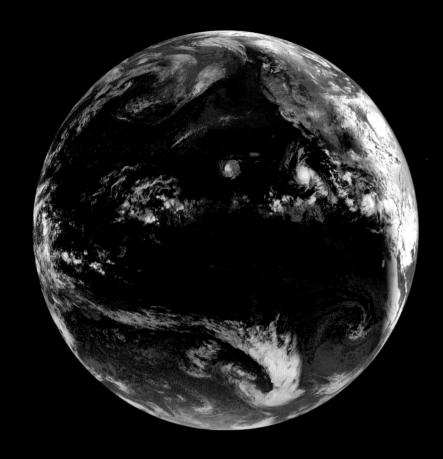

[*above*]

TROPICAL STORMS

GOES-15 – which stands for Geostationary Operational Environmental Satellite, and is run by the US National Oceanic and Atmospheric Administration – caught this image of tropical cyclones swirling over the eastern Pacific Ocean in July 2012. Seventy-one percent of Earth's surface is covered by water, and the oceans hold more than ninety-five percent of our planet's water.

[*opposite*]

A SYNTHESIZED VIEW OF EARTH

This image of Earth was captured by VIIRS – the Visible Infrared Imaging Radiometer Suite on the *Suomi National Polar-orbiting Partnership* satellite. The image, which was generated over the course of six orbits, displays a view of North Africa and southwestern Europe.

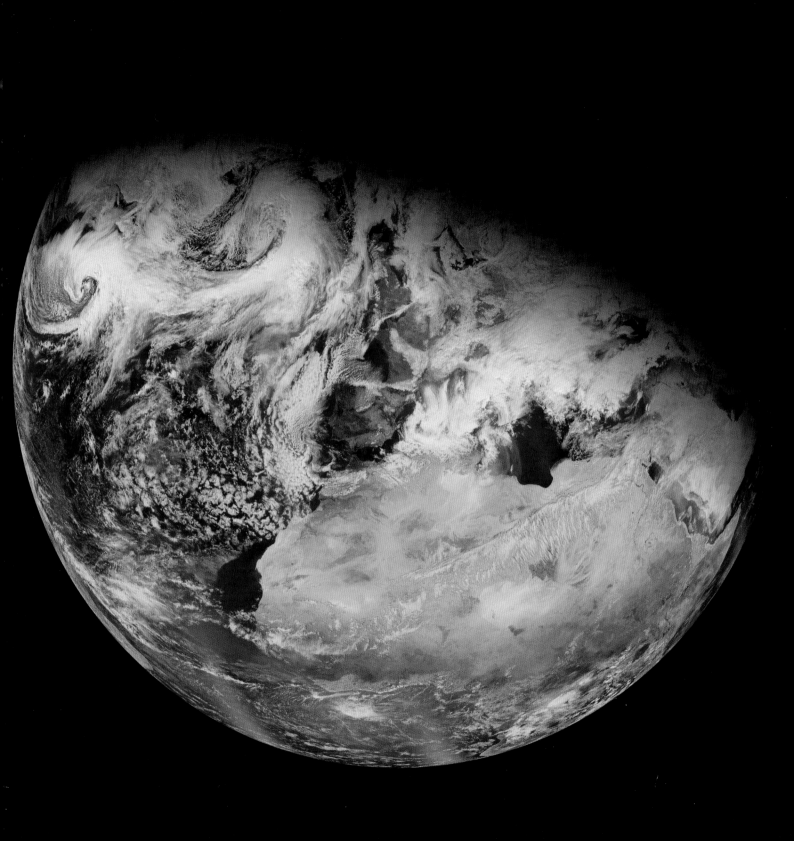

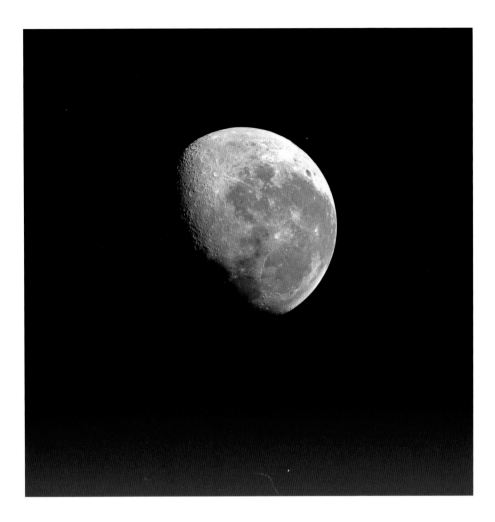

MOONSET

This March 2016 photo of a moonset
was captured by a flight engineer
aboard the International Space Station.

[*opposite*]

LUNAR BOULDER

In December 1972, astronauts Eugene A. Cernan and Harrison H. Schmitt – the last two
men to walk on the Moon in NASA's historic Apollo program – took this photograph using
a handheld Hasselblad camera. The image shows Earth looming like an alien form above
a massive lunar boulder in the foreground. The photograph was taken in the vicinity of
the Moon's Taurus-Littrow region on the southeast border of the Sea of Serenity – the
landing site of Apollo 17. Scientists believe the Taurus-Littrow valley was formed roughly
3.9 billion years ago, when an enormous asteroid impacted the Moon and violently
excavated a basin 435 miles (700 kilometers) in diameter. As blocks of rock were ejected
from the surface of the moon, rings of mountains formed, and in some areas, radial valleys
were strewn throughout the mountains. The valley was an ideal place for a Moon landing,
as it is conveniently located for soil-collecting and examining crustal material.

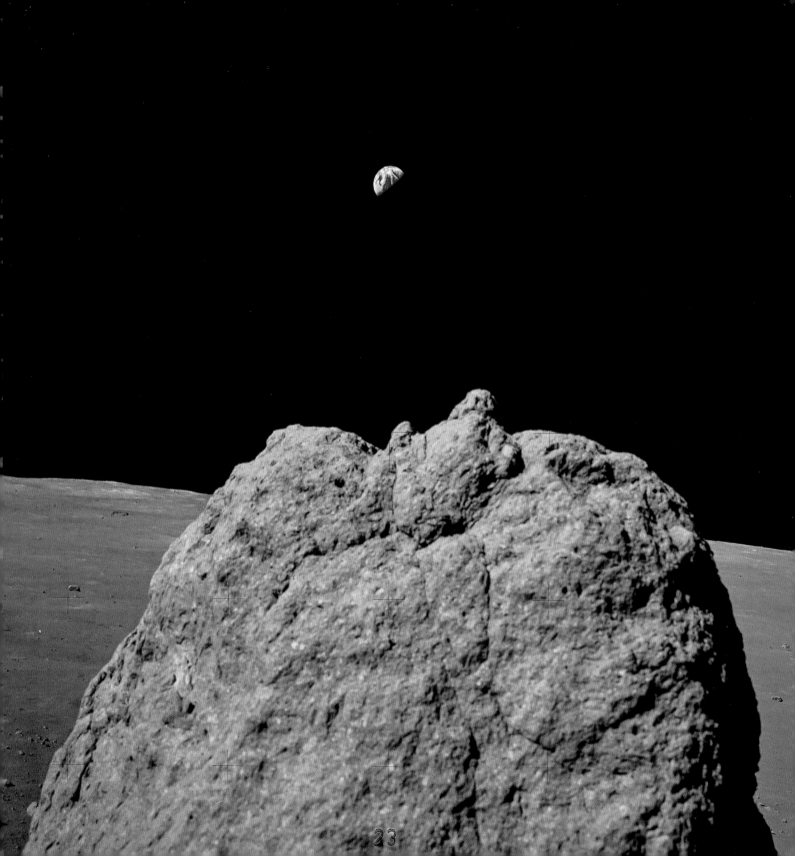

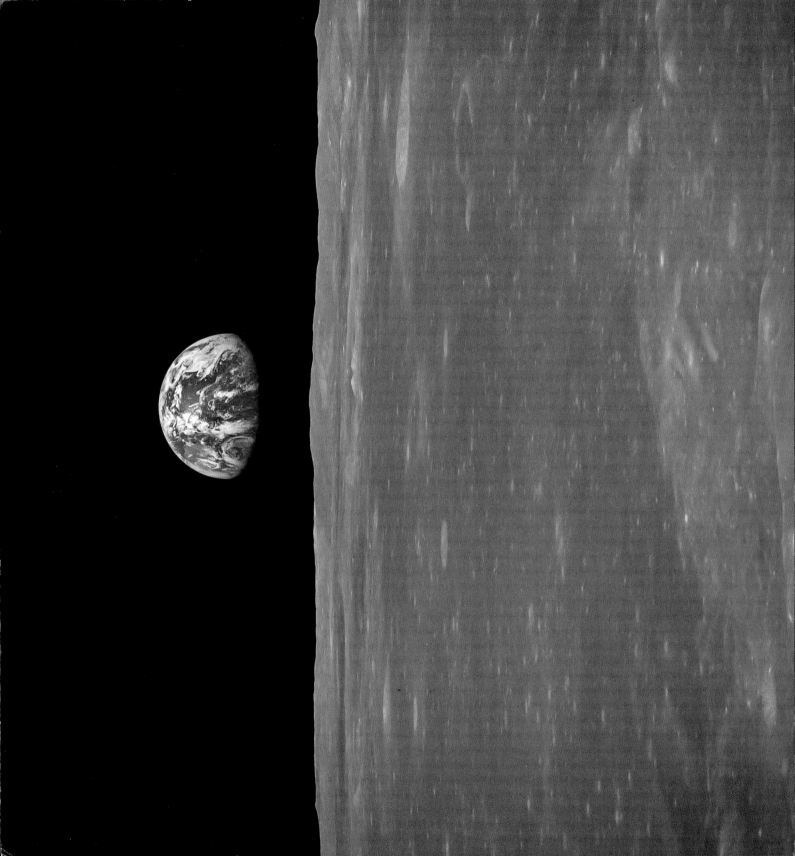

A VIEW FROM APOLLO 11

This view of Earth rising above the Moon's horizon
was captured by the *Apollo 11* spacecraft in July 1969
as it flew over the Mare Smythii, one of many large
basaltic plains formed by volcanic eruptions.

CRESCENT EARTH

The Apollo 15 mission captured this view during an
orbit around the moon in 1971. The surface of the
moon appears in the foreground while the crescent
Earth glows in the distance.

[*opposite*]

THE ORIGINAL EARTHRISE

NASA's *Lunar Orbiter 1* captured this high-resolution image in 1966. It is recognized as the very first photograph of Earth as seen from a vantage point close to the Moon. *Lunar Orbiter 1* was an unmanned mission that was responsible for meticulously mapping the surface of the Moon to prepare for the Apollo missions.

[*following spread*]

EARTHRISE: UPDATED

This is the first photograph of Earth as seen from the Moon. It was taken in 1966 by *Lunar Orbiter 1*, and was fully reconstructed and corrected in 2015 by the Lunar Orbiter Image Recovery Project, a project that has recovered and enhanced the original image data from the five spacecraft sent to the Moon in the 1960s by NASA.

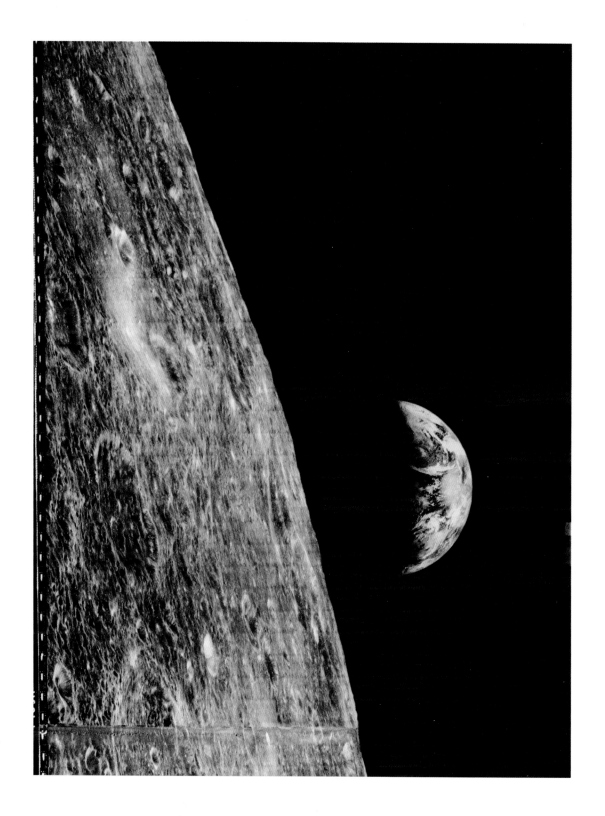

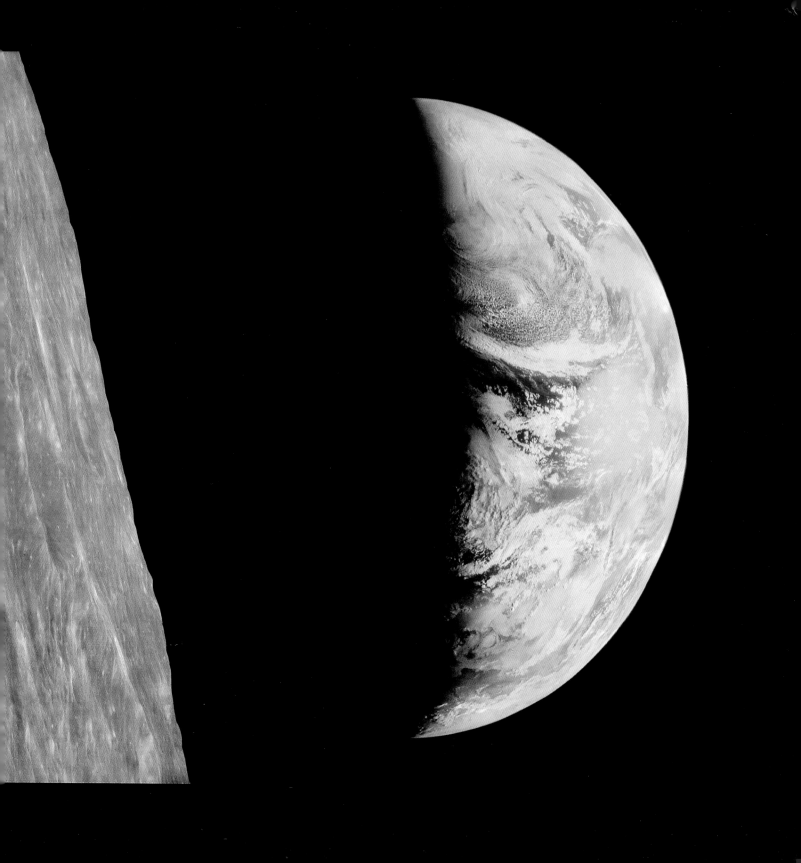

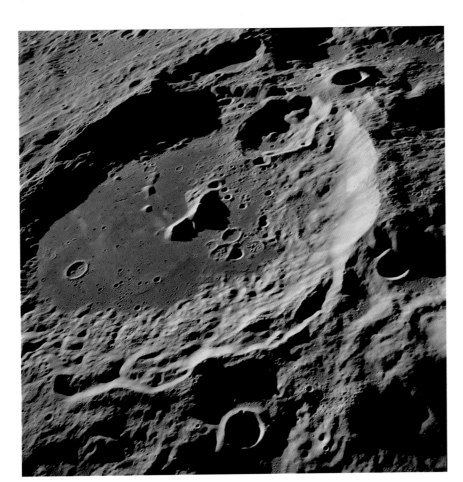

AITKEN CRATER

This Apollo 17 image shows the Aitken Crater, which is at the northern edge of the South Pole–Aitken basin, the Moon's largest and possibly oldest impact basin. Aitken Crater is roughly 84 miles (135 kilometers) in diameter, while the entire South Pole–Aitken basin boasts a diameter of 1,550 miles (2,495 kilometers) and spans almost a quarter of the Moon. The majority of the Aitken Crater's original floor has been submerged by younger rock formations, but the floor also contains highly reflective features that scientists call "swirls" (not visible here), which may be connected to variations in the Moon's magnetism. The idiosyncratic bulbous hills emerging from the crater are not entirely understood, but they may be the result of the Moon's tectonic activity.

[opposite]

A GLOBAL MOSAIC OF THE MOON

This 2011 global mosaic of the Moon comprises more than fifteen thousand photographs taken by the Wide Angle Camera on the *Lunar Reconnaissance Orbiter* (LRO), which captures almost the entire surface of the Moon every month. The photo is one of the most complete looks at the far side of the Moon. Until lunar probes and astronauts explored the Moon in 1959, we had never seen the lunar far side, as it never appears in Earth's night sky. Tidal forces between Earth and our Moon have affected the Moon's rotation so that it only ever reveals its luminous "near side" to us, a phenomenon known as tidal locking. While the near side is marked with basaltic plains known as "maria," the result of ancient volcanic activity, the far side has far fewer maria and a higher number of impact craters.

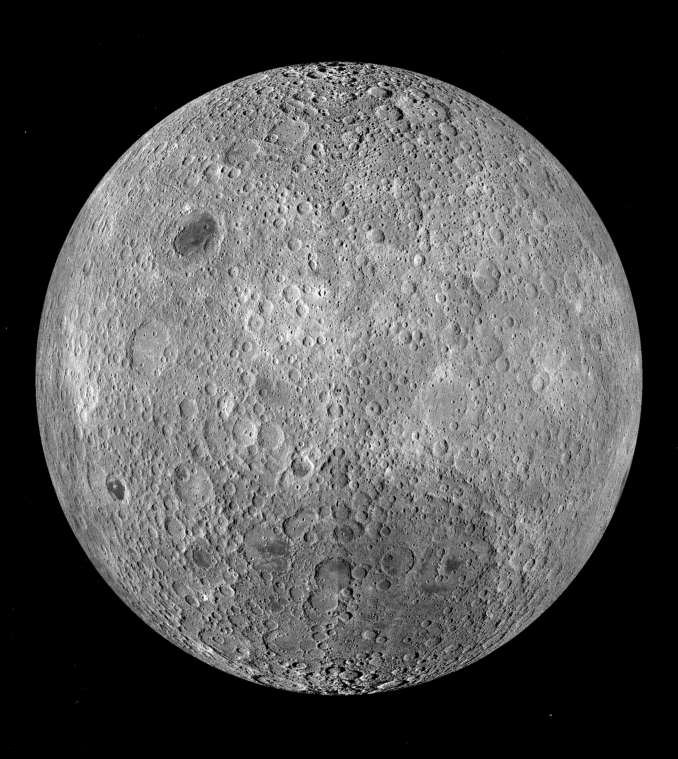

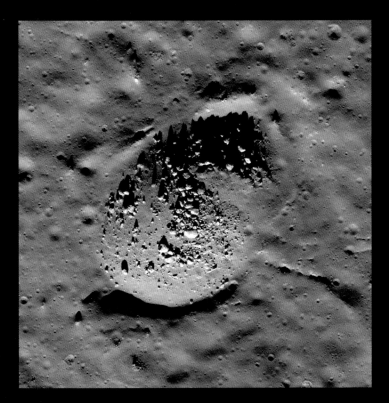

ANAXAGORAS CRATER

Anaxagoras is a massive crater of indeterminate age on the Moon's far side. Samples of rock melt taken from craters help determine the exact age of the crater and the moment of the impact event.

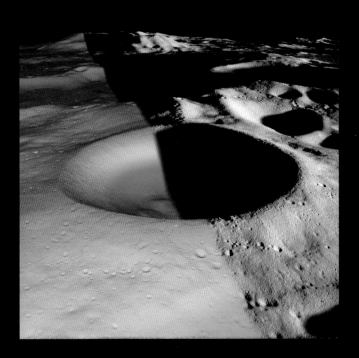

SHACKLETON CRATER

This image from NASA's *Lunar Reconnaissance Orbiter* features the interior of the massive Shackleton Crater illuminated with infrared laser light. LRO data is responsible for the most detailed maps of the lunar surface. Because the crater's floor is more reflective than the floors of craters in close proximity, researchers believe it's an area where ice has accumulated.

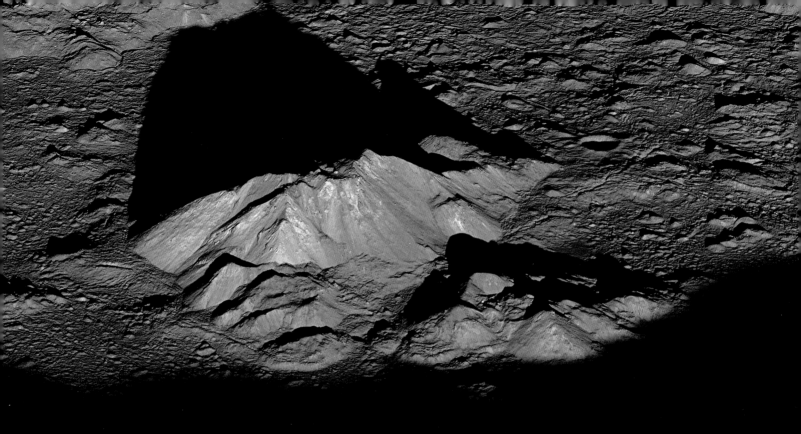

THE MOON AS ART

This LRO image shows the Tycho Crater's central peak, a 1.24-mile-
(2-kilometer-) high summit that emerges from the center of the impact crater
and has a boulder roughly 328 feet (100 meters) wide at its apex. This image
was included in NASA's 2014 "Moon as Art Campaign," an event honoring the
LRO's fifth anniversary navigating Earth's next-door neighbor. As part of the
campaign, this photo was identified as the public's favorite image of the Moon

MARS

♂

A MOSAIC OF MARS

Mars has evoked the imagination of space explorers and armchair cosmologists for centuries. The fourth planet from the Sun is only half the diameter of Earth, but despite its cold desert climate, it bears similarities that have raised the question of whether Mars might support life. Just like our planet, Mars experiences seasons and weather, and it has polar ice caps, canyons, and volcanoes. Although its atmosphere is much too thin to support the existence of liquid water, there is ice at the poles of the planet as well as in colder locations. However, it is unlikely that the ice melts in the hotter seasons substantially enough to support microbes. This 2003 mosaic of Mars is compiled from a series of images taken by the *Viking 1* orbiter. The center of the image features the massive Valles Marineris canyon, while the east gives way to chaotic irregular terrain.

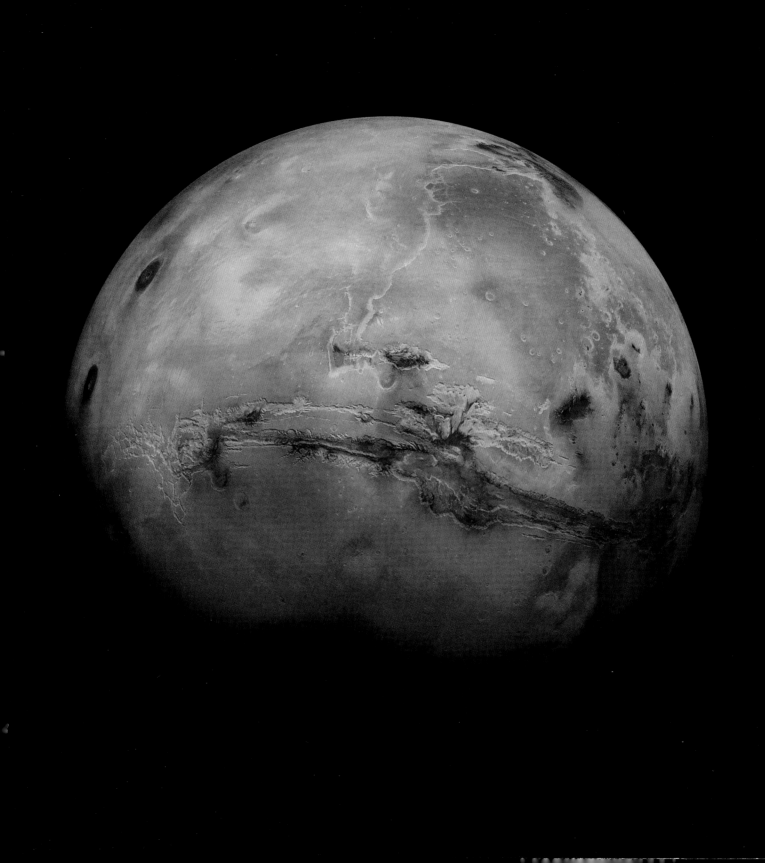

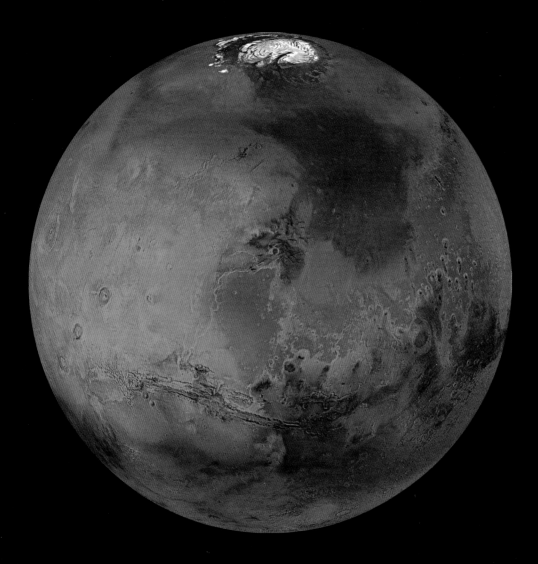

[*above*]

GLOBAL COLOR IMAGE OF MARS

This *Viking 1* orbiter mosaic image combines approximately one thousand red- and violet-filter photographs. Images were chosen to provide the most accurate global coverage of the planet (free of atmospheric fuzziness and seasonal frost). Then any atmospheric effects and variations in illumination were removed to offer a uniform image. The color balance was chosen to approximate the natural color of the planet. There have been more than a dozen NASA missions to Mars, and five are still currently in process. While all of the Mars missions thus far have been unmanned, or robotic, NASA hopes to send humans to the red planet in the 2030s using the Space Launch System (SLS) — which when completed will be the most powerful rocket ever built — and Orion, the exploration vehicle that the SLS will carry.

[*opposite*]

VALLES MARINERIS

This composite image shows the Valles Marineris, an extensive system of canyons along the Martian equator. The image was created from photos taken in 1998 by the *Viking 1* space probe.

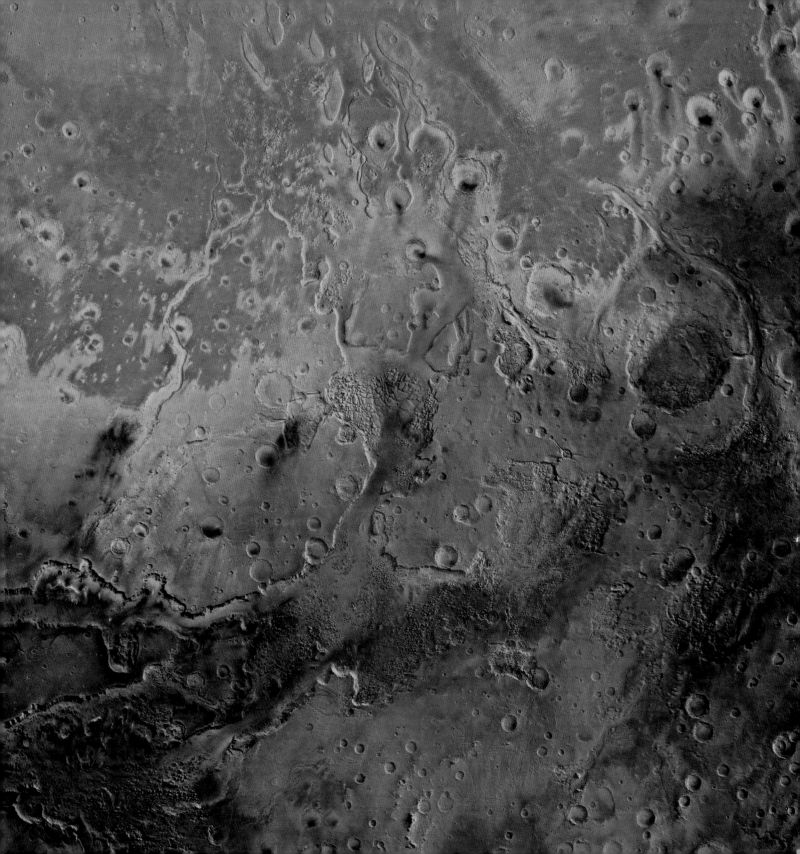

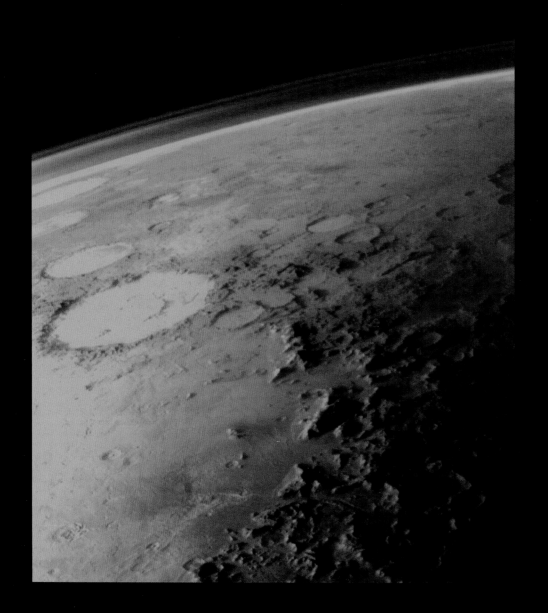

THE ATMOSPHERE OF MARS

This *Viking 1* orbiter image reveals Mars's thin hazy layer of atmosphere. The atmosphere of Mars is less than 1 percent that of Earth, meaning the planet is not protected from the Sun's radiation and cannot retain heat at its surface. Scientists conjecture that the planet lost its magnetosphere roughly four billion years ago. Without a magnetosphere to protect the planet, Mars's ionosphere is stripped of atoms by the solar wind, leading to a low-density atmosphere as ionized particles trickle off into the blackness of space. Mars's atmosphere is made up of 95 percent carbon dioxide, 3 percent nitrogen, 1.6 percent argon, and small amounts of oxygen, water vapor, other gases, and small particles of iron oxide, which give the planet its reddish color.

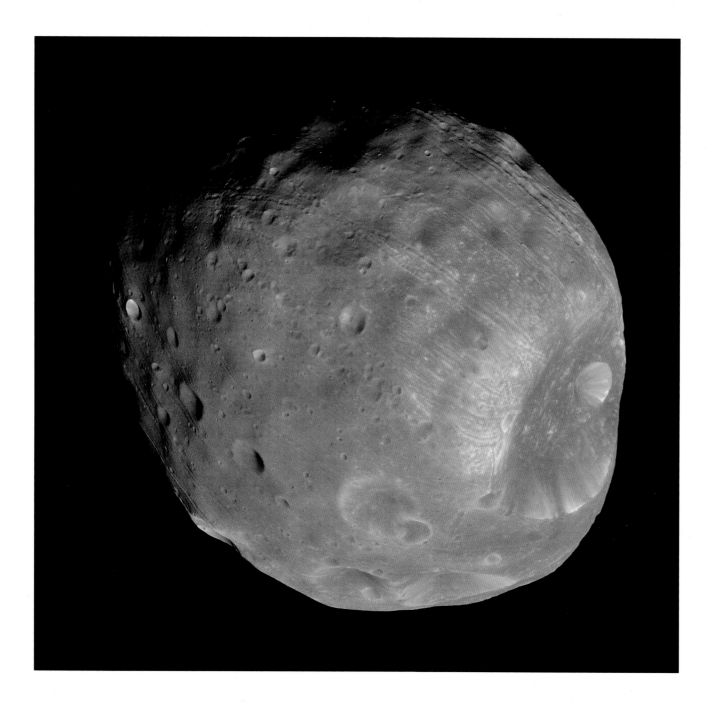

PHOBOS

This image of Mars's moon Phobos was taken in 2008 by the *Mars Reconnaissance Orbiter*. Enhanced-color data reveals a large blue spot featuring the crater known as Stickney. Comparisons to variations in materials from our own Moon have led scientists to believe that this area is younger than other regions of Phobos.

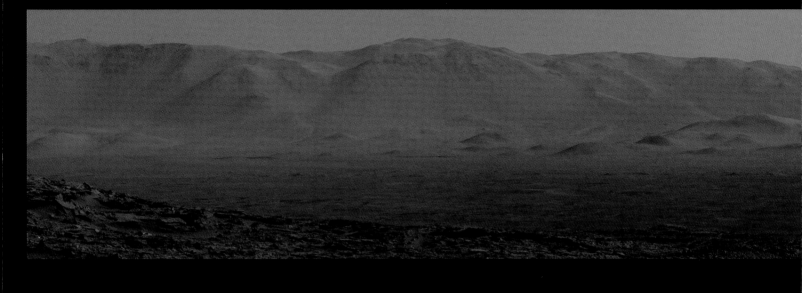

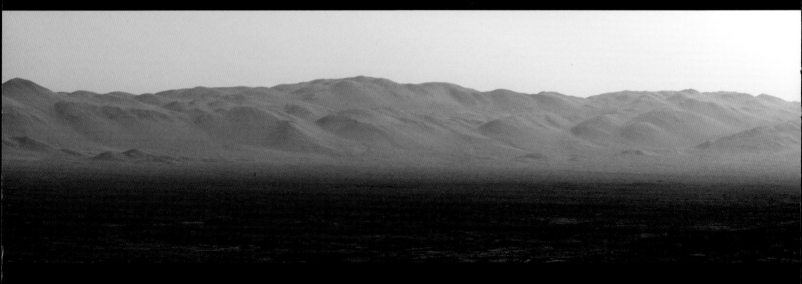

A PANORAMA FROM THE CURIOSITY ROVER

This panoramic image of Mars (split into two pieces to fit here) was taken in 2016 by NASA's Curiosity rover, which has been on the red planet since August 6, 2012. The rover is exploring the terrain and composition of Mars's massive and ancient Gale Crater. A composite of many images taken in quick succession, this panorama provides a 130-degree field of view of the crater's interior wall, captured when the rover was on a plateau near the base of Mount Sharp. The diverse shapes and patterns of the

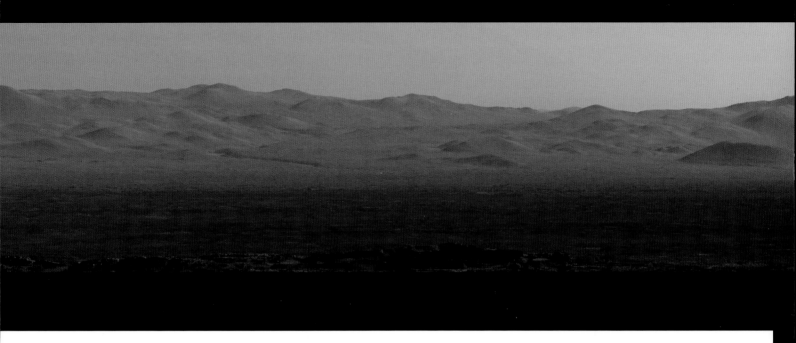

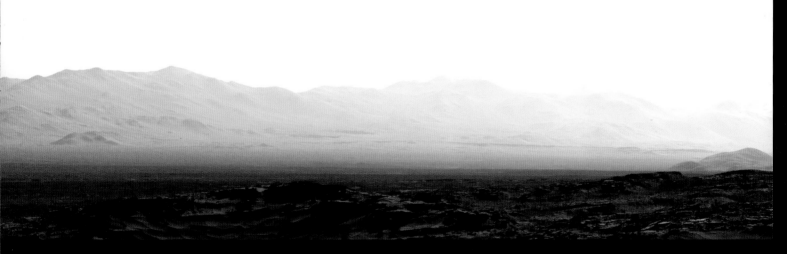

crater include peaks, gullies, channels, and debris fans (cone-shaped sediment deposits). The overall color adjustment approximates what the landscape would look like according to daylight conditions on Earth; the far right of the image is hazier, as the landscape in this area of the montage is fading into the rising Sun.

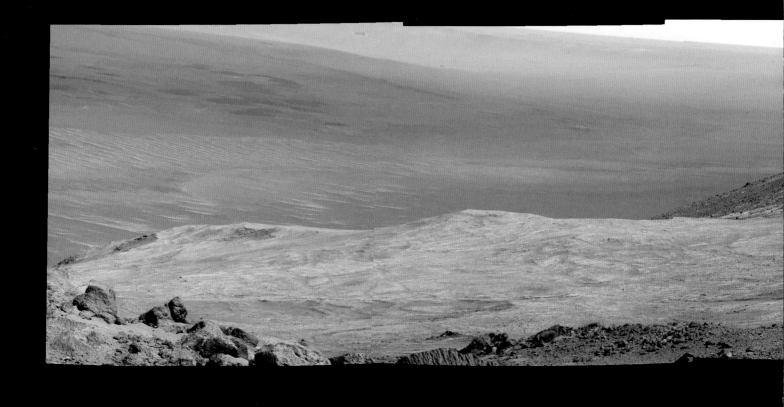
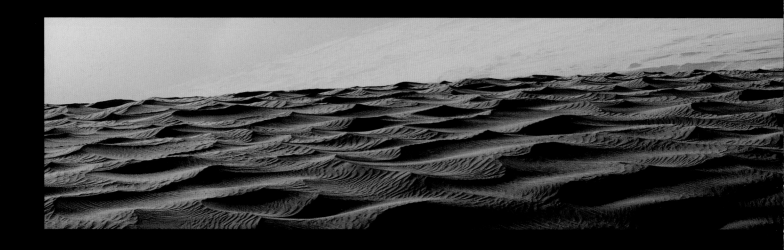

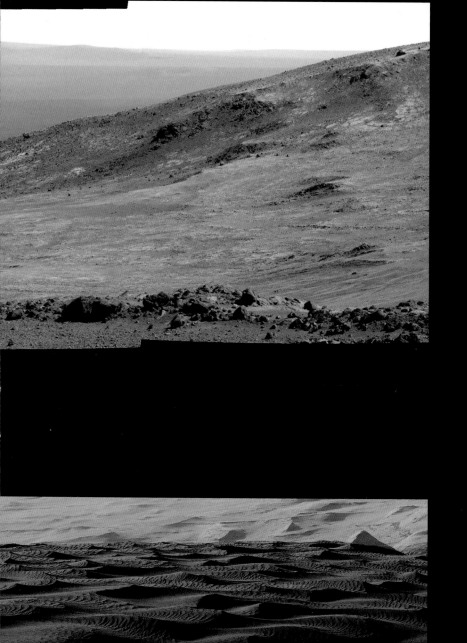

MARTIAN PANORAMAS

The top image was taken in 2015 by the Opportunity rover, which has been active in the Meridiani Planum region of Mars since 2004. This false-color image overlooks the Marathon Valley, an area that contains evidence of clay minerals, which suggests that wet, marshy environments once existed early in the planet's geological history.

The bottom image is a mosaic of photos taken by the Curiosity rover's Mast Camera (Mastcam) in December 2015, when the rover began the first up-close investigation of active sand dunes on Mars. On the dunes, a series of large ripples spaced 10 feet (3 meters) apart can be seen; the sand appears dark due to the early morning shadows and its mineral composition. Scientists have concluded that the ripples were created by sand particles dragged by the wind – they believe that the atmosphere on Mars was thicker in the past, and this resulted in smaller wind-drag ripples, as seen in the preserved ripples found in ancient Martian sandstone.

[*left*]

MARTIAN ROCK

NASA's Curiosity rover captured this protruding chunk of Martian rock on January 30, 2013.

[*right*]

POINT LAKE

In February 2013, the Curiosity rover captured this outcrop of Point Lake, a massive formation that may be erosion-resistant sedimentary rock or the result of cooled lava flows.

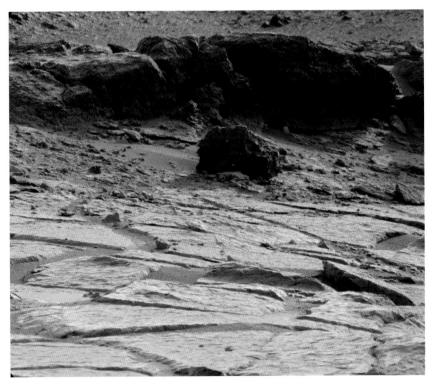

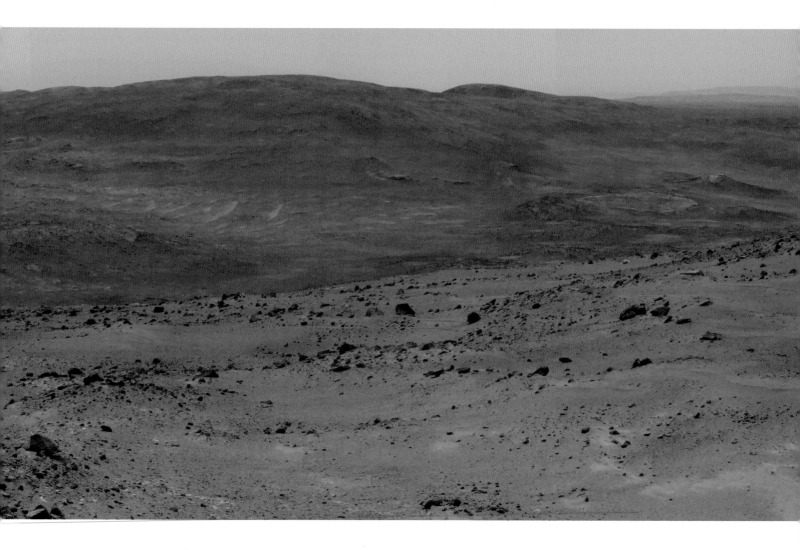

HUSBAND HILL

NASA's Mars Exploration Rover program has sent two rovers to Mars: Spirit and Opportunity. In 2005, Spirit captured this panorama of Husband Hill, a tall peak displaying evidence that a wet, nonacidic environment containing hot springs or steam vents once existed in the planet's early age.

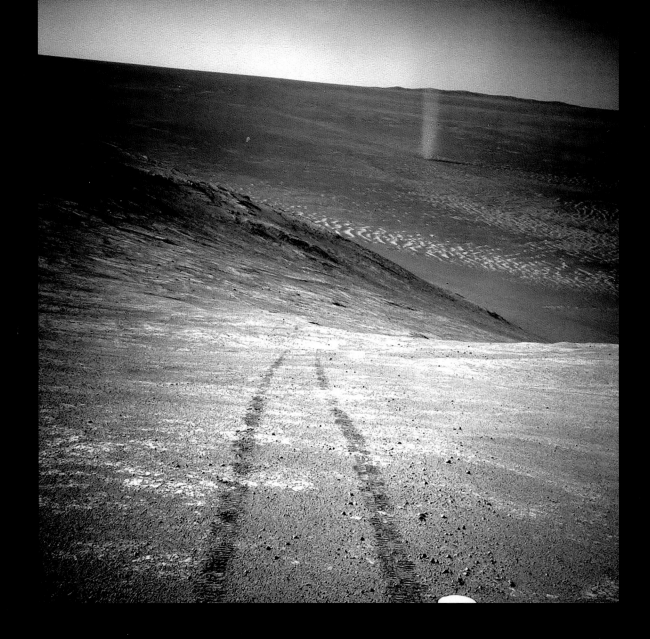

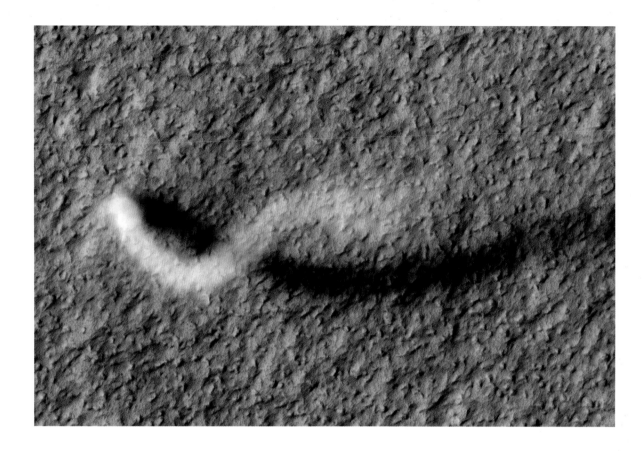

[*opposite*]

MARTIAN DUST DEVIL

This 2016 image shows the tracks of NASA's Mars Exploration Rover Opportunity trailing behind and away from a Martian dust devil — a whirling, fast-moving steam of rising hot air that accumulates dust at high speeds.

[*above*]

A DUST DEVIL IN THE AMAZONIS PLANITIA

In 2012, this ghostly puff of dust snaking across the Amazonis Planitia region in northern Mars was captured by the High Resolution Imaging Science Experiment (HIRISE) camera on the *Mars Reconnaissance Orbiter*. The area viewed in the image is 4/10 mile (644 meters), and while the dust devil may appear diminutive, it towers more than ½ mile (805 meters) high. Dust devils on Mars form when the surface of the planet is hotter than the air above it; as the less-dense heated air rises into a layer of cooler air, the hot and cool air begin to circulate vertically in self-contained convective cells. When a horizontal wind blows through the cells, they are toppled onto their sides and start to spin horizontally, which results in the kind of vertical column seen here.

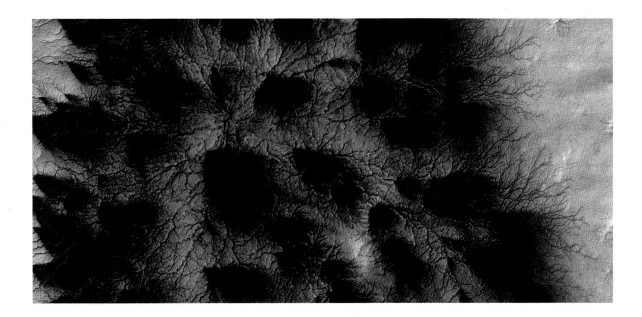

A SEASONAL CAP OF CARBON DIOXIDE

This image of a carbon dioxide ice cap on Mars was taken on February 4, 2009, by the High Resolution Imaging Science Experiment (HIRISE) camera on the *Mars Reconnaissance Orbiter*. This ⁶⁄₁₀-mile (1-kilometer) area was photographed during Mars's northern autumn season. Every spring, the seasonal cap of carbon dioxide transforms from ice to vapor. Scientists believe the starburst patterns in the image form when accumulated gases surge from beneath the seasonal ice and exit through surface openings. The gas also carries dust with it into the atmosphere, which falls back to the surface of the ice in fan-shaped collections. While the "fans" at the top of the image are positioned in one direction, the ones at the bottom are oriented differently. This indicates that the deposits resulted from different wind patterns, leading scientists to speculate that gas jets in different areas of the ice cap are active at separate times.

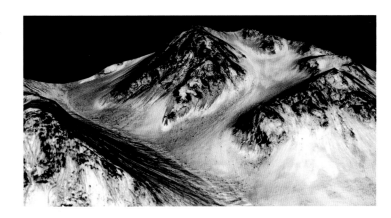

A FALSE-COLOR VIEW OF THE HALE CRATER

The dark streaks on these Martian slopes are believed to come from a seasonal flow of briny liquid water. This image was captured by NASA's *Mars Reconnaissance Orbiter* and consists of a false-color image superimposed onto a 3-D computer model.

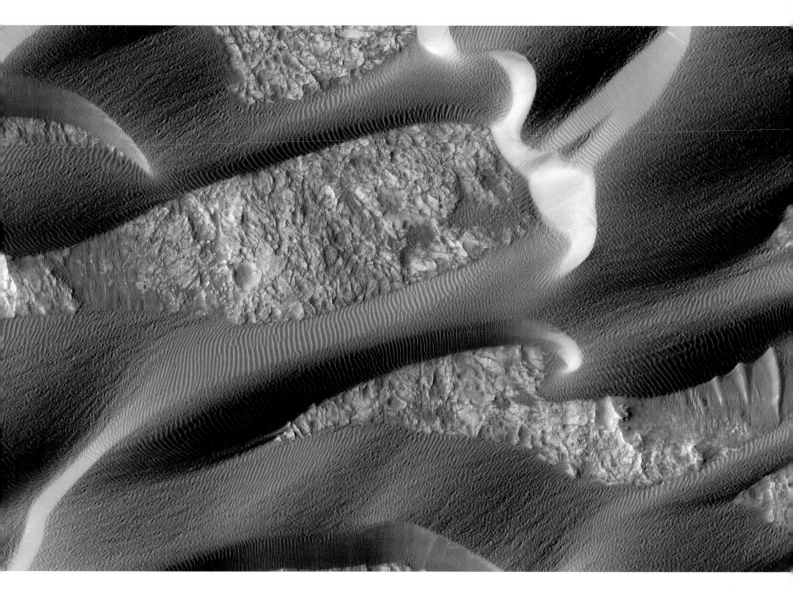

NILI PATERA

HIRISE captured this scenic image of the Nili Patera caldera (a large volcanic crater), which is characterized by curving faults and fractures as well as complex volcanic features, including two different types of lava flows. The photograph displays evidence of rapid sand migration and landscape erosion. HIRISE has monitored significant changes in the flowing dunes in this area, including new avalanches and dune migrations of more than a few meters over a short period of time.

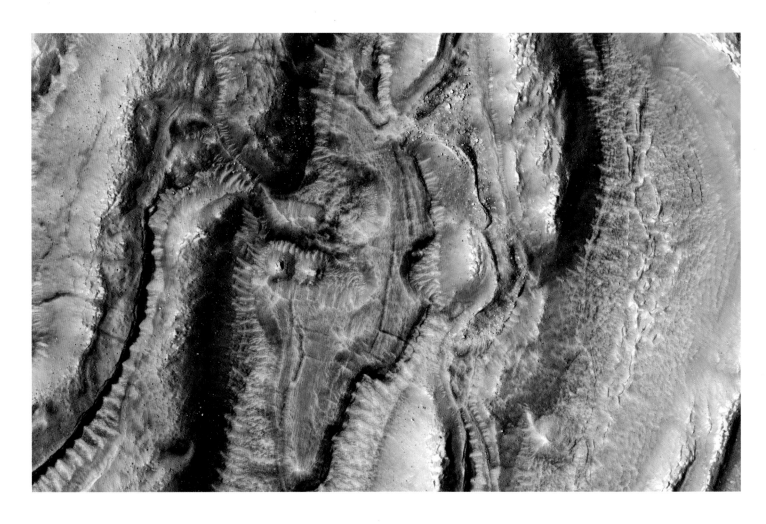

MARS'S VISCOUS FLOW FEATURES

HIRISE captured this image of Mars's viscous flow features (VFF), which are formations of ice and rock, similar to Earth's glaciers, that slowly creep across the middle regions of the red planet. Here, the VFF (the white-blue areas) flow around and combine with mineral deposits from impact ejecta of an ancient impact event (the tan areas protruding from Mars's surface, on the left side and the upper right of the image).

BARCHAN SAND DUNES

This 2016 *Mars Reconnaissance Orbiter* image provides a view of barchan sand dunes, which is the term for any crescent-shaped dune. Common in Earth's deserts, barchan sand dunes are created when the wind blows across the landscape from one direction. The idiosyncratic shape of these Martian dunes suggests two intersecting wind currents from different directions.

JUPITER

A MOSAIC OF JUPITER

This true-color mosaic image was taken by the narrow-angle camera aboard NASA's *Cassini* spacecraft during a close flyby of Jupiter in 2000. Captured from roughly 6.2 million miles (10 million kilometers) from the giant planet, the image reveals the smallest visible features and details ever captured of Jupiter. The color portrait is made up of twenty-seven images that mimic what the human eye might see. All the planet's visible features — reddish and white bands, cream-colored ovals, and the iconic Great Red Spot — are artifacts of its turbulent, cloudy atmosphere. Jupiter's Great Red Spot is actually a massive, three-hundred-year-old storm whose winds rage at 250 miles (402 kilometers) an hour. The size of the storm is larger than Earth; it is equivalent to over one Earth tall and over two Earths wide, measuring east to west. The massive gas giant is composed of an enormous atmosphere, predominantly hydrogen and helium, and it has no firm interior surface, unlike the terrestrial planets.

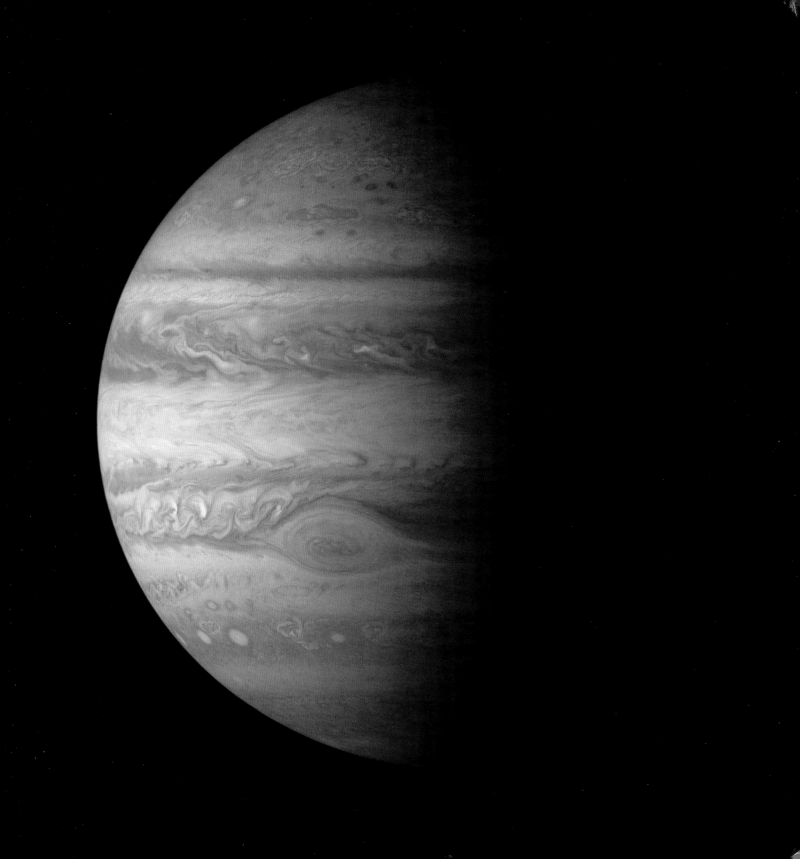

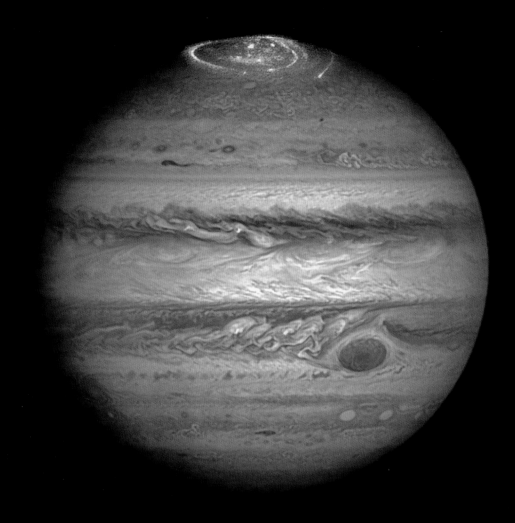

A LIGHT SHOW ON JUPITER

On June 30, 2016, the Hubble Space Telescope recorded some of the brightest
auroras ever captured by humankind. This aurora above Jupiter's cloud top is
the result of the gas giant's magnetic field interacting with its atmosphere, and
it glows over a thousand times brighter than the auroras at Earth's poles.

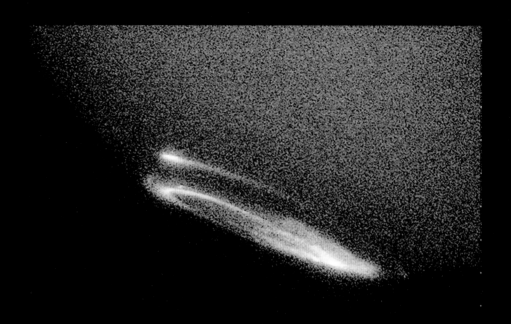

[right]

JUPITER'S SOUTHERN AURORA

This fuzzy 1998 image captured by the Hubble Space Telescope shows Jupiter's southern aurora in ultraviolet. The aurora's light radiates out several hundred miles beyond the planet's surface and is caused by electrically charged particles in Jupiter's magnetic field hitting the upper atmosphere of the planet.

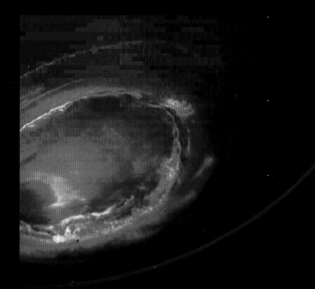

[left]

SOUTHERN AURORA OF JUPITER

NASA's *Juno* spacecraft took this spectacular photograph of Jupiter's southern aurora in August 2016.

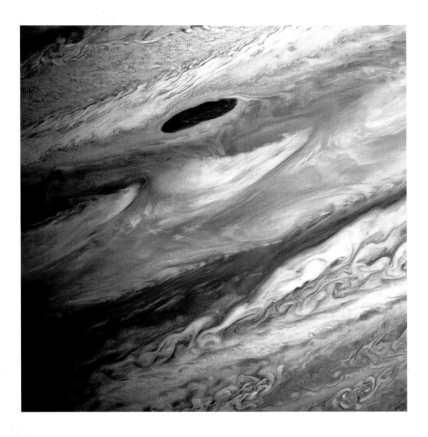

JUPITER'S EQUATORIAL ZONE

This color composite comes from a series of *Voyager 2* images captured in 1979. The color was enhanced to provide greater detail of the features in the turbulent cloudy atmosphere. Across the top of the photograph, the dark North Equatorial Belt sits directly above the Equatorial Zone (middle of image), the wispy yellow-brown region where the atmosphere rotates faster than the interior of the planet, which is under so much pressure that its hydrogen gas compresses, forming a liquid. Even deeper into the surface of the planet, this liquid hydrogen becomes so pressurized that its properties become similar to a metal. The blueish-white plumes sandwiched between the North Equatorial Belt and the Equatorial Zone are thought to be lower and warmer regions in the atmosphere.

EUROPA, IO, AND THE GREAT RED SPOT

Voyager 1 captured this view of the surface of Jupiter in March 1979. The composite image is made of dozens of photos taken with orange and violet filters. In the bottom left, Europa transitions across Jupiter. Toward the middle of the image, Io's shadow reflects on the surface of the planet.

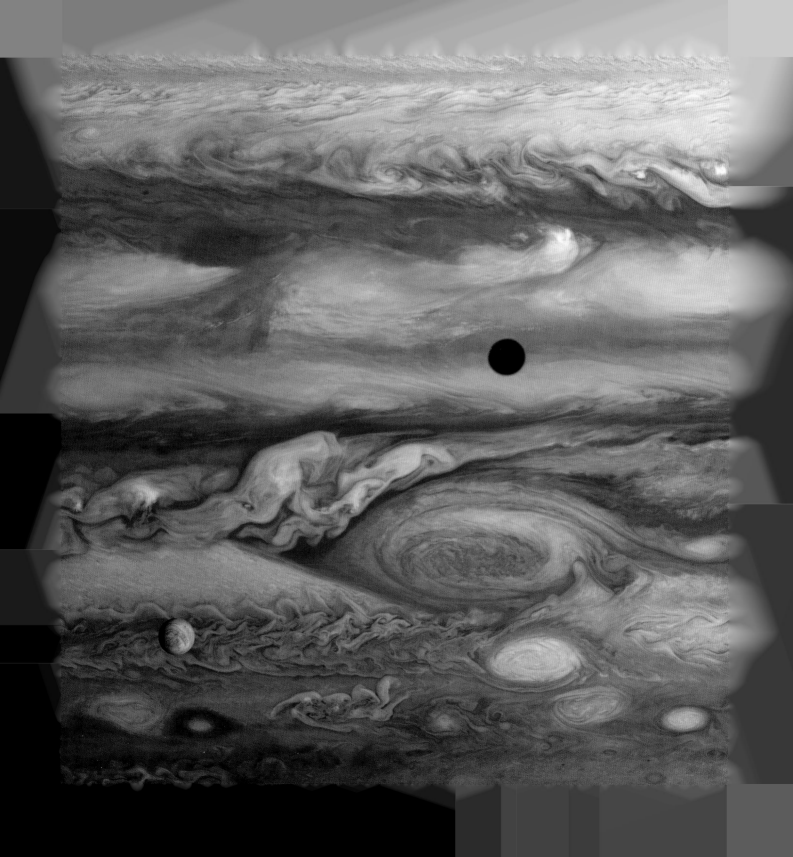

[*right*]

CLOSE-UP OF JUPITER'S NORTH POLE

The *Juno* spacecraft captured this 2016 image of Jupiter's north pole, with contrast enhancement at the black terminator – which is in the middle of the image, where the illuminated day side of a planet transitions to the dark night side – and at the bright limb on the right, where the atmosphere of a planet gives way to space.

[*opposite*]

CLOSE-UP OF JUPITER'S SOUTH POLE

Juno took this detailed image of Jupiter's south pole, where clockwise and counterclockwise storms of various sizes form mottled rings.

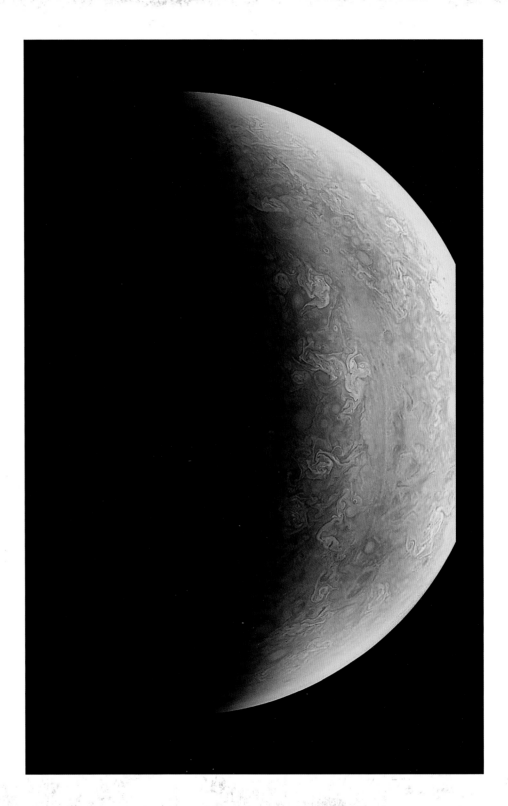

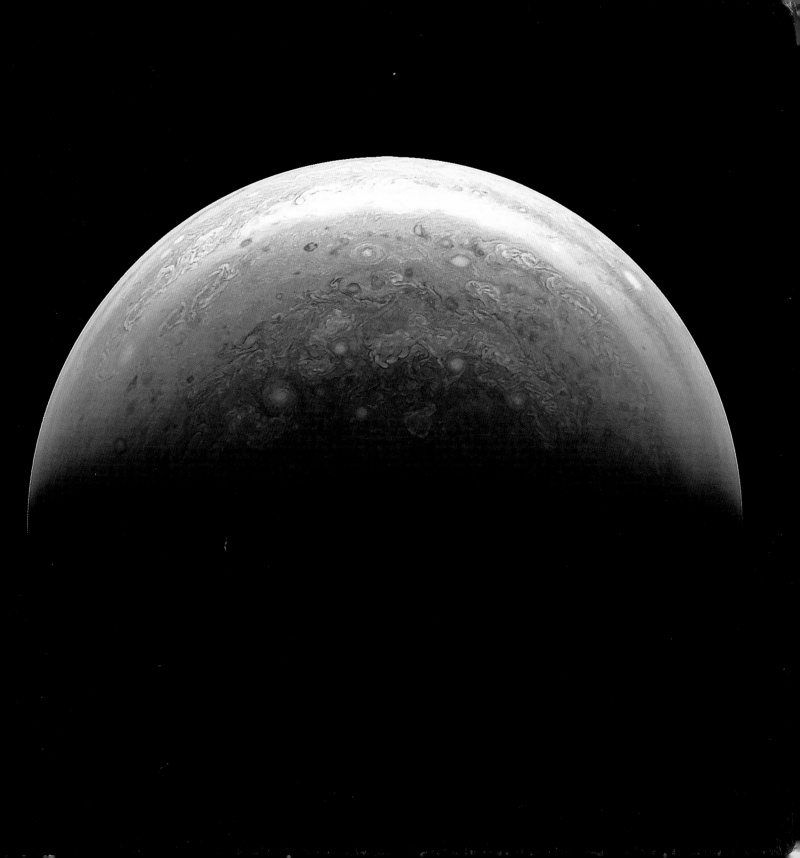

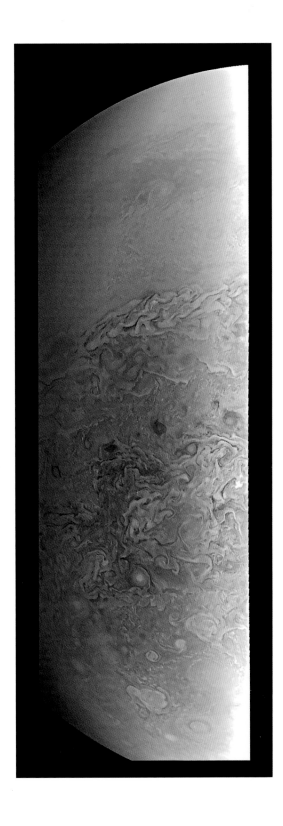

JUPITER'S SOUTHERN HEMISPHERE

The *Juno* spacecraft captured this close-up of the south pole of Jupiter in August 2016, revealing the contrast between the banded areas of the equator and the stormier polar region below.

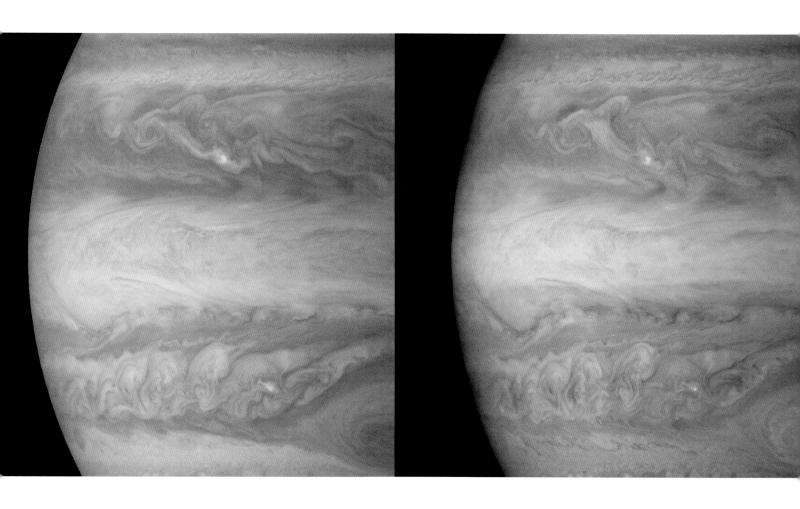

COLOR COMPOSITE FRAMES OF JUPITER'S MIDSECTION

These side-by-side global views of Jupiter were obtained in 2000 by *Cassini* during the spacecraft's closest flyby of the giant planet. The images reveal an enormous amount of information about Jupiter's active, colorful atmosphere. The left image presents the planet's natural color, while the right is made up of three images taken through different colored filters. The colors represent cloud height: bright blue ones are higher in the atmosphere, reddish-brown areas point to clouds lower down in the atmosphere, and dark blue ones are extremely low "hot spots" from which thermal gases erupt into space.

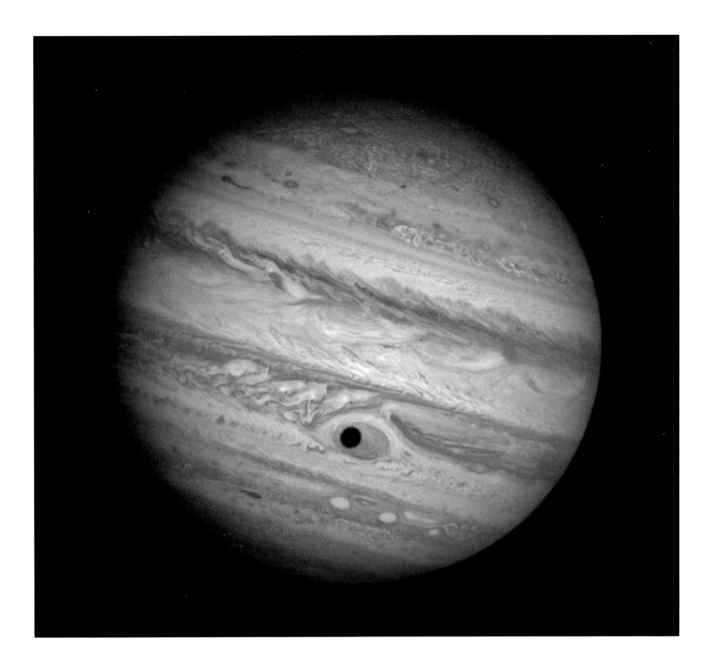

GANYMEDE

In 2014, the Hubble captured this close-up of Jupiter's massive moon Ganymede (the largest moon in the solar system) transiting the planet's Great Red Spot — a raging storm large enough to contain the overall volume of three Earths.

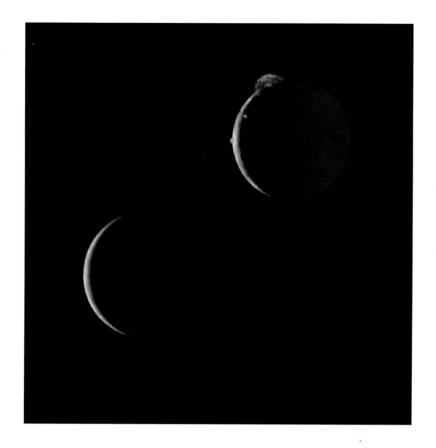

IO AND EUROPA

This image is a composite of two photographs of Jupiter's moons Io (top right) and Europa (bottom left), captured in 2007 by *New Horizons* during its mission to study Pluto and its moons. The image approximates the positions of the two moons at the moment the photos were taken: Io was 2.8 million miles (4.5 million kilometers) away, and Europa was 2.4 million miles (3.8 million kilometers) away. On the top of Io, a magnificent bluish plume erupts from the Tvashtar volcano, and on Io's side are two smaller volcanic bursts, one from Prometheus (the lowest on the left) and one from Amirani (in between the other two, on the terminating line between day and night). In the middle of Tvashtar's plume, lava can be seen glowing red, while the volcano's ejected streams of dust particles scatter the light in a cloud of blue.

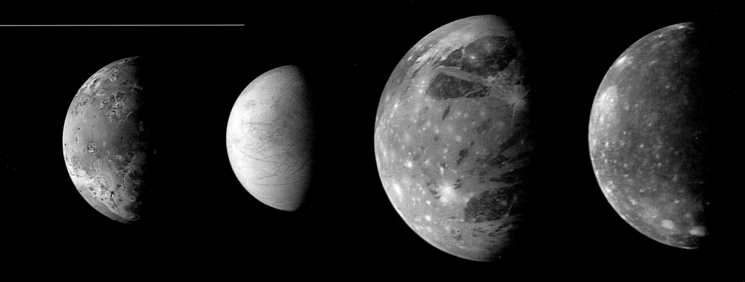

JUPITER'S MOONS

New Horizons delivered the images that make up this composite during a 2007 flyby of Jupiter's largest moons, known as the Galilean moons – Io, Europa, Ganymede, and Callisto – arranged in order from their proximity to the planet and scaled to feature their relative sizes.

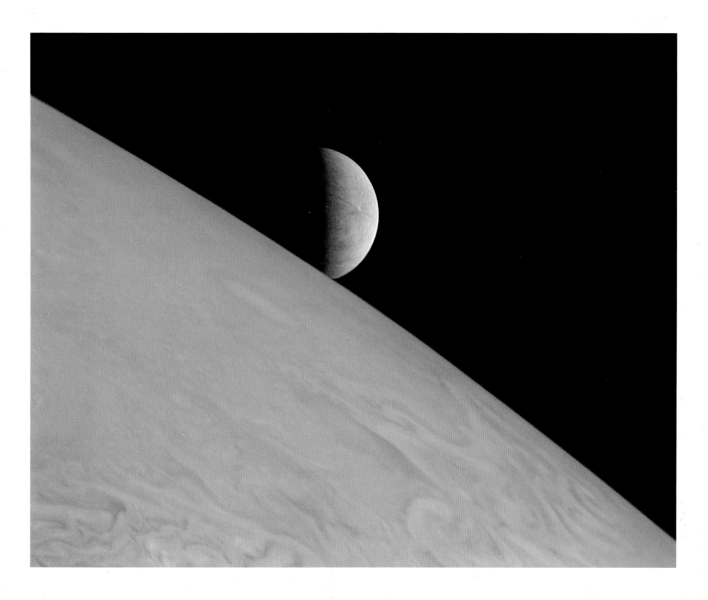

EUROPA RISING

This image of Jupiter's smallest Galilean moon was captured by *New Horizons* during a flyby in February 2007.

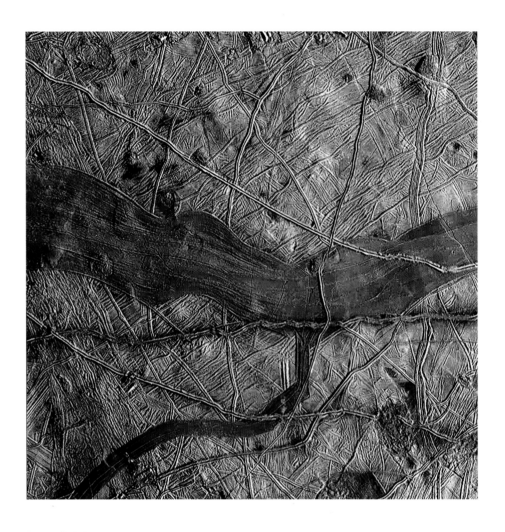
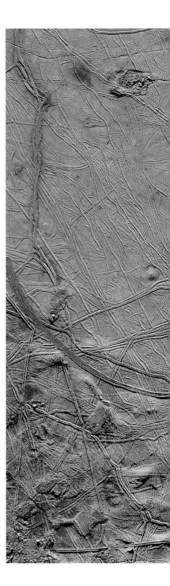

EUROPA

This image shows Jupiter's moon Europa. This colorized composite is the product of NASA's *Galileo* spacecraft's 1997 grayscale images combined with 1998 low-resolution color data. The blue-white areas indicate the presence of water ice; the reddish ones include water ice, as well as hydrated salts (salt molecules loosely attached to water molecules).

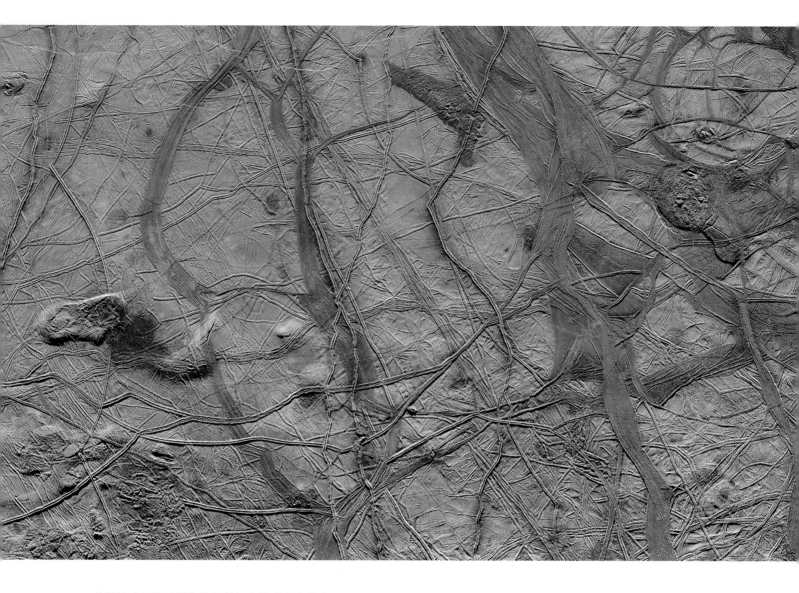

THE ICY SURFACE OF EUROPA

Europa is one of the most reflective moons in the solar system, and scientists surmise that a life-harboring ocean exists below the moon's icy surface. In 1998, NASA's *Galileo* spacecraft captured Europa's surface in this enhanced-color view, which is composed of several high- and low-resolution images. New and old fractures zigzag across one another. The darker areas represent regions where the surface of the moon spread apart in previous ages. According to scientists, these areas are rich in hydrated salts and may have formed on the surface when salty water from the ocean below the moon's crust erupted onto the surface, thereby evaporating into space and leaving behind salt deposits. Scientists believe that the surface ice of Europa is geologically active and carries valuable oxidants that could interact with the chemicals buried beneath the sea floor, making for the possibility of a biologically habitable system.

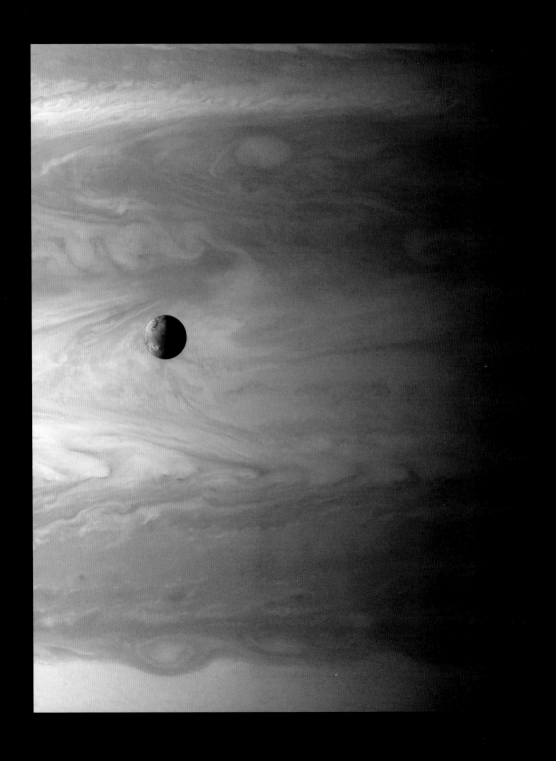

IO AND JUPITER

Io drifts across the picturesque backdrop of Jupiter's clouds in this image from *Cassini* taken on January 1, 2001. Although Io looks like it's directly interacting with Jupiter, the planet and its moon are separated by 217,480 miles (350,000 kilometers), the equivalent of 2.5 Jupiter-size planets. Io, known for its massive volcanic eruptions, is one of Jupiter's best-known moons, but the giant planet has a total of sixty-seven known moons, the majority of which are less than 6.2 miles (10 kilometers) in diameter.

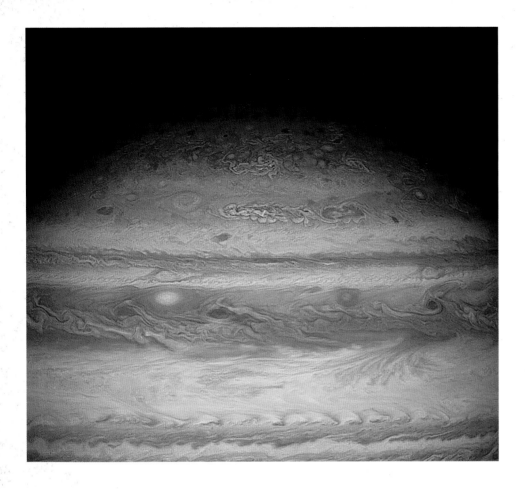

[*above*]

THE HIGH LATITUDES
OF JUPITER

The *Cassini* spacecraft captured this true-color image of Jupiter at high latitudes. The appearance of the mottled clouds in the northern polar region suggests a distinct chemical composition and thickness, quite different from those in the lower banded regions of the planet.

[*opposite*]

IO AND ITS SHADOW

Cassini took this true-color composite image (from images captured in December 2000) from about 12.1 million miles (19.5 million kilometers) away. It shows the tiny, golden moon Io and its shadow transiting the lower region of the giant planet. Io is the fifth moon from Jupiter, the fourth-largest moon in the solar system, and the most volcanically active body. It is approximately 4.5 billion years old, roughly the same age as Jupiter. As Io rotates around Jupiter in an elliptical pattern, it is stretched and squeezed by fluctuations in gravity. As a result, Io's surface is covered in lava lakes and bulging planes of liquid rock. The black areas of the moon indicate the presence of silicate rocks, while the white and red colors indicate a variety of sulfurous chemicals.

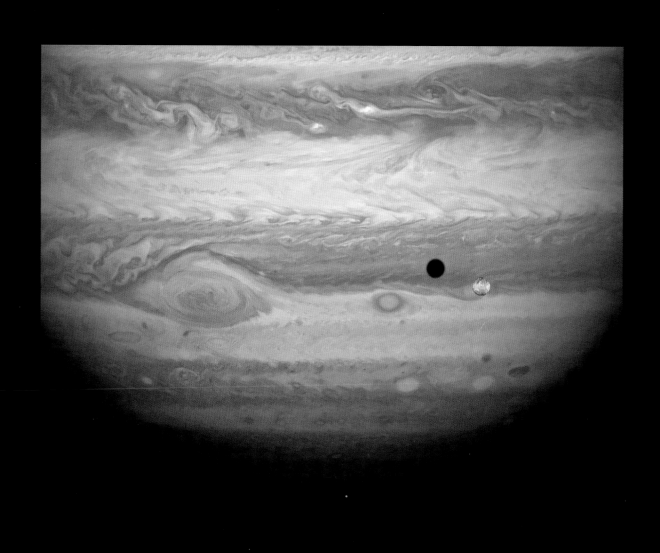

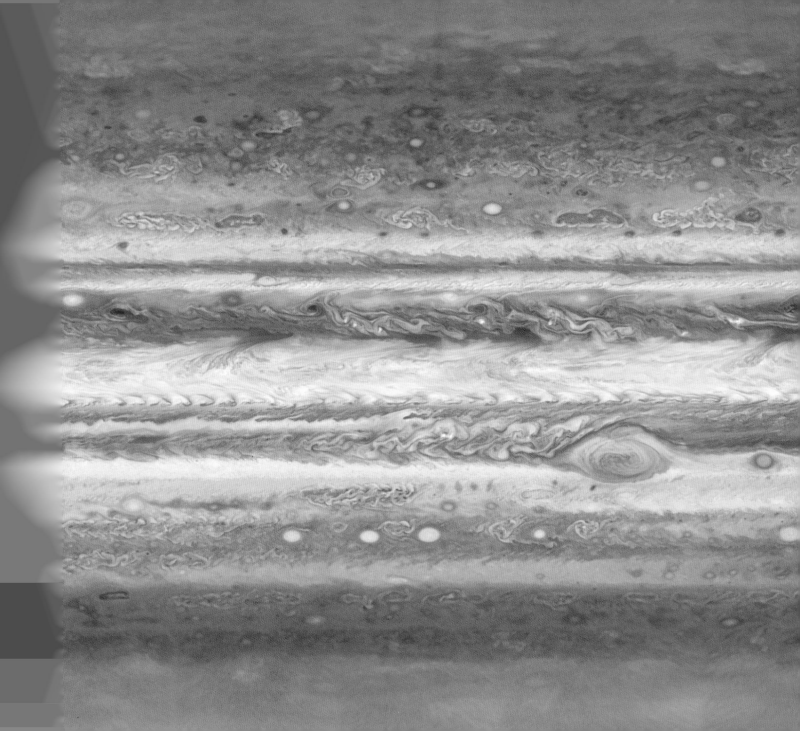

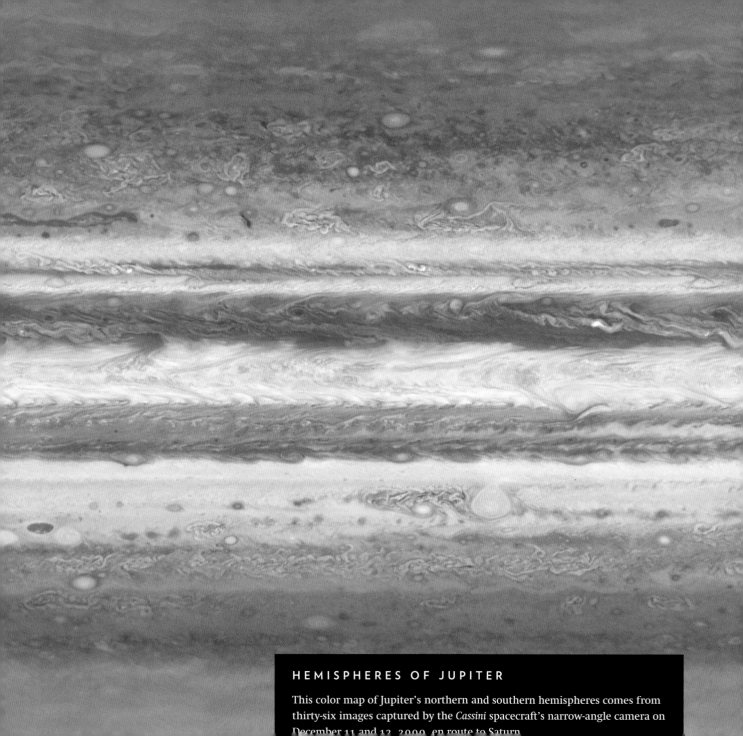

HEMISPHERES OF JUPITER

This color map of Jupiter's northern and southern hemispheres comes from thirty-six images captured by the *Cassini* spacecraft's narrow-angle camera on December 11 and 12, 2000, en route to Saturn.

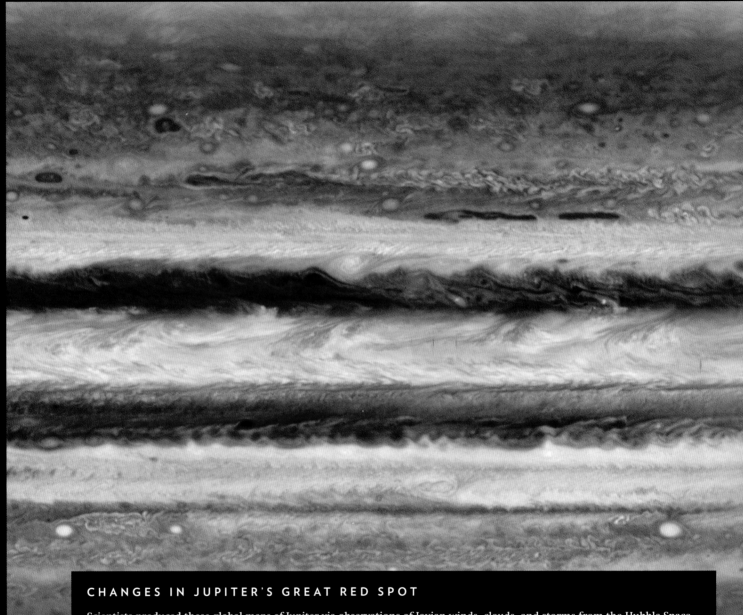

CHANGES IN JUPITER'S GREAT RED SPOT

Scientists produced these global maps of Jupiter via observations of Jovian winds, clouds, and storms from the Hubble Space Telescope's Wide Field Camera 3. Scientists have confirmed that Jupiter's Great Red Spot is shrinking and becoming more circular; between 2014 and 2016 it shrank by 150 miles (242 kilometers). Jupiter's Great Red Spot may be the source of the planet's extraordinarily high temperatures; scientists recently observed temperatures to be higher in the latitudes and longitudes in the vicinity of the southern hemisphere, where the spot resides. The storm produces colliding energy waves that heat the upper atmosphere up to 500 miles (805 kilometers) above the Great Red Spot—an effect similar to what has been observed directly over the Andes mountain range on Earth.

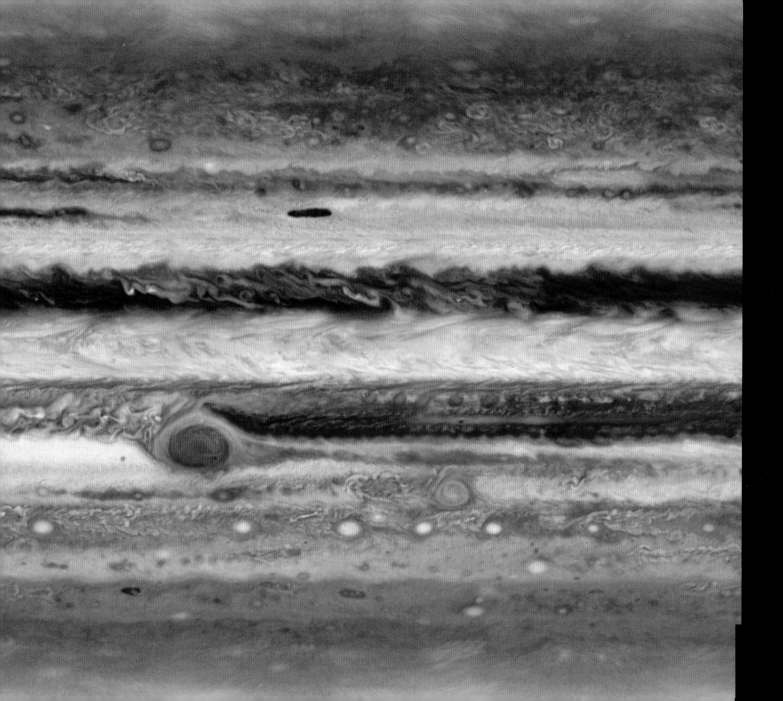

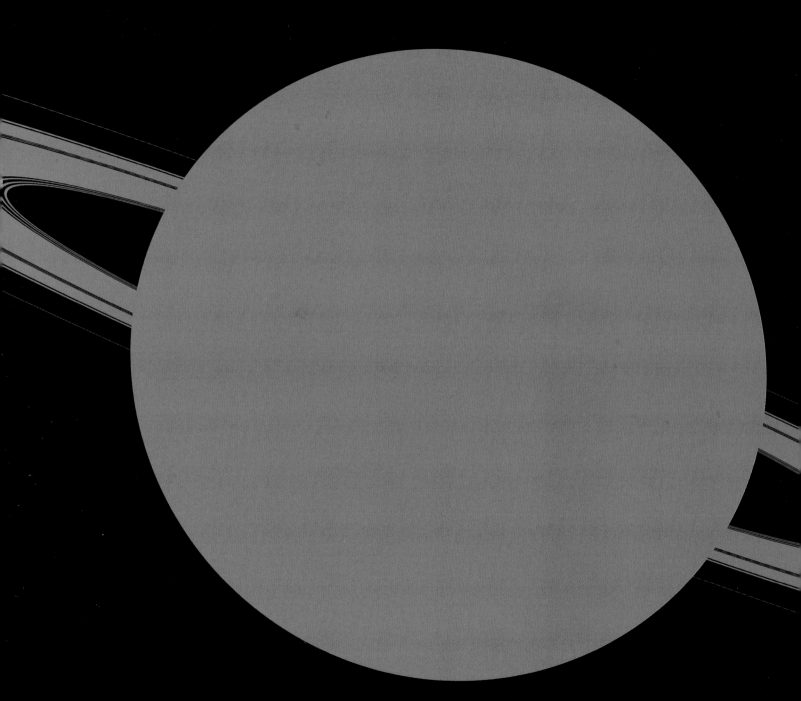

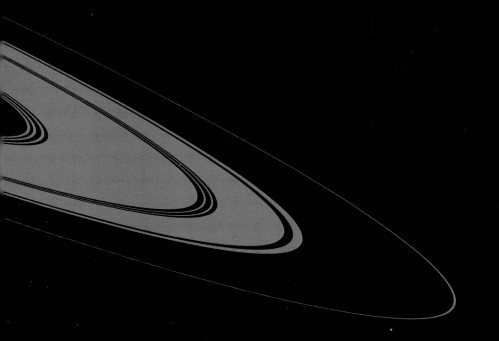

SATURN

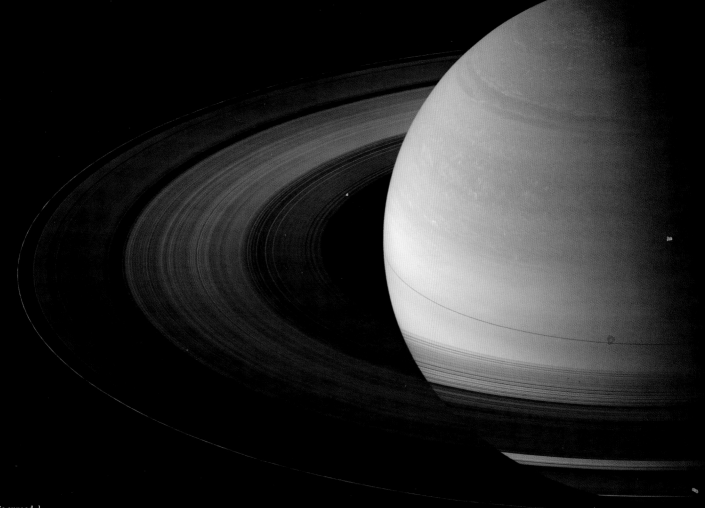

EQUINOX ON SATURN

The *Cassini* spacecraft, which orbits Saturn and produces detailed studies of the ringed planet and its moons, captured this breathtaking scene in August 2009. The image was taken during a Saturnian equinox, when the Sun is directly above the planet's equator. A Saturnian equinox is relatively rare, occurring once every fifteen Earth years. From Earth, it is difficult to view Saturn's rings during the planet's equinox – but *Cassini* was able to capture a mosaic of images drenched in light and shadow over the course of eight hours. Several of Saturn's moons are visible in the image: Janus is the brightest speck outside the rings on the far left; Epimetheus is faintly visible toward the middle bottom; Pandora is a tiny dot just outside the farthest ring on the right; and Atlas floats directly above Pandora, just inside the farthest visible ring.

[*following page*]

DARK SATURN AND TETHYS

In this 2015 *Cassini* image, Saturn's moon Tethys
appears as a barely perceptible dot in the lower
left, just below Saturn's rings. The faint outline of
Saturn's polar hexagon, an iconic cloud pattern at
the planet's north pole, peeks out from the shadows
at the top of the planet.

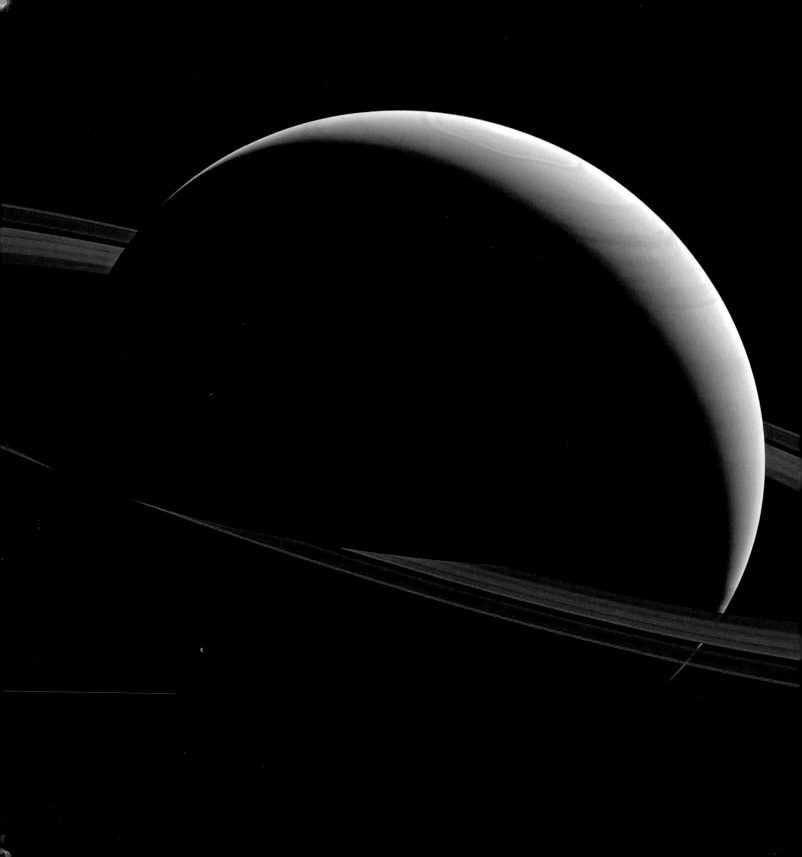

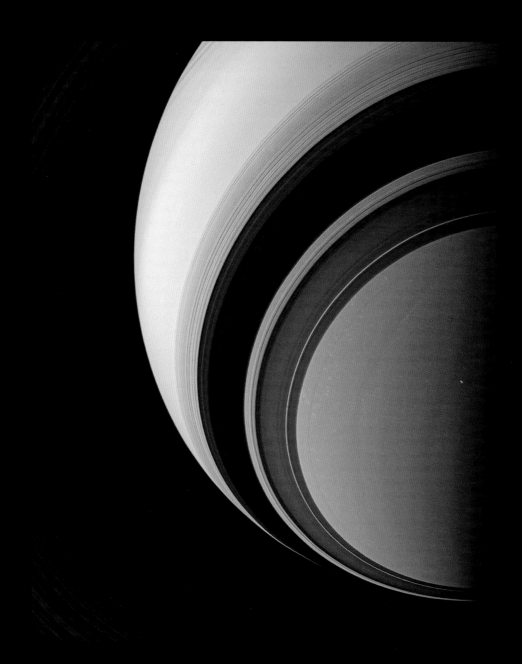

[*above*]

APPROACHING WINTER IN THE SOUTHERN HEMISPHERE

As the southern hemisphere tilts away from the Sun, bringing winter, the reduction in sunlight creates the blue tint seen in this image. This is likely the result of a reduction in ultraviolet sunlight and the haze that it generates, which facilitates the "blueing" due to increased methane absorption, and the scattering of smaller particles. *Cassini* captured this natural-color view with a composite of several exposures made in July 2013, using red, green, and blue spectral filters.

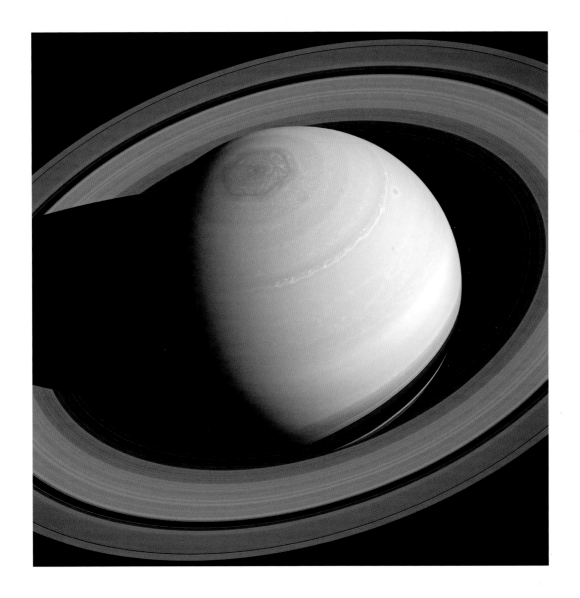

SATURN'S NORTH POLAR VORTEX AND HEXAGON

This 2014 *Cassini* image was captured roughly 2 million miles (3.2 million kilometers) from Saturn, using a spectral filter that captures wavelengths of near-infrared light. Saturn's massive ring system was first observed in 1610 by Galileo. The rings themselves are made up primarily of ice rock and carbon dust. Saturn's hexagonal-shaped flurry of clouds is clearly visible around the north pole. The polar diameter (the distance from a pole to the center of the planet) is approximately 90 percent of the equatorial diameter, due to the planet's low density and rapid rotation. The planet turns once on its axis every ten hours and thirty-four minutes, making Saturn's day the second shortest of all the planets in the solar system. Jupiter's day is the shortest, lasting only around nine hours and fifty-four minutes (the length of the day varies by a few minutes, as it is shorter at the equator and longer at the poles).

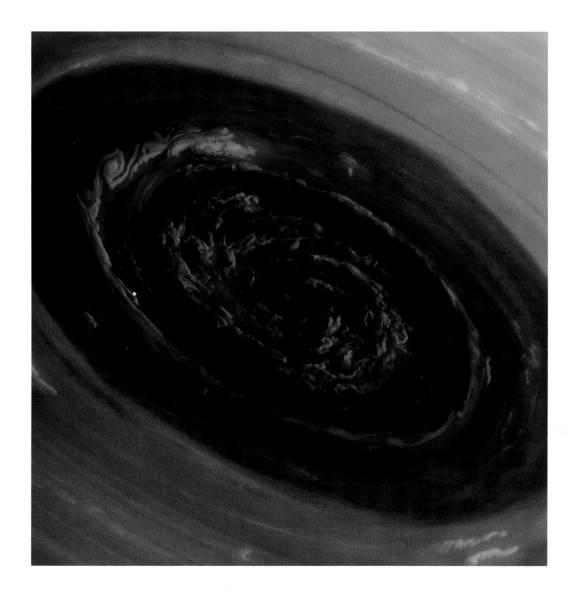

A RED ROSE AT SATURN'S NORTH POLE

In 2012, *Cassini* captured a stunning series of false-color images of Saturn's north pole, using spectral filters sensitive to near-infrared light. The red areas show low-altitude clouds, while the green areas show clouds higher in the atmosphere. This is one of the first sunlit photographs of the region. *Cassini* first neared Saturn in 2004, but the north pole was then immersed in the darkness of winter. *Voyager* flybys of the ringed planet in 1980 and 1981 captured evidence of the cloud, but this data wasn't examined by scientists until 1998, and its presence wasn't confirmed until *Cassini* came along. The spot at the pole is a high-speed hurricane, and this is a close-up view of the eye of the storm.

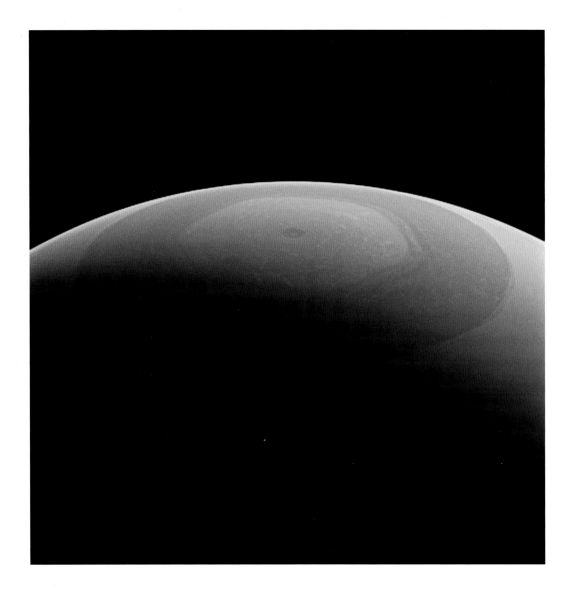

SATURN'S NORTHERN JET STREAM

The *Cassini* spacecraft took this image of Saturn in natural color in July 2013. The central yellowish hexagonal ring is the planet's northern jet stream. According to observations, the hexagonal shape is not influenced by seasonal changes, and it has maintained its consistency over the years.

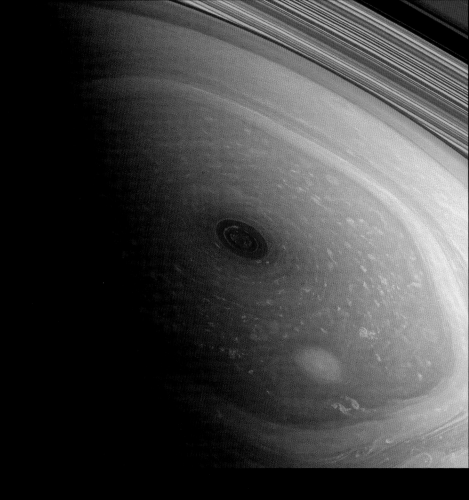

THE NORTHERN STORM

This false-color image from *Cassini* shows the vast storm at Saturn's north pole,
which gathers within the yellow-green, hexagonally shaped jet stream. The storm
within the hexagonal ring is 20,000 miles (32,000 kilometers) across, or over twice
the diameter of Earth. The eye of the storm, which appears dark red, is 1,250 miles
(2,010 kilometers) across and contains speeds up to 330 miles (531 kilometers) per
second. Outside the eye, lower clouds are depicted in orange, while a smaller pale-
blue vortex (at the bottom, center-right) indicates a smaller storm within the overall
storm. In fact, there are many smaller vortices spinning within the enormous storm;
the largest of these spans 2,200 miles (3,540 kilometers), twice the size of the
largest hurricane ever recorded on Earth. In this image, the north pole region is
framed by Saturn's rings, which appear vibrant blue.

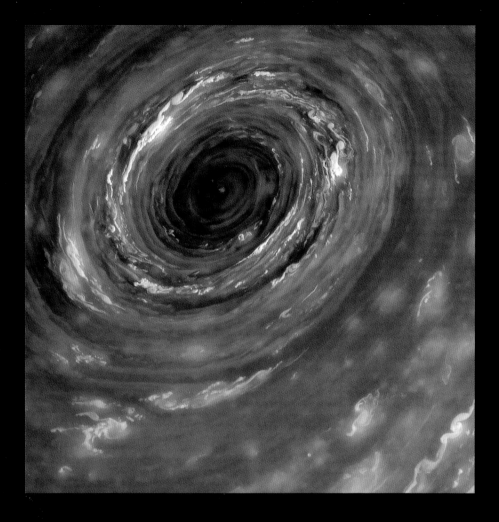

[*opposite, top*]

A CHURNING STORM IN SATURN'S NORTHERN HEMISPHERE

Cassini captured this true-color image of an enormous storm in Saturn's northern hemisphere in February 2011. The storm seen here is the largest Saturnian storm observed by NASA spacecraft.

[*above*]

AN INFRARED VORTEX

Cassini's infrared technology captured the eye of the massive storm at the center of Saturn's north pole on June 14, 2013. Although scientists don't know exactly how long the storm has been raging, they know that it has been around for at least thirty years. While such patterns would normally disperse fairly quickly on Earth, the ringed planet has no landforms to disperse hurricanes, so this one continues to spin without interference, goaded into shape by rambling eastern winds.

[*opposite, bottom*]

A STORM ON SATURN

This false-color image taken by *Cassini* features a small portion of the largest and most dramatic storm on Saturn ever observed by the spacecraft. Circling the northern latitudes, this storm spans the circumference of the planet and extends 186,000 miles (300,000 kilometers).

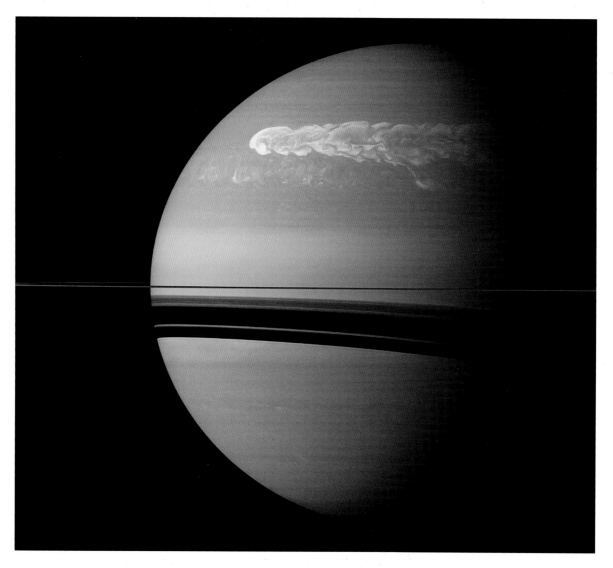

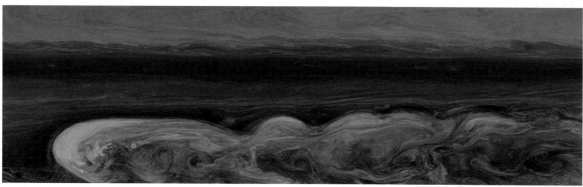

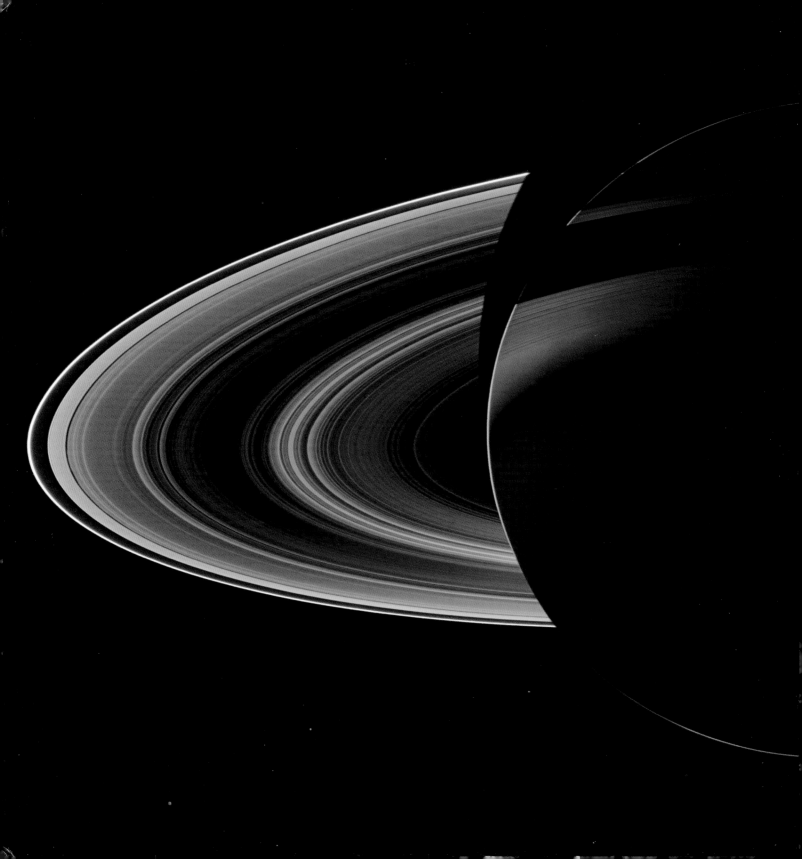

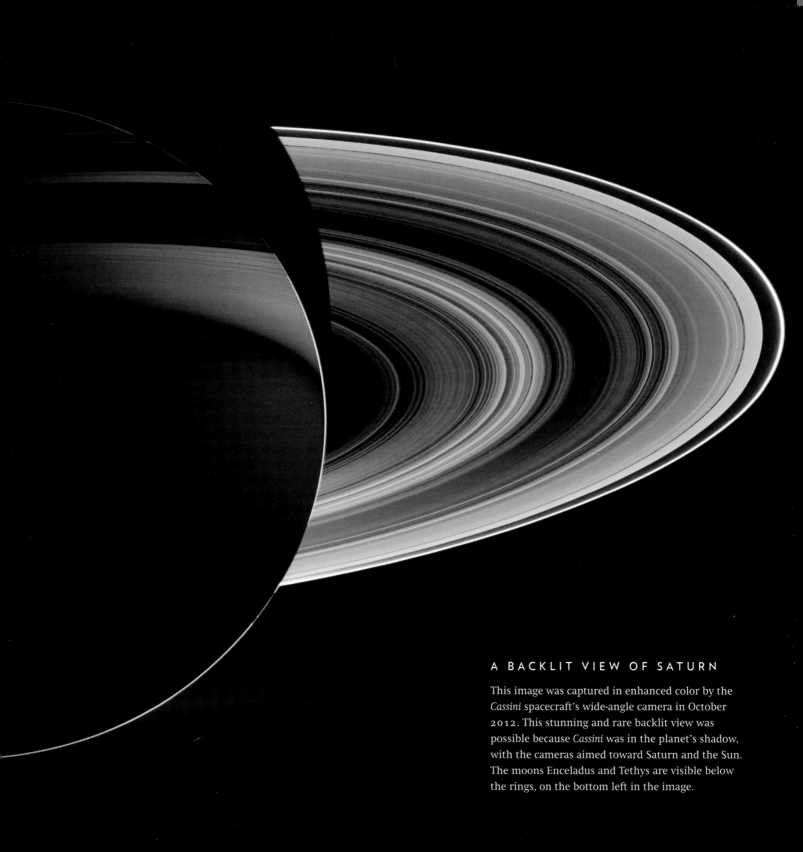

A BACKLIT VIEW OF SATURN

This image was captured in enhanced color by the *Cassini* spacecraft's wide-angle camera in October 2012. This stunning and rare backlit view was possible because *Cassini* was in the planet's shadow, with the cameras aimed toward Saturn and the Sun. The moons Enceladus and Tethys are visible below the rings, on the bottom left in the image.

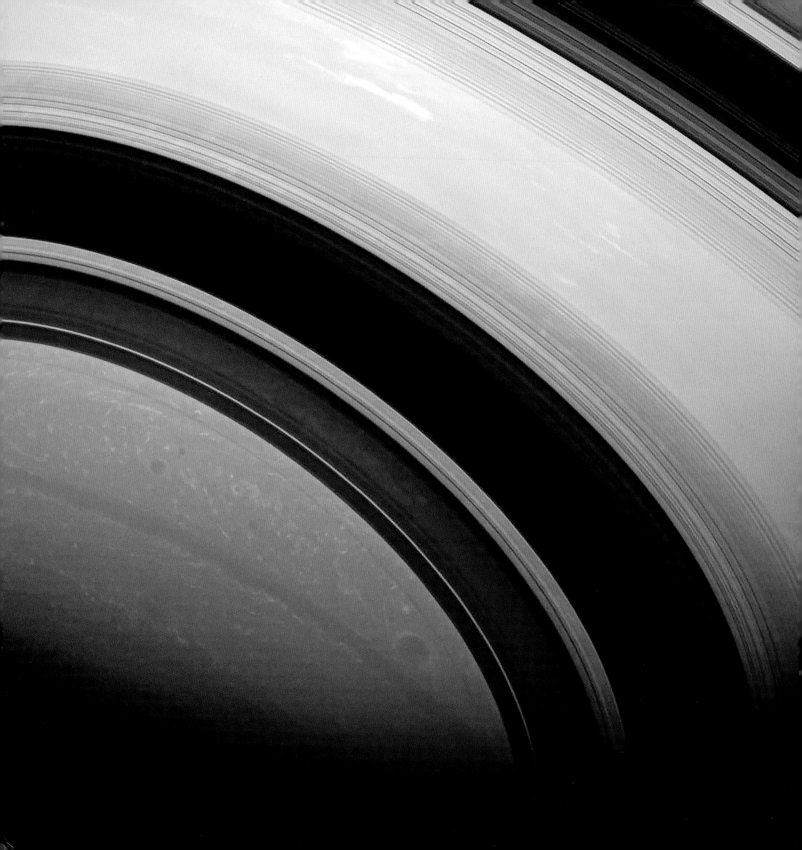

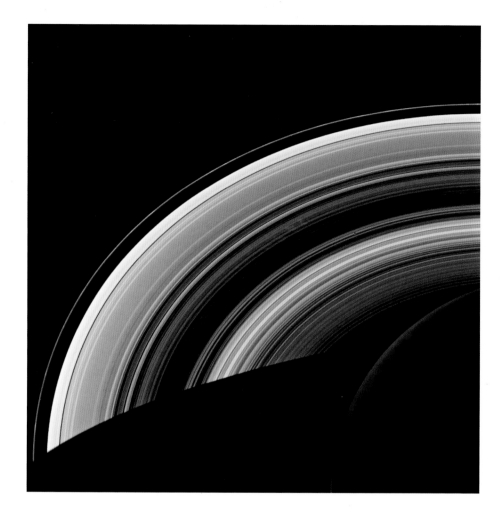

[*left*]

SPOKES IN SATURN'S B RING

A series of ghostly radial spokes can be seen crossing Saturn's B ring close to the center of this image. The B ring is the brightest, largest, and most massive of Saturn's rings. While the spokes are not entirely understood, it is believed that they are dust particles charged by the planet's global magnetic field.

[*opposite*]

THE SHADOW OF SATURN'S RINGS

Cassini's wide-angle camera took this image, which shows the shadows of Saturn's rings on the surface of the planet (not the rings themselves). As the planet revolves toward winter in its southern hemisphere, the shadows edge farther south. Saturn's rings comprise one of the most enigmatic features in our solar system. From far away, the planet appears to have seven distinct rings; up close, there are four main groups of rings and three narrower groups of rings. Overall, the seven ring groups comprise thousands of small "ringlets," evident in *Cassini* images. Each of the ring systems is named for a letter, but these do not correspond to the distance from Saturn; rather, the groups were named in the order of discovery. In fact, more ring groups and ringlets could be discovered as *Cassini* obtains further information about these ever-moving systems.

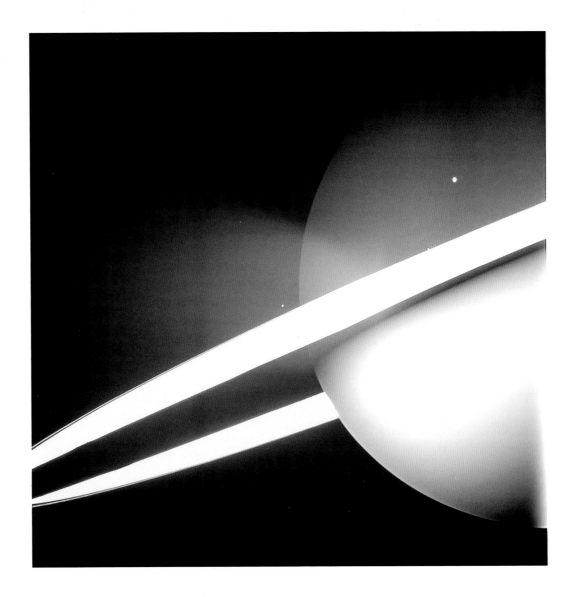

THE MOONS OF SATURN:
JANUS, PANDORA, AND ENCELADUS

This *Cassini* image was taken in 2005 and features three of the sixty-two moons that orbit Saturn. A heavily cratered moon, Janus is a speck floating directly above the planet's rings and just left of the planet itself. The moon Pandora is to the right of Janus and sitting directly atop (as if it were touching) the bright ring, while massive Enceladus is the largest bright spot, just above Pandora and in the upper right of the image. This is a raw image, which means the data in the image has not yet been processed or calibrated by NASA.

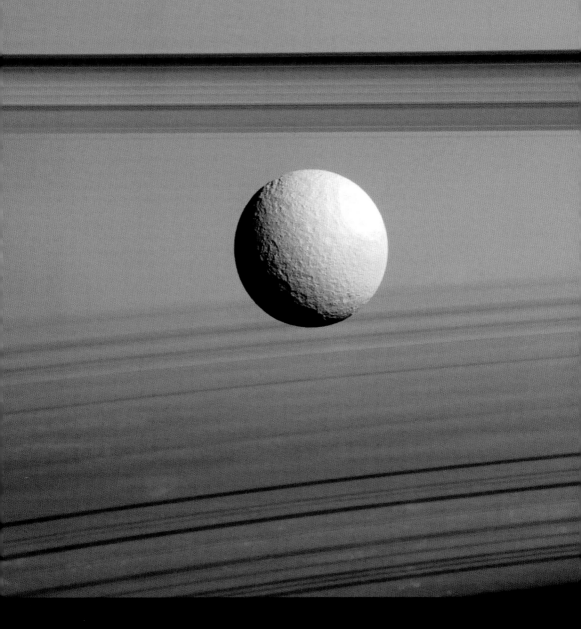

TETHYS AND SATURN'S RINGS

Saturn's moon Tethys is heavily cratered and composed almost entirely of water ice. It sits beneath the planet's rings, which in this image are the dark bands above Tethys. The bands below Tethys are the rings' shadows on the planet's surface. The image was taken by *Cassini*'s wide-angle camera in 2015.

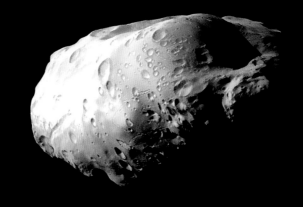

PROMETHEUS

Saturn's heavily cratered, potato-shaped moon Prometheus is seen in great detail in this
narrow-angle camera image, captured during a December 2015 *Cassini* flyby. Distinctly
elongated, the moon's many craters, ridges, and valleys are clearly visible, even though this
image was taken from approximately 23,000 miles (37,000 kilometers) away. Prometheus
resides just within Saturn's thin F ring, which can be seen above the moon.

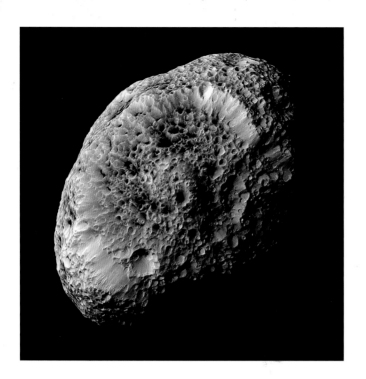

HYPERION

Cassini captured this false-color image of the moon Hyperion during its flyby of Saturn on September 26, 2005.

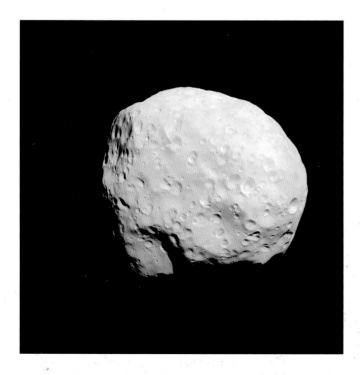

EPIMETHEUS

Using its narrow-angle camera, *Cassini* took this image of the fifth moon from Saturn, Epimetheus, in December 2015 from about 22,000 miles (35,400 kilometers) away. This is one of the highest-resolution images ever taken of the diminutive Epimetheus, which is about 72 miles (116 kilometers) across, roughly the size of Los Angeles. The oblong moon takes roughly seventeen hours to circle Saturn, and it shares its orbit with its sister moon, Janus. Both moons also travel within the Janus/Epimetheus dust ring, and they periodically trade places in their orbital distance from the ringed planet. Epimetheus and Janus are thought to have formed early in Saturn's own formation after the dissolution of another moon.

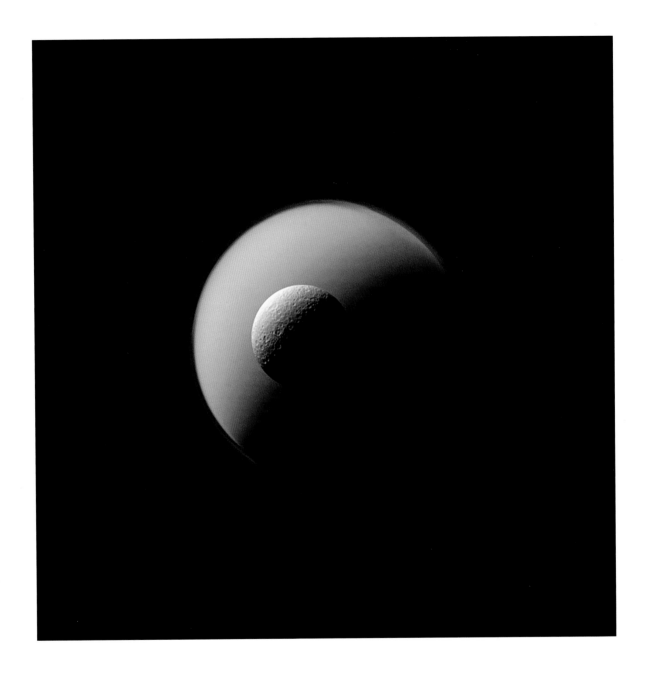

RHEA AND TITAN

This true-color photograph makes two of Saturn's moons – Rhea in the foreground and Titan behind – appear in close proximity to one another. However, *Cassini*'s narrow-angle camera was roughly 1.1 million miles (1.8 million kilometers) from Rhea and 1.5 million miles (2.5 million kilometers) from Titan when it captured this image. Among Saturn's moons, Titan (3,200 miles, or 5,150 kilometers, across) and Rhea (950 miles, or 1,530 kilometers, across) are the largest and second largest, respectively.

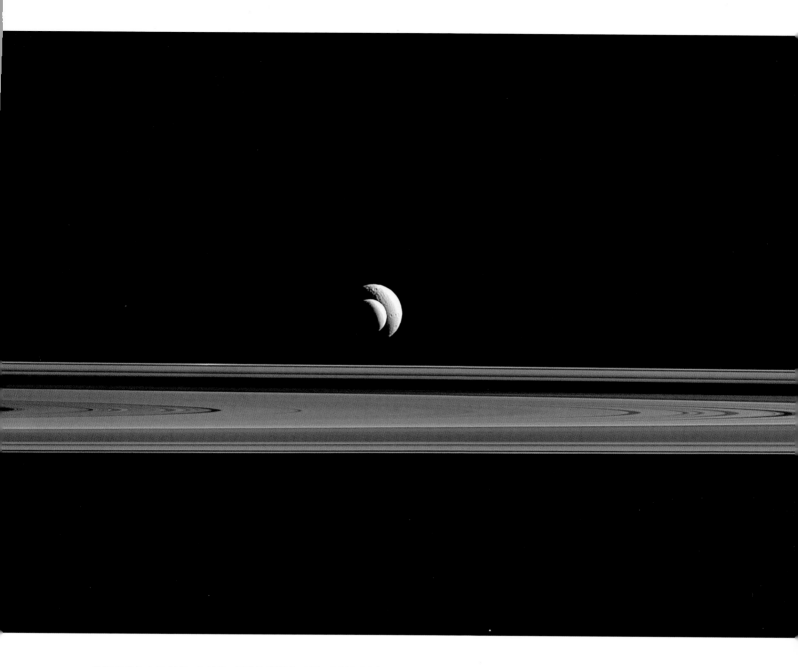

ENCELADUS AND TETHYS IN BULL'S-EYE FORMATION

Two different moons of Saturn were lined up when *Cassini* captured this image with its narrow-angle camera, which was aimed toward the unlit side of Saturn's rings. Enceladus, the moon in the foreground, is roughly 313 miles (504 kilometers) across, while Tethys is 660 miles (1,062 kilometers) across. Although the moons look close in the photo, they are actually 35,190 miles (56,700 kilometers) apart.

TITAN

This composite image of Saturn's largest moon, Titan, comes from frames captured in November 2015 by *Cassini*'s visual and infrared mapping spectrometer. *Cassini* was aimed at the Saturn-facing hemisphere of the moon; this image captures the dune-covered regions of the Fensal area. Titan is larger than the planet Mercury and is the second-largest moon in our solar system (after Jupiter's Ganymede). It is the only moon in our solar system with a thick atmosphere. Covered in a haze of nitrogen, Titan's cold surface is composed of vast pools of liquid ethane and methane, and it probably contains cryovolcanoes, or "ice volcanoes" that contain water instead of lava. Because Titan has so few impact craters, scientists believe that its surface is still quite young.

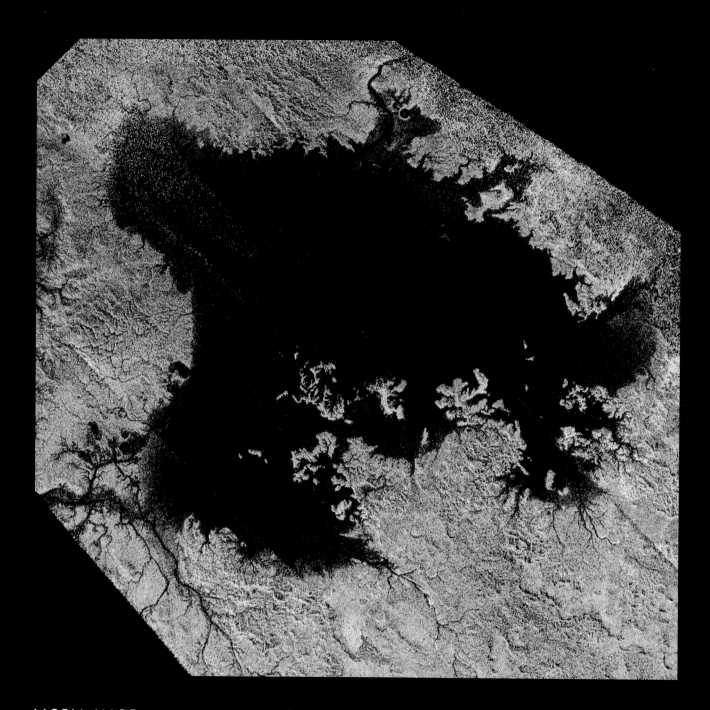

LIGEIA MARE

This false-color mosaic of Ligeia Mare, Titan's second-largest body of liquid, was taken by
Cassini between February 2006 and April 2007. Ligeia Mare – made up of hydrocarbons
like ethane and methane – is located in the moon's north pole region.

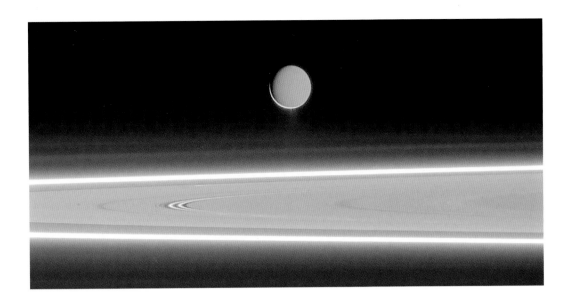

ENCELADUS AND SATURN'S RINGS

In this *Cassini* image, Enceladus hovers above Saturn's rings, while a continuous spray of icy particles covers the moon's surface in a snow-white layer. Enceladus lives within the outermost E ring, a hazy doughnut-shaped ring that is not visible here. Icy particles also fill the brightest, outer ring in this photo, which is the F ring.

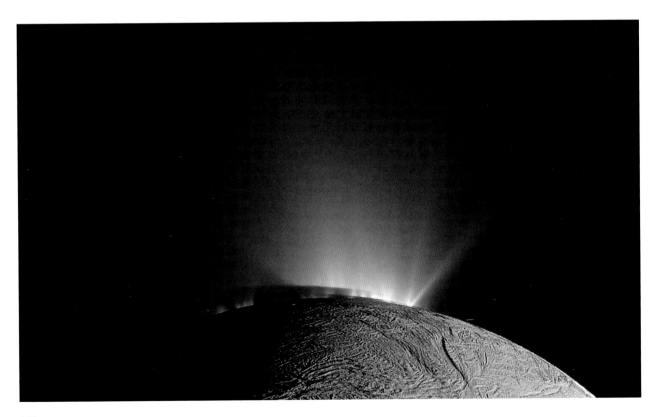

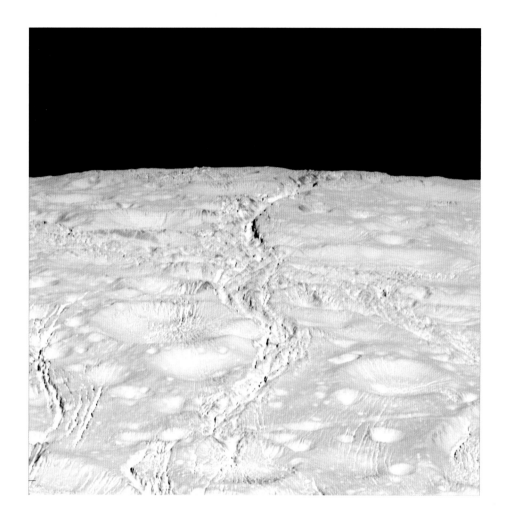

[opposite, bottom]

ENCELADUS'S SOUTH POLE GEYSER BASIN

Cassini took this image of Enceladus on November 30, 2010. It shows the moon's shadow cast against the lower regions of its iconic geyser jets. The photo was taken shortly after Saturn's equinox.

[above]

ENCELADUS'S NORTH POLE FRACTURES

This *Cassini* image from October 14, 2015, was taken at a distance of 4,000 miles (6,440 kilometers) from Enceladus. It reveals a network of thin fracture lines along the moon's north pole.

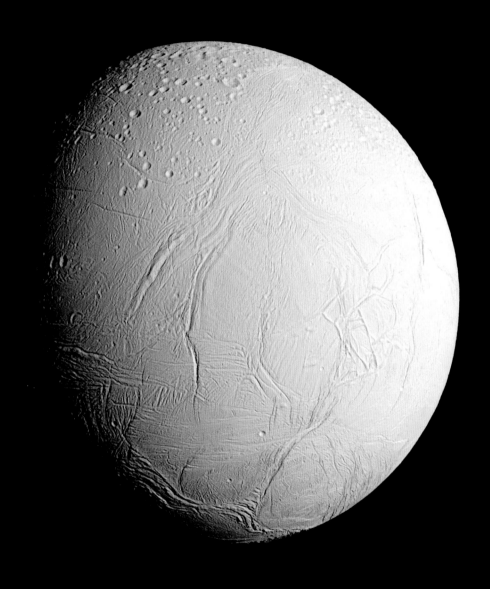

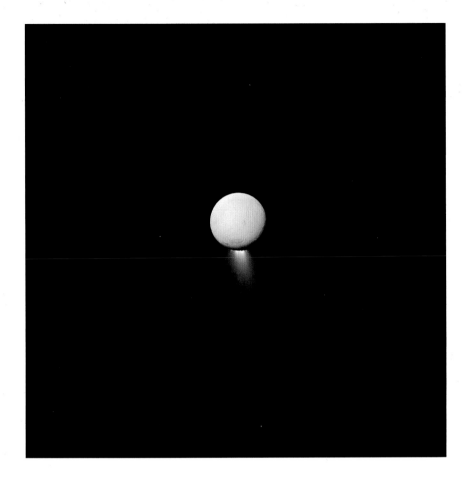

[left]

A PLUME ON ENCELADUS

Saturn's moon Enceladus looks like it's emitting a flash of light in this 2013 *Cassini* image taken by the spacecraft's narrow-angle camera from about 517,000 miles (832,000 kilometers) away. However, that "flash" is actually fast-moving jets of water erupting from the moon's south pole, evidence that Enceladus possesses active ice volcanism. The light source in this image is none other than Saturn, though normally the jets are only visible when *Cassini* and the Sun are on opposite sides of Enceladus. The plumes erupt from deep fissures that resemble tiger stripes and explode thousands of miles into space at 19,000 miles (30,580 kilometers) per hour. Scientists believe that this plume is jetting from an enormous salty ocean beneath the moon's surface.

[opposite]

THE TERRAIN OF ENCELADUS

The pockmarked craters at the north pole of Saturn's icy moon Enceladus are on display at the top of this image. The equatorial and southern regions are characterized by wavy plains.

[following spread, left]

SATURN'S RINGS AND SHADOWS

This dramatic 2014 image from *Cassini* features Saturn's rings seen almost edge-on. The shadows of Saturn's rings circle the southern pole of the planet.

[following spread, right]

DIONE AND ENCELADUS

Saturn's fourth-largest moon, Dione, is pictured during a close *Cassini* flyby in June 2015, while Enceladus is a bright and distant spot just above Saturn's rings in the upper right.

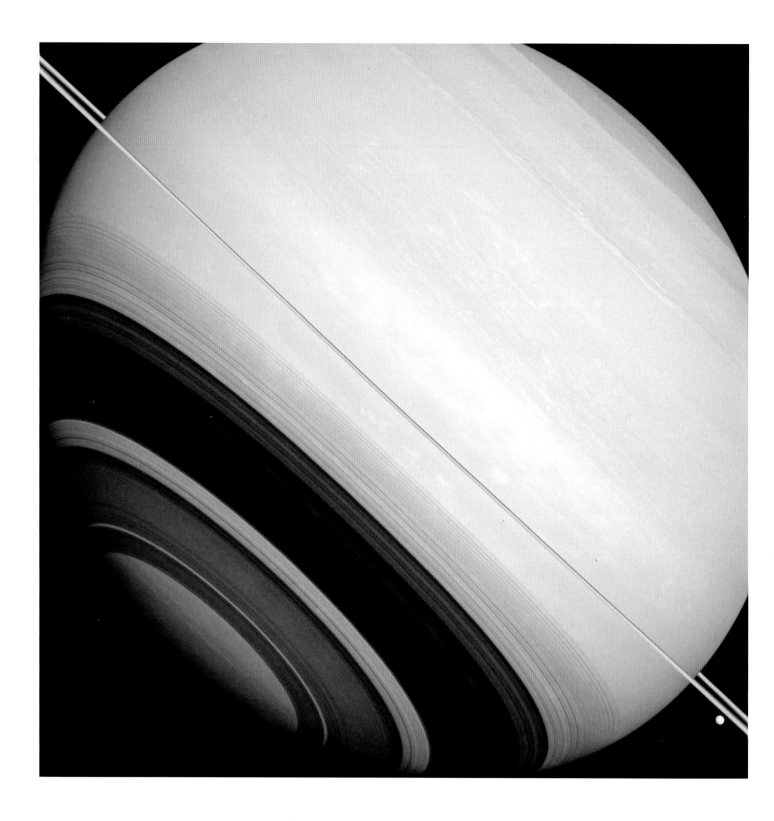

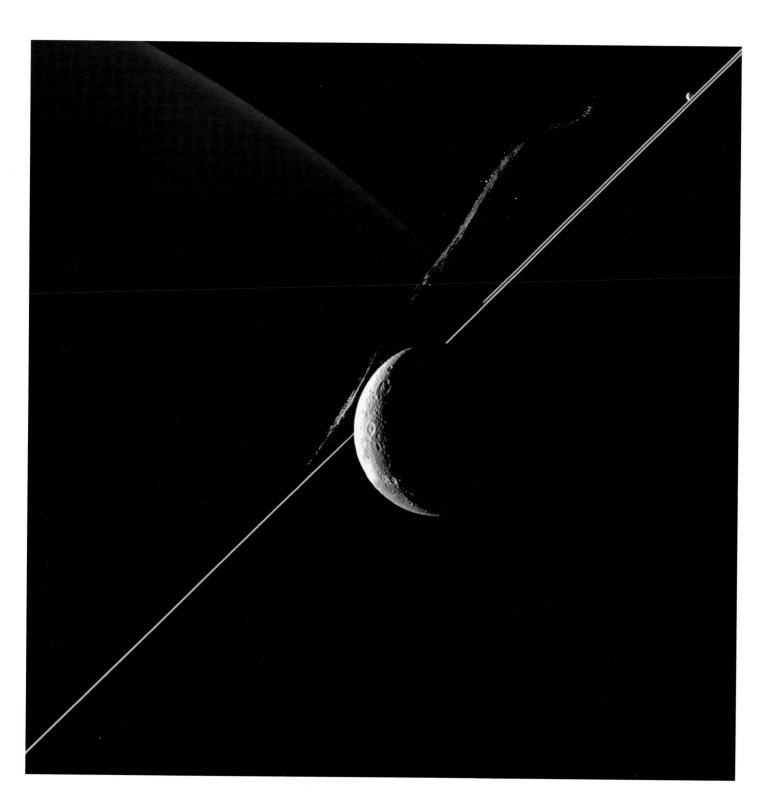

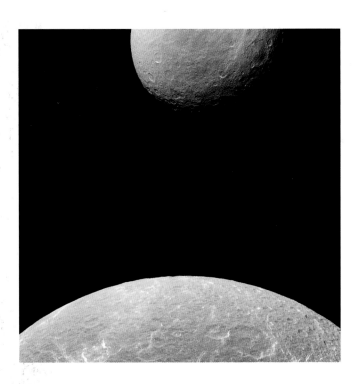

DIONE AND RHEA

In this *Cassini* image, Saturn's moon Dione (bottom) appears larger than the moon Rhea (top), but it's actually the smaller sibling. Dione measures 698 miles (1,123 kilometers) across and Rhea measures 949 miles (1,527 kilometers) across. However, *Cassini* was much closer to Dione when it captured this image: Dione was merely 68,000 miles (109,400 kilometers) away, and Rhea was 300,000 miles (482,800 kilometers) away.

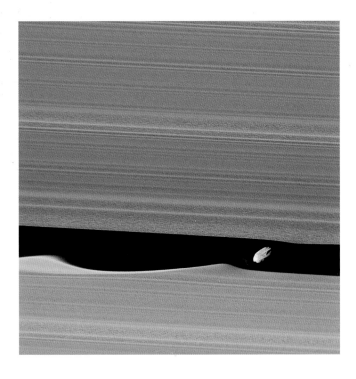

DAPHNIS MAKES WAVES

This *Cassini* image provides our closest look at Saturn's moon Daphnis. Though it's only 5 miles (8 kilometers) across, Daphnis is massive enough to create waves in Saturn's rings. As Daphnis orbits, its gravitational pull attracts ring particles, creating ripples like the ones seen in the bottom left of this image.

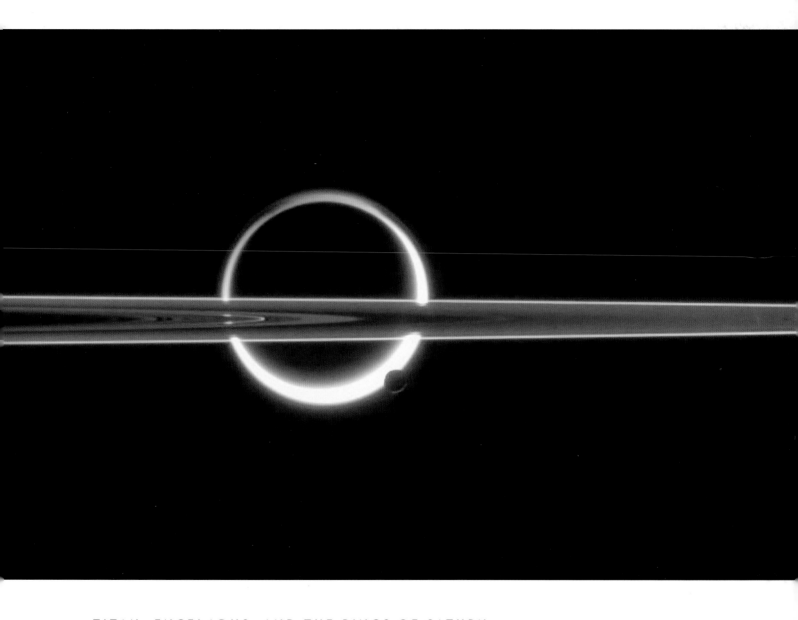

TITAN, ENCELADUS, AND THE RINGS OF SATURN

In this June 2006 *Cassini* image, the brilliant silhouette of Titan is visually bisected by Saturn's elongated rings. The moon Enceladus transits the scene at the bottom right. *Cassini* captured this view in visible red light; Enceladus was 2.4 million miles (3.9 million kilometers) away and Titan was 3.3 million miles (5.3 million kilometers) away. Astrobiologists believe that both Titan and Enceladus may be habitable with the right supplies. Surviving on Titan would require only an oxygen mask and warm clothing, as well as the willingness to live through days that are equivalent to sixteen Earth days. In contrast, the icy geyser moon Enceladus is so cold that the warmest areas in the south pole only reach negative 120 degrees Fahrenheit (negative 84 degrees Celsius).

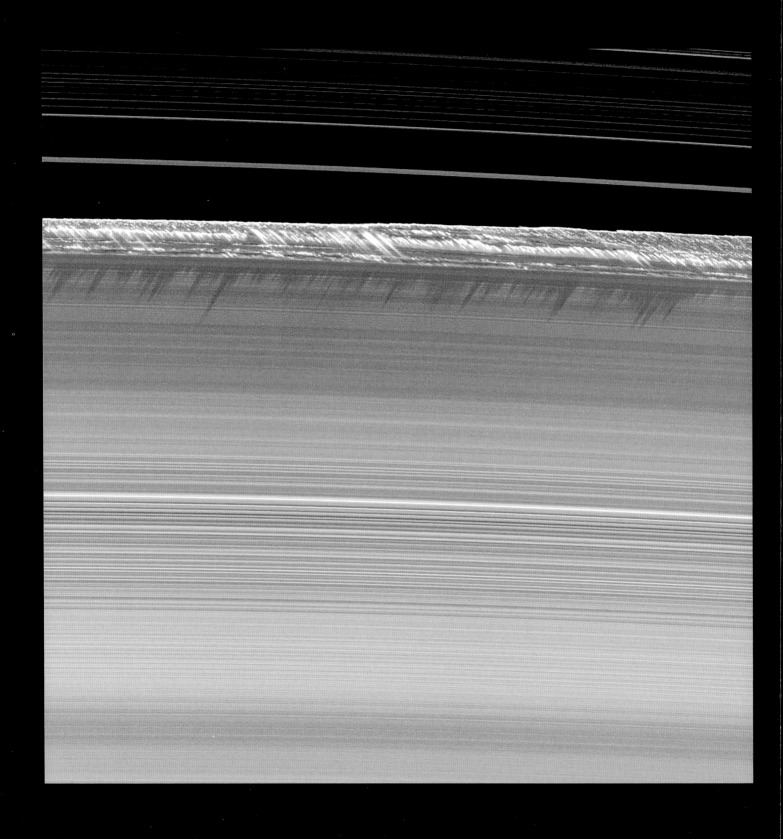

VERTICAL STRUCTURES IN SATURN'S B RING

Cassini captured this image shortly before Saturn's August 2009 equinox. Here, towering vertical structures peak from the planet's B ring and cast a medley of jagged shadows. The vertical structures rise as high as 1.6 miles (2.6 kilometers) above the flat, thin rings, which are about 30 feet (9 meters) thick. The vertical pulling is a ripple effect of moons whose gravitational force compresses the rings and forces their material to jut up and out. This is only one example of the complicated relationship between the moons and rings.

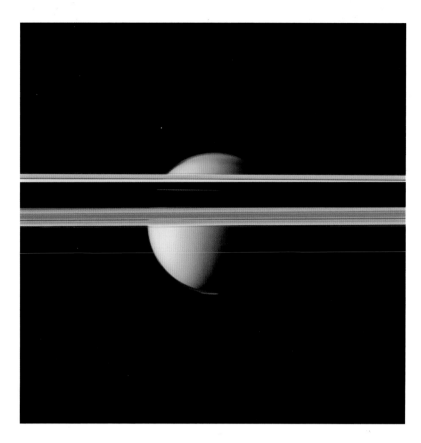

[*above*]

TITAN

This 2012 *Cassini* image of Saturn's moon Titan, partially obscured by Saturn's rings, features the moon's "north polar hood" – a haze somewhat darker than the rest of Titan's atmosphere – and the "south polar vortex" – a region of swirling gas that was not present during the early period of the *Cassini* mission.

[*left*]

DIONE

The *Cassini* spacecraft captured this raw, uncalibrated image of Saturn's moon Dione in October 2016. The tiny moon orbits Saturn from roughly the same distance as our Moon orbits the Earth. Although it isn't visible here, a fine, smoky ice powder from Saturn's E ring (a byproduct of the geyser activity from the moon Enceladus) constantly assails Dione.

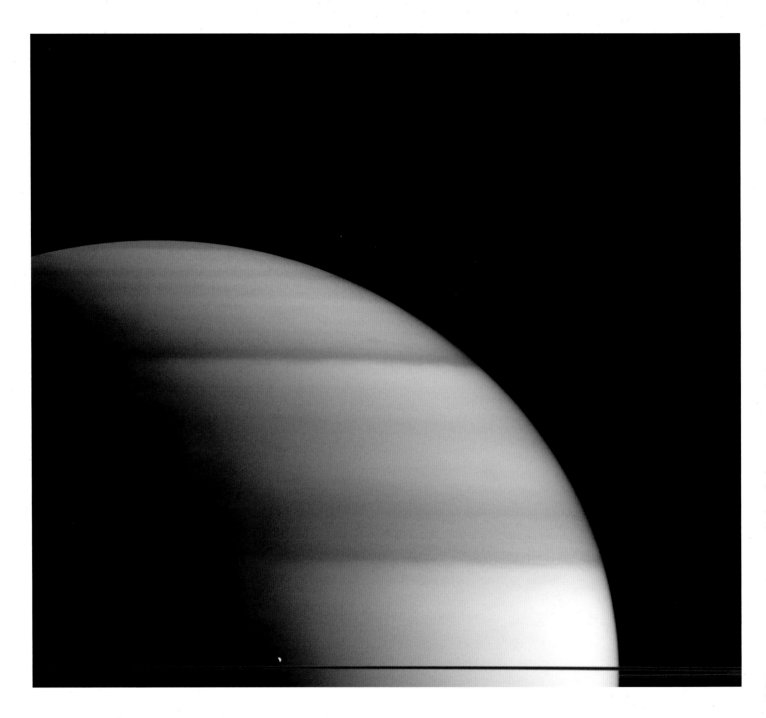

ENCELADUS IN TRANSIT

Enceladus appears as a tranquil speck above Saturn's rings, belying its active crust, which *Cassini* has revealed to be a thin cover over a massive ocean of liquid salt water.

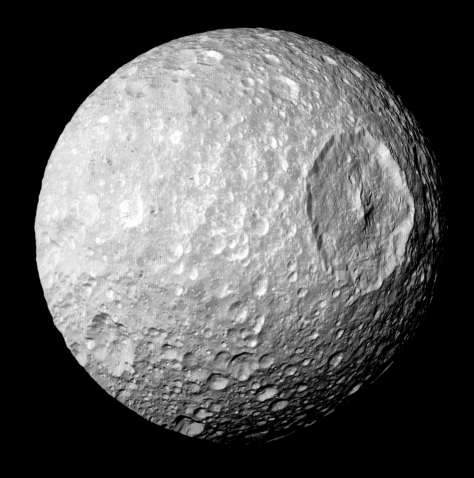

MIMAS

Cassini captured this composite view of Saturn's moon Mimas in 2010. Mimas is the innermost of Saturn's moons and one of the smallest, with a 123-mile (198-kilometer) radius. The giant Herschel Crater, on the upper right, covers a third of the moon's face. Mimas's low density has led scientists to conjecture that the moon is made almost entirely of water ice.

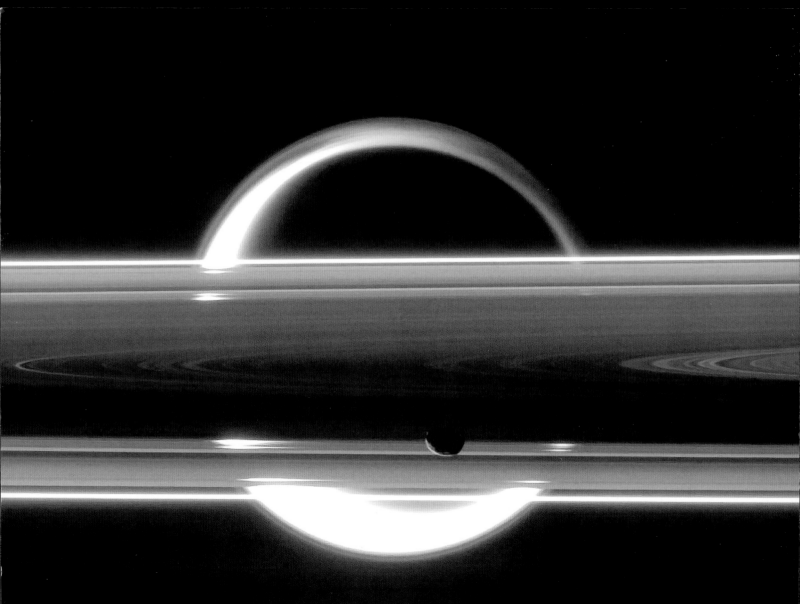

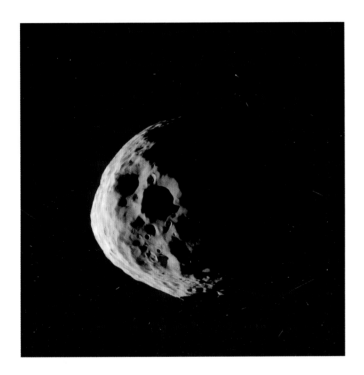

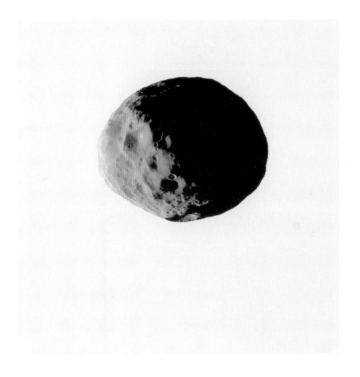

[opposite]

JANUS AND TITAN

This 2006 raw image shows Janus with Saturn's rings and Titan in the background.

[above, left]

A VIEW OF JANUS

In March 2012, *Cassini* captured this raw, uncalibrated image of Saturn's moon Janus transiting the giant planet against the black backdrop of space. The spots and streaks on the image indicate noise on the camera's electronic detector, most likely in the form of cosmic rays. And because of the long exposure, the image comes with a significant amount of "noise."

[above, right]

A SECOND VIEW OF JANUS

Cassini took this raw, unprocessed image of Janus the day after it captured the above left photograph. Here, the backdrop of black space has been replaced by the brightly lit face of Saturn.

URANUS

♅

with an Earth-size planet may have caused this dramatic axial shift. Uranus is the least massive of the gas giants, with an overall mass 14.5 times that of Earth (Neptune's mass is 17 times that of Earth; Saturn's, 95 times; and Jupiter's, 318 times). *Voyager 2* is the only spacecraft to have ever come so close to the icy planet, and it took thousands of photographs. Although the images revealed little about Uranus beyond what we know from Earth-based telescopes, they did unearth evidence of two new rings around the planet and ten previously undiscovered moons.

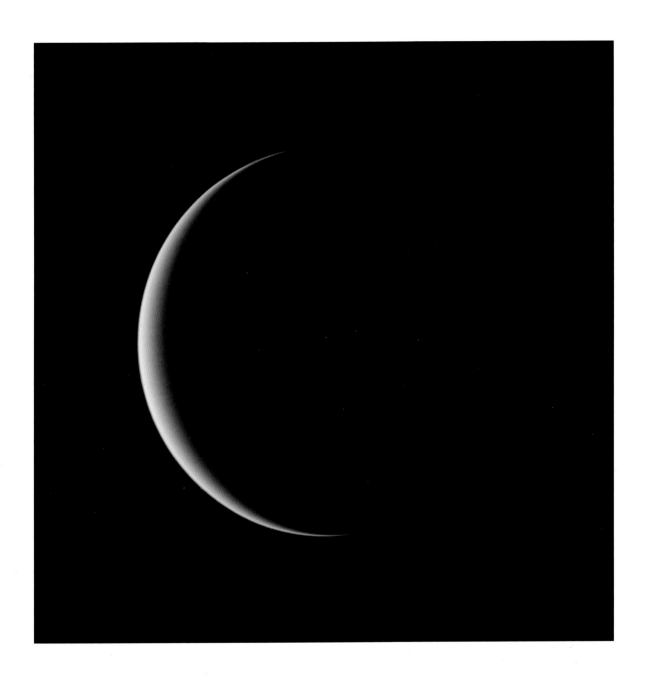

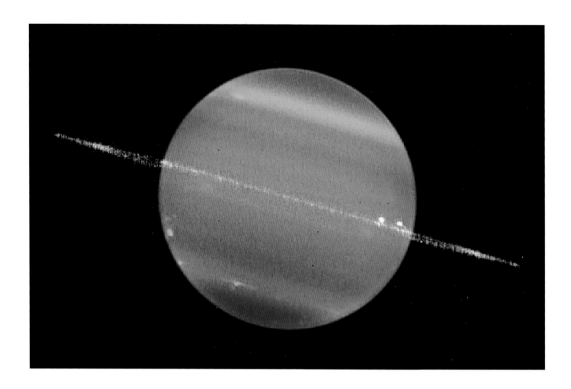

[*above*]

A COMPOSITE VIEW OF URANUS

The Keck Observatory took this image of Uranus through infrared filters,
revealing ring details that would otherwise be invisible to the human
eye. The rings are composed of relatively dark boulders of water ice
that are faint when observed through an unfiltered telescope.

[*opposite*]

A PERFECT BLUE ORB

This *Voyager 2* image of Uranus's sphere reveals few features beyond the ubiquitous haze that
keeps most of the planet under cover. Launched in 1977, *Voyager 2* arrived at the icy planet
in 1986 and was able to come within 50,600 miles (81,500 kilometers) of the planet for
5.5 hours of closer examination. The atmosphere of Uranus is 85 percent hydrogen and
15 percent helium, and scientists believe there is a boiling ocean roughly 500 miles
(805 kilometers) below the thick clouds at the top of the atmosphere. *Voyager 2* scientists
also discovered ten new moons (we currently know of twenty-seven), including the
geologically active Miranda, whose canyons could be twelve times as deep as those of the
Grand Canyon.

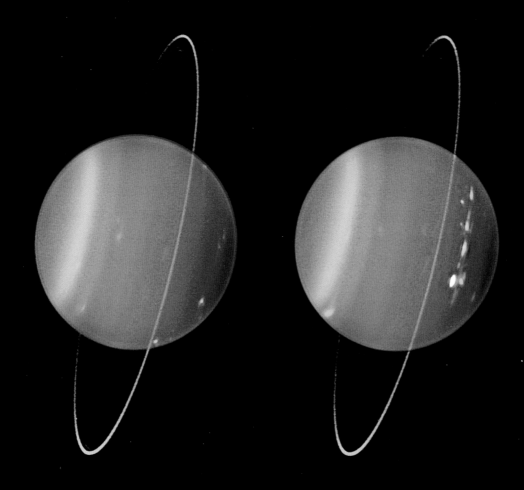

THE TWO HEMISPHERES OF URANUS

The Keck Observatory created this infrared composite image in 2004. Because Uranus's spin axis is tilted by 98 degrees, it lies on its side. So its north pole is at the four o'clock position.

THE DARK SIDE OF URANUS'S RINGS

This 2007 Keck Observatory image shows an infrared visualization of the ice giant's mysterious rings. Sunlight is scattered from the area of the planet exposed to the Sun, lighting up the dark side of the rings.

[*below*]

URANUS'S RINGS AND MOONS

The Hubble Space Telescope's Advanced Camera for Surveys took this image of Uranus in August 2003, revealing the planet's rings – made up of dust, debris, and rocks – and six moons. The moons include Ariel in the bottom right corner of the image, and clockwise around the planet from the top are Desdemona, Belinda, Portia, Cressida, and Puck.

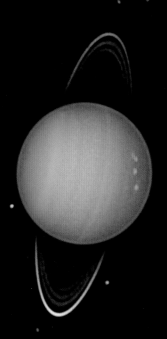

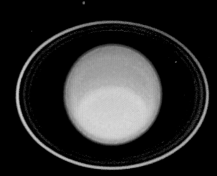

[*above*]

URANUS IN INFRARED

This infrared image taken by the Hubble Space Telescope in 1996 gives us a glimpse into Uranus's atmosphere. The image shows several layers of gas, indicated by a red haze circling the planet, and a yellow one just below it, close to the top of the planet's atmosphere. The blue area on top indicates a layer that is much deeper in Uranus's atmosphere. Although the rings of the planet appear bright because of image processing, they would be invisible to the naked eye.

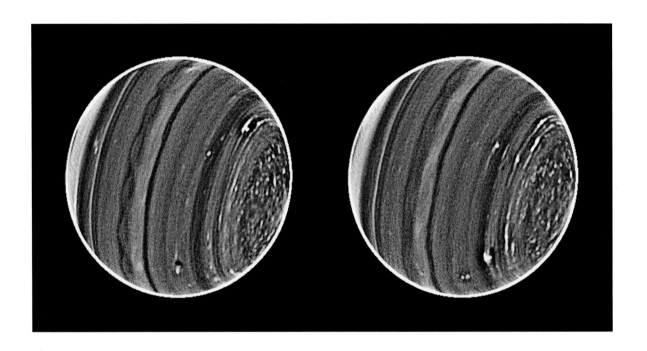

URANUS'S ATMOSPHERE

This pair of images from the Keck Observatory feature the most detailed infrared imagery of the ice giant to date. Convective clouds appear on the north pole (on the right side of the planet), while a wavy formation of clouds rings the equatorial plane.

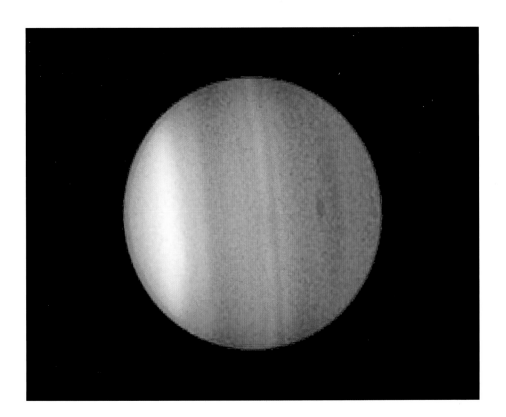

A DARK SPOT IN URANUS'S NORTHERN REGION

This Hubble Space Telescope image from 2006 reveals the first dark spot (a splotch in the middle right of the planet, close to its north pole) ever observed on Uranus. The spot is most likely a quickly mutating storm cloud high in the planet's atmosphere.

ARIEL

Ariel is the fourth largest of Uranus's twenty-seven moons. In this Hubble Space Telescope photograph, it is visible as a bright white dot passing over the face of the planet, and accompanied by its shadow.

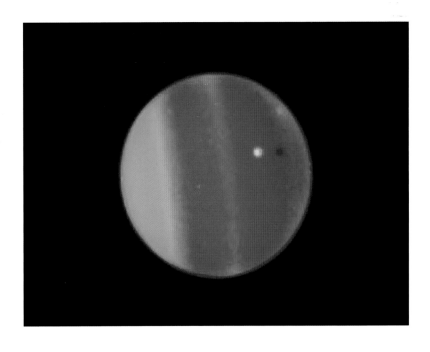

URANUS IN TRUE AND FALSE COLOR

The image on the left is Uranus in true color, while the other is shown in false color to bring out details in the planet's polar region. Both are composites of images taken by the narrow-angle camera of *Voyager 2* in 1986.

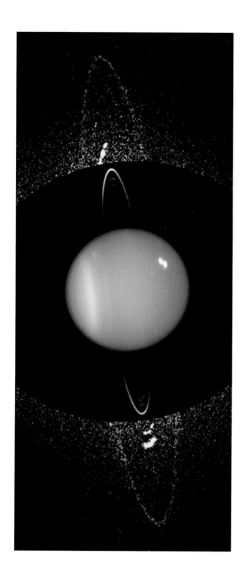

A PAIR OF RINGS

This 2005 Hubble image features a pair of newly discovered, faint, enormous rings circling Uranus, beyond its known ring system (the bright formations within the black space). The largest of the rings, visible at the top and bottom of the image, is twice the diameter of the previously known ring system. The second ring in the pair is visible as two bright smudges oriented outside the known ring system and within the large ring. The rings are also interacting with two previously undiscovered moons, Mab and Cupid (not visible in image).

THE RING SYSTEM OF URANUS

In this 2007 Hubble Space Telescope image, the entire ring system of Uranus can be seen, creating a ghostly flashlight effect around the ice giant. The rings can be seen as bright, narrow spikes extending from the top and bottom of the image, but they are not visible across Uranus's face, as the glare of the planet was removed during image processing, making the rings in this region invisible.

NEPTUNE

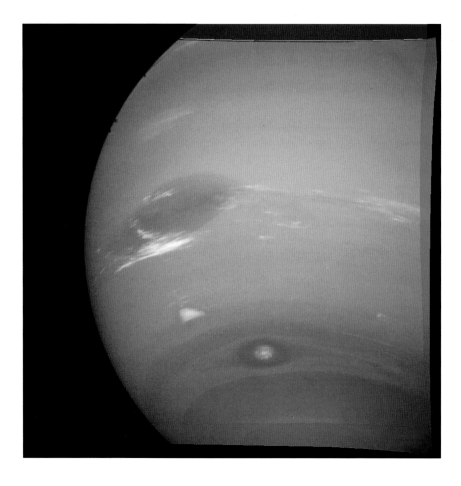

[*above*]

SPOTS ON NEPTUNE

This composite photograph of Neptune comes from *Voyager 2*'s narrow-angle camera during the spacecraft's flyby in 1989. In the middle of the planet is Neptune's Great Dark Spot, a high-pressure weather storm the size of Earth. Directly below this is a small, bright, triangular patch of cirrus clouds that has been dubbed "Scooter," and below and to the right of Scooter is a circular storm with a glowing center near the south pole known as the Small Dark Spot.

[*opposite*]

NEPTUNE, EIGHTH PLANET FROM THE SUN

Voyager 2's narrow-angle camera produced this 1989 image of Neptune from photographs taken with green and orange filters when the spacecraft was roughly 4.4 million miles (7.1 million kilometers) from the planet. In the center of the planet is the famous Great Dark Spot, a giant storm whose interior is nearly cloud-free. The planet's upper atmosphere is rife with enormous high-speed storms. The intensity of Neptune's gravity is second only to Jupiter's. Its atmosphere is composed primarily of hydrogen and helium, but Neptune's methane absorbs red light and gives the planet its bright-blue appearance. As the most distant planet from the Sun, it takes Neptune 165 Earth years to complete one solar orbit. *Voyager 2* is the sole spacecraft to have been in the blue planet's vicinity, providing us with much of our data on Neptune, including the images in the following pages. Launched in 1977, *Voyager 2* is also the only spacecraft that has studied all four outer planets at close proximity. It is now in the outermost area of the solar system; in September 2007 it crossed the threshold known as the "termination shock," one of the known boundaries of our solar system where the solar wind (the charged particles from the Sun that stream out into space) slows down to below the speed of sound. The termination shock is 84 astronomical units from Earth; an astronomical unit is 92.9 million miles (149.6 million kilometers).

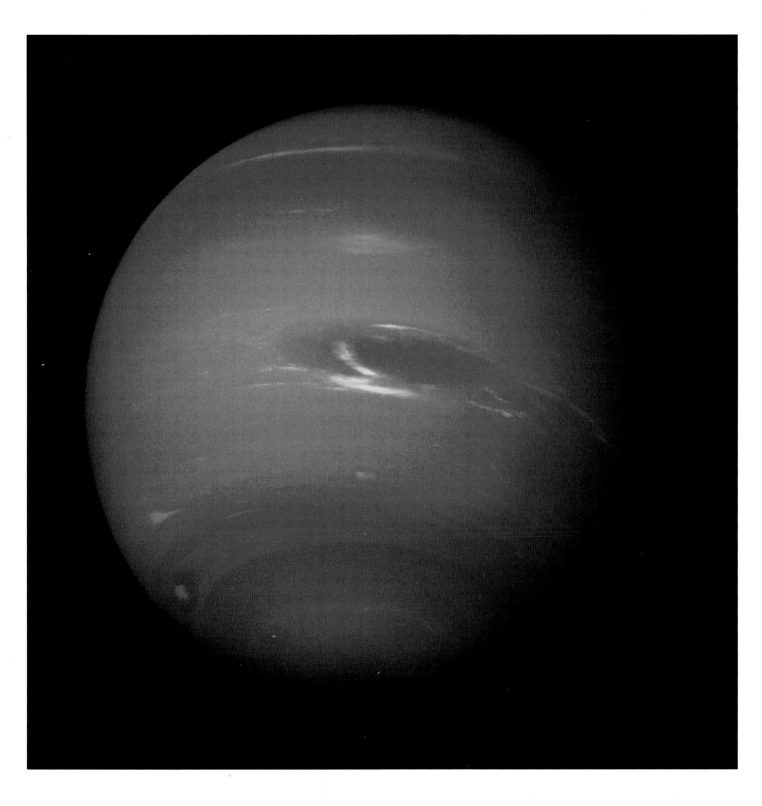

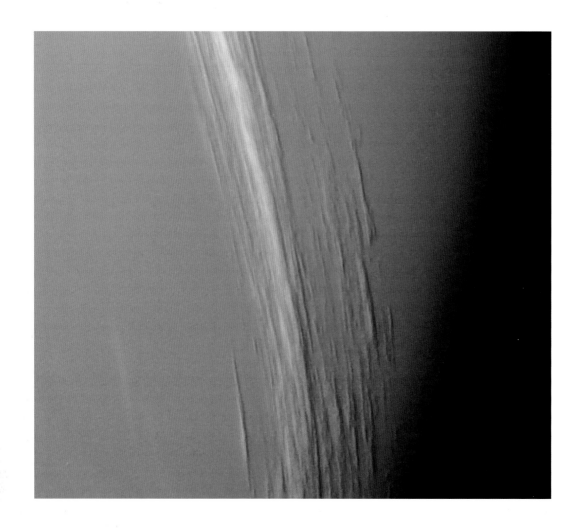

NEPTUNE'S CIRRUS CLOUDS

This high-resolution image reveals a series of cloud streaks that span up to 124 miles (200 kilometers) near the planet's east terminator, where the darkness of night and the luminosity of daylight meet. The clouds are high in the planet's atmosphere, so they are illuminated by the Sun on one side and cast shadows on lower clouds on the other. The composition of Neptune's clouds varies with the altitude. The highest layers, such as the cirrus clouds pictured here, are composed of frozen methane. Lower in the atmosphere, clouds are composed of hydrogen sulfide, ammonium sulfide, ammonia, and water.

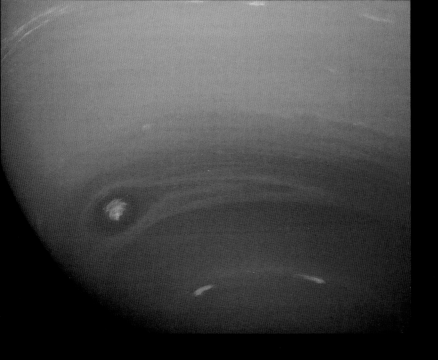

THE SOUTHERN HEMISPHERE OF NEPTUNE

This close-up image of the southern hemisphere of Neptune features a massive cloud system with a higher number of winds in its southern region. The storm was eventually dubbed the Small Dark Spot.

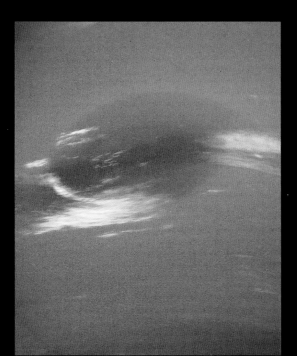

NEPTUNE'S GREAT DARK SPOT

Voyager 2 captured this image of the Great Dark Spot, featuring the pinwheel-like structure of the Neptunian storm, which moves counterclockwise.

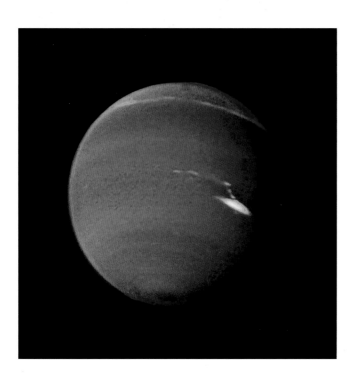

NEPTUNE'S ATMOSPHERE

This false-color image was captured by *Voyager 2*'s wide-angle camera. The white spot is a cloud high in the atmosphere, just south of the Great Dark Spot (whose clouds are indicated by the pinkish area around the white spot). The blue areas represent objects farther down in Neptune's atmosphere.

A HAZE AROUND NEPTUNE

This false-color image features the translucent haze that scatters incoming sunlight and appears as a red rim around Neptune.

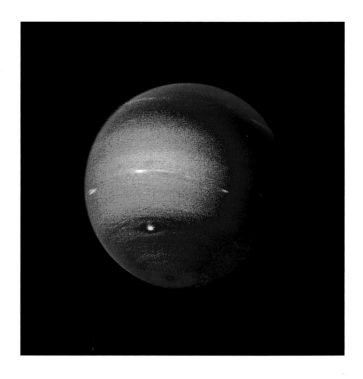

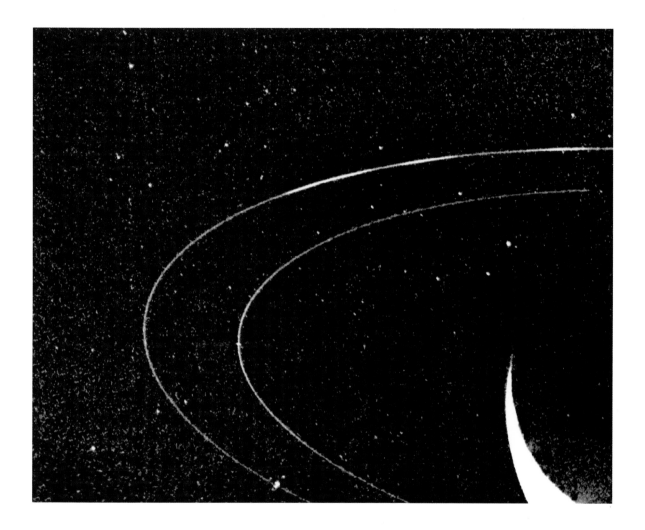

NEPTUNE'S OUTERMOST RING

In this image, Neptune's narrow, outermost ring contains three brighter sections or arcs; this indicates that material is denser and unevenly clustered in these places. Scientists are puzzled by this, as the laws of motion dictate that material should be distributed evenly throughout the rings.

NEPTUNE'S MOON TRITON

This composite image comes from three images taken by *Voyager 2* through colored filters. The mottled surface in the bright southern hemisphere may indicate a rigid icy crust.

TRITON'S SOUTHERN HEMISPHERE

This false-color image was taken from 330,000 miles (531,000 kilometers) away. It shows Neptune's bright southern hemisphere and rough topography.

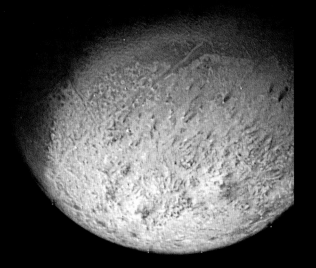

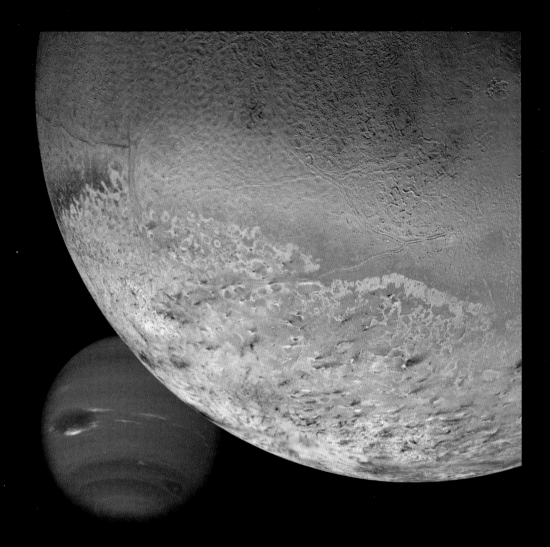

APPROACHING TRITON

This composite image – created from a mosaic of images of the moon Triton, which was then
composited against an image of Neptune – shows how Neptune might look as seen from behind
the largest of its thirteen moons. Triton's eroded south polar cap, the result of prolonged Sun
exposure, is shown in detail, as is Triton's surface, which has a number of craters as well as
smooth volcanic plains and icy lava flows. Its crust, made of frozen nitrogen, is believed to
cover a dense core of rock and metal. Triton is the only large moon that we know of with a
retrograde orbit (meaning it orbits in a direction counter to Neptune's rotation). Scientists
believe that Triton is a Kuiper Belt object that was pulled in by Neptune's gravity millions of
years ago. Like our Moon, Triton is in a synchronous rotation with its mother planet, meaning
that only one side of the moon ever faces the planet.

DESPINA

This composite image of the tiny moon Despina, Neptune's third satellite, is made up of four different frames captured through blue, orange, violet, and green filters. Despina has a diameter of 90 miles (145 kilometers), and it orbits Neptune every eight hours. The irregularly shaped, geologically inactive moon stays close to Neptune's equatorial plane and transits the planet within its ring system.

THE CRESCENTS OF NEPTUNE AND TRITON

Voyager 2 took this image soon after its closest approach to the planet in 1989. Neptune does not appear blue from this vantage point, as it does not absorb red light as readily at this high angle from the Sun. Below Neptune is the moon Triton.

NEPTUNIAN CRESCENT

Voyager 2 took this image of Neptune's south pole as it zoomed away from the planet after its closest approach.

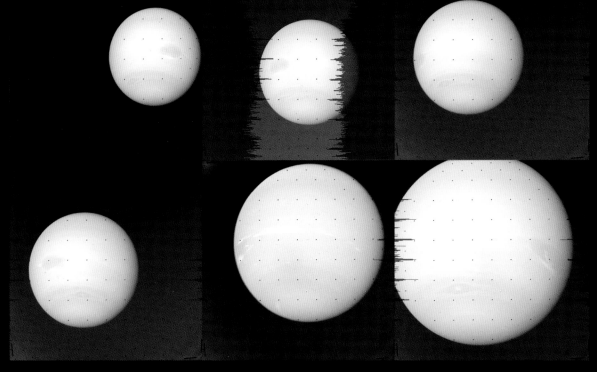

[*this spread*]

RAW IMAGES OF NEPTUNE FROM VOYAGER 2

These raw, uncalibrated, uncorrected images are chronological points of data from the *Voyager 2* flyby of Neptune on August 25, 1989 – roughly twelve years after the craft left Earth. The images themselves were selected to offer a record of the visual progression of approach. At its closest approach, *Voyager 2* passed over Neptune's north pole at a distance of 3,000 miles (4,830 kilometers).

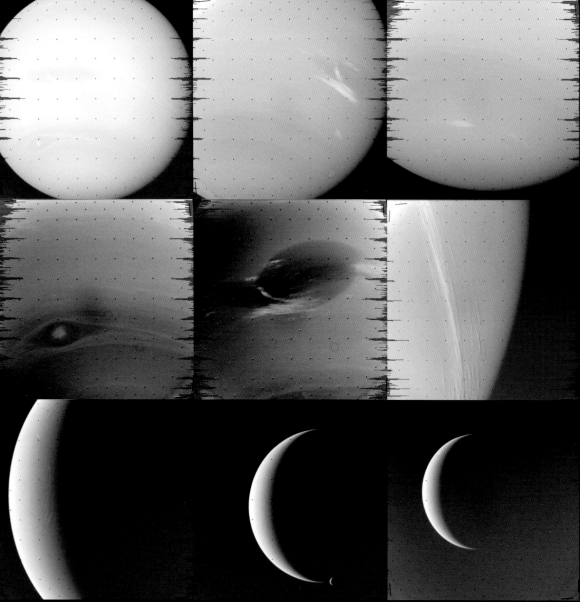

OTHER BODIES
OF THE
SOLAR SYSTEM

THE SUN

A PROMINENCE ON THE SUN

As massive as the gas giants in the outer solar system are, the Sun is responsible for 99.86 percent of the solar system's mass. The Solar and Heliospheric Observatory's Extreme ultraviolet Imaging Telescope took this image of an enormous prominence on the face of the Sun in 1999. A solar prominence is a large arc of gas that spouts out from the surface of the Sun, often extending hundreds of thousands of miles and lasting for a period of months, as the Sun's strong magnetic fields keep the loops intact. Prominences are cool compared to the Sun's hot corona (the plasma surrounding the Sun, which extends millions of miles into space), but they can eventually erupt and escape the atmosphere of the Sun. In this image, the hottest regions of the Sun appear almost white, while the darker red areas indicate cooler temperatures.

DETAIL OF A SUNSPOT

This detailed image taken in 2010 by the New Jersey Institute of Technology's New Solar Telescope at the Big Bear Solar Observatory – a project partially funded by NASA – features an enormous sunspot on the photosphere of the Sun that is slightly larger than the Earth. The dark area shows the relatively cooler region of the sunspot, known as the umbra, while the lighter, spoke-like region is the hotter penumbra.

A SUNSPOT

In 2014, NASA's Solar Dynamics Observatory (SDO) captured this image of an enormous sunspot that's roughly 80,000 miles (128,700 kilometers) across. This active region of the Sun, known as AR 2192, is large enough to hold ten Earth-size planets.

THE SOLAR CHROMOSPHERE

This composite image from the New Solar Telescope features the solar chromosphere over a massive sunspot (in the center of the image). The chromosphere is an irregular layer of the Sun where hydrogen emits a reddish-colored light. The vibrant, wave-like formations around the sunspot are tubes of hot plasma, many of which extend distances that exceed the diameter of the Earth.

A COLORFUL CORONA

This colorized image, captured by the SDO, features a series of high-speed jets that led to the slow eruption of massive amounts of solar material at the Sun's corona; this eruption lasted for roughly three days, beginning on January 17, 2013.

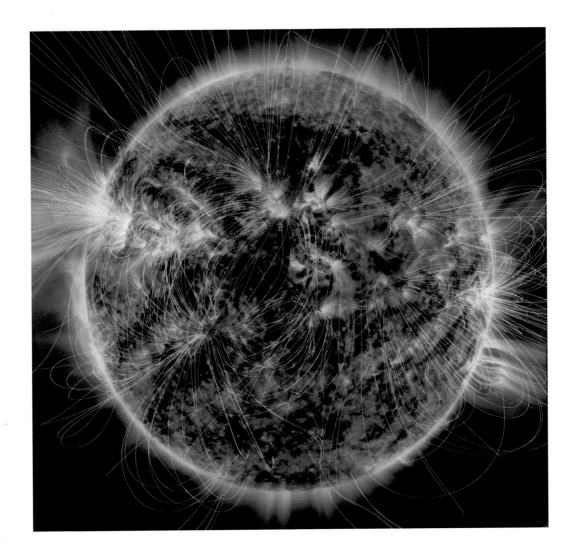

[*above*]

THE SUN'S MAGNETIC FIELDS

The SDO took this colorized image in ultraviolet wavelengths in March 2016, and it was overlaid by an illustration of the Sun's invisible magnetic fields. These massive fields are created by gas-like plasma flows, which are generated by nuclear fusion at the center of the Sun.

[*opposite*]

A MIDLEVEL SOLAR FLARE

The SDO captured this solar flare — the brightest, most luminous spot in the middle of the Sun — on December 16, 2014. Solar flares are magnetic storms that release enormous amounts of hot gaseous particles and arc out from the Sun's surface. Although flares are the largest explosions in our solar system, they usually only last for an hour. In that short time, they can cause "sunquakes," which are the solar equivalent of earthquakes: cataclysmic seismic events whose waves radiate violently from the epicenter. A sunquake can unleash forty thousand times more energy than the earthquake that devastated San Francisco in 1906.

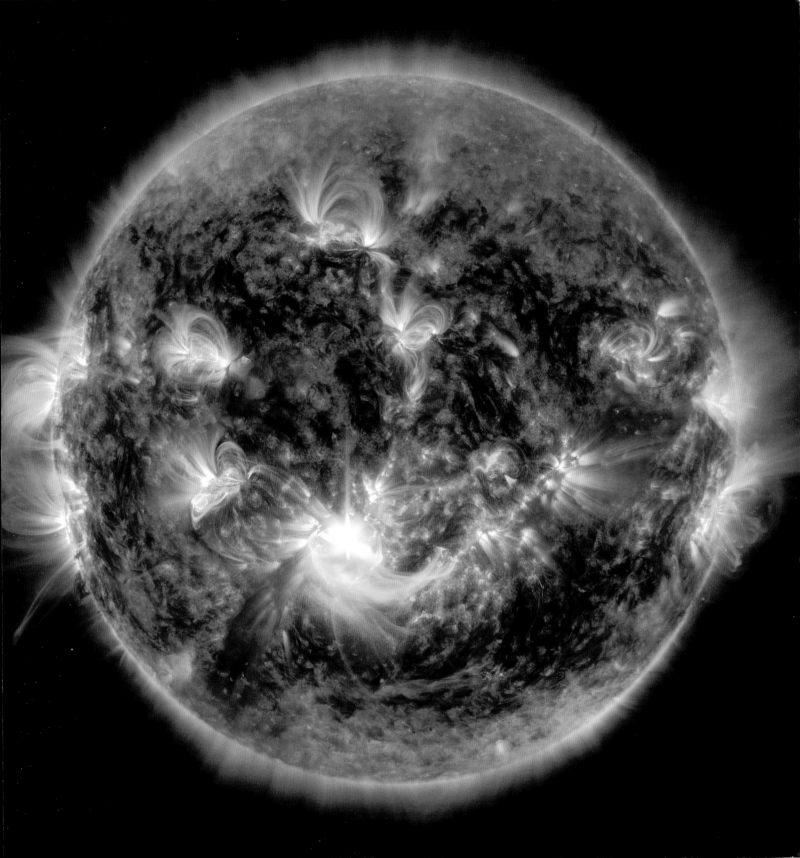

PLUTO

THE DWARF PLANET PLUTO

Long considered the solar system's ninth planet, Pluto
was reclassified as a dwarf planet in 2006. This was
because, among the sea of objects in the Kuiper Belt
that orbit the Sun just beyond Neptune, Pluto is simply
not distinctive enough. The dwarf planet is 1,473 miles
(2,371 kilometers) in diameter, or roughly one-fifth the
size of Earth, and it continues to be the subject of scientific
study. In 2015, NASA's *New Horizons* probe completed its
nine-year, 3-billion-mile (4.8-billion-kilometer) journey
to Pluto and sent back the most detailed images to date,
featured in the following pages. This image combines data
from *New Horizons'* Long Range Reconnaissance Imager and
the spacecraft's visible/infrared imager, dubbed "Ralph."
This global view of Pluto reveals remarkable detail,
including features as small as 1.4 miles (2.3 kilometers).

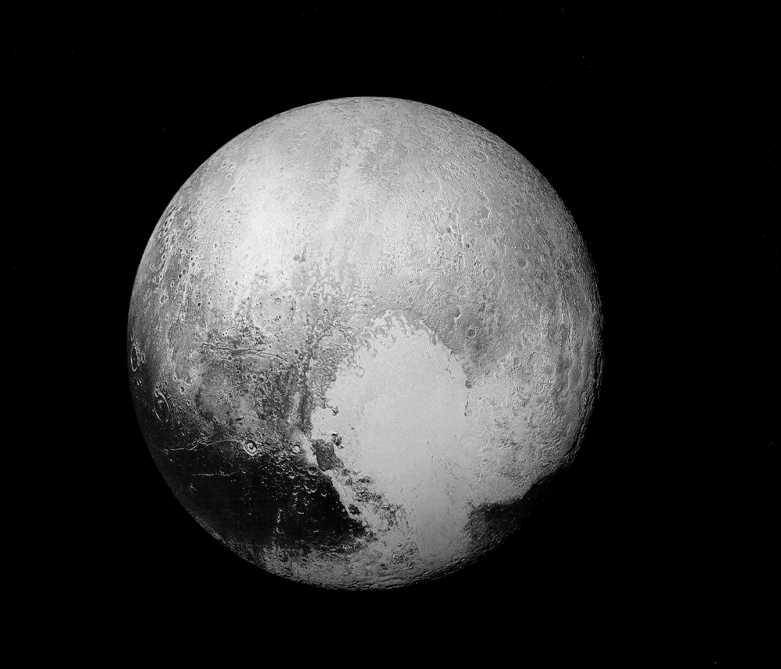

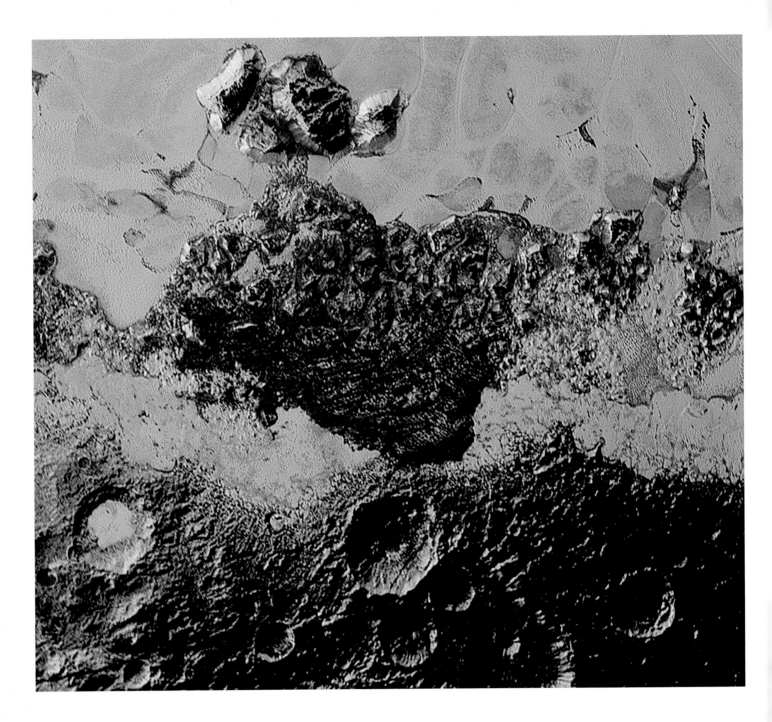

PLUTO'S SURFACE

This image of Pluto is 220 miles (354 kilometers) wide and features smoother, lighter regions that are relatively young compared to the surrounding ancient cratered terrain.

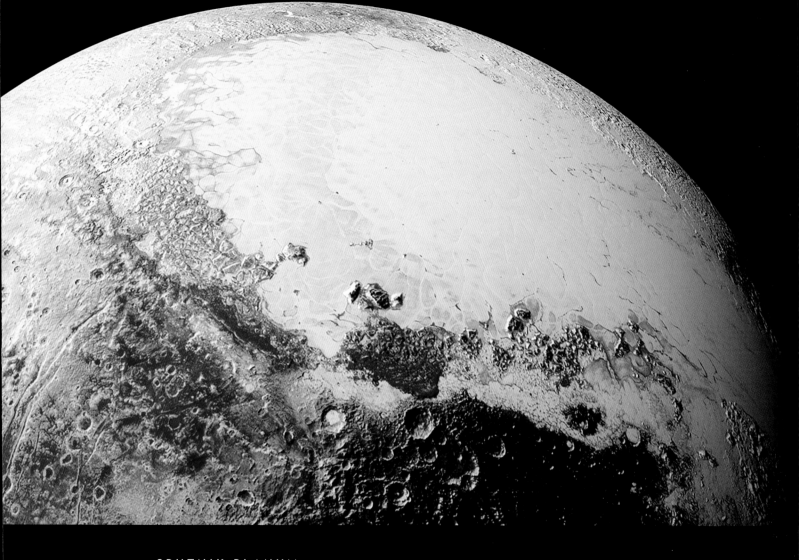

SPUTNIK PLANUM

This high-resolution image was captured in blue, red, and infrared filters. It features a region of icy plains that are abundant in nitrogen, carbon monoxide, and methane and is known as Sputnik Planum.

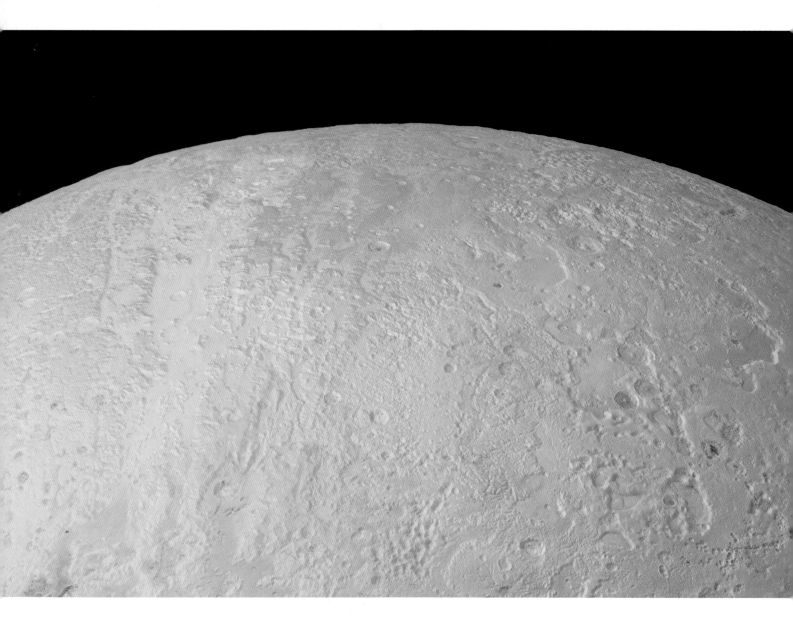

LONG CANYONS ON PLUTO

This detailed close-up of the deep canyons along Pluto's north pole was taken in July 2015 by *New Horizons'* Ralph/
Multispectral Visible Imaging Camera (MVIC). The largest canyon is in the north pole region, left of top center, and
measures 45 miles (72 kilometers) wide, flanked by smaller parallel canyons to the east and west. Scientists believe that
the canyons pictured here are geologically older than those of other regions on Pluto. Interspersed among the canyons
are large pits that may mark areas where subsurface ice melted, creating collapsed hollows in the ground. The region's
yellowish color is unusual compared to other regions of Pluto, and it may indicate old methane deposits that have been
exposed to solar radiation. The bluish-white terrain at the bottom right of the image indicates lower elevations.

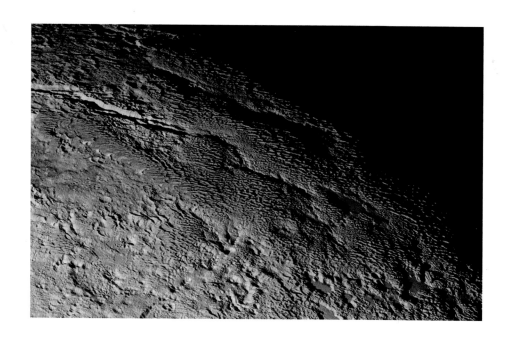

THE MOUNTAINS OF PLUTO

New Horizons took this image of a mountain range on Pluto known as the Tartarus Dorsa, which features rounded ridges and a pockmarked texture.

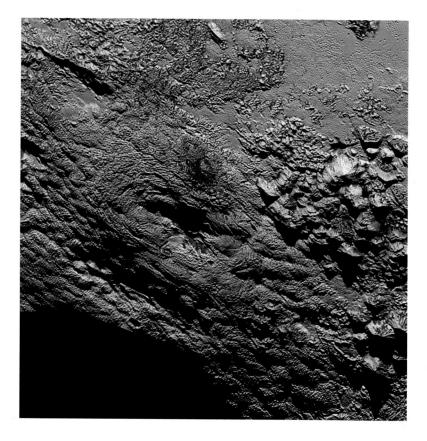

WRIGHT MONS

This image features the mountainous region south of Sputnik Planum. In the center is Wright Mons, which is 100 miles (161 kilometers) wide and 2.5 miles (4 kilometers) high and is thought to have been formed by the eruption of ice beneath the surface of Pluto.

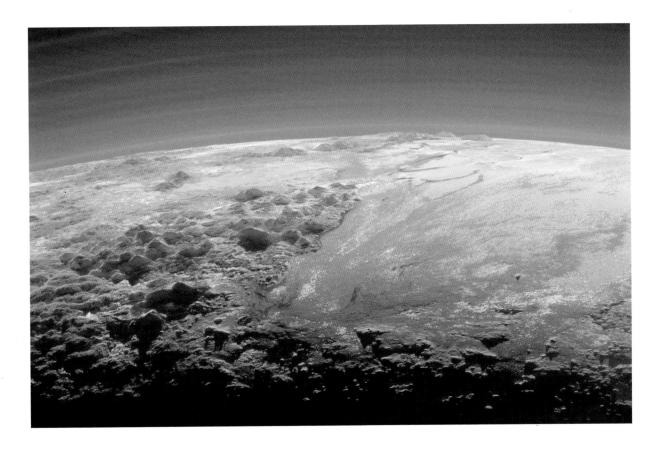

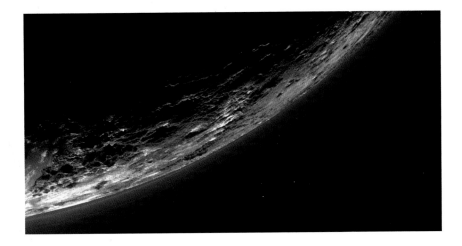

[above]

SUNSET ON PLUTO

This image was taken on July 14, 2015, fifteen minutes after *New Horizons'* closest approach to Pluto. It features an expansive, backlit view of Pluto's mountains and flat planes as well as its hazy atmosphere.

[*left*]

PLUTO'S LIMB

The haze above Pluto's limb (the border at the edge of a celestial body) contains twenty layers. In the lower left, one layer extends 3 miles (5 kilometers) into space.

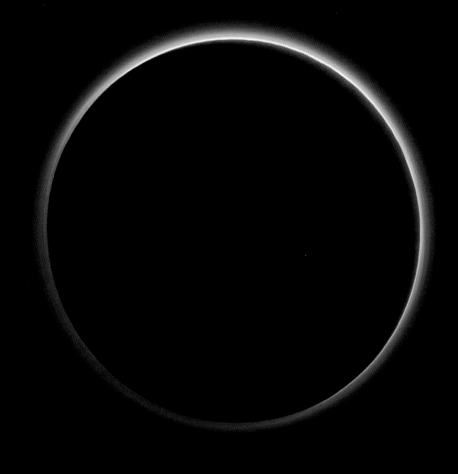

PLUTO'S LIMB

New Horizons' Ralph/Multispectral Visible Imaging Camera (MVIC) took this image of the atmospheric
haze around Pluto's limb. Scientists theorize that the haze is a smog resulting from chemical
reactions between methane and nitrogen, initiated by sunlight. These reactions create tiny particles
that actually get larger in size as they drift toward Pluto's surface. The highest layers are generally
unstable, as the temperatures far above the planet's surface are warm enough to vaporize the
particles. Scientists believe that there are so many layers because gentle winds transporting heat
from the warmer outer regions to the colder surface regions of Pluto generate gravity waves that
expand upward, thereby compressing and thinning particle bands at regular intervals. This activity
distributes the atmosphere in a ring-like pattern around the planet.

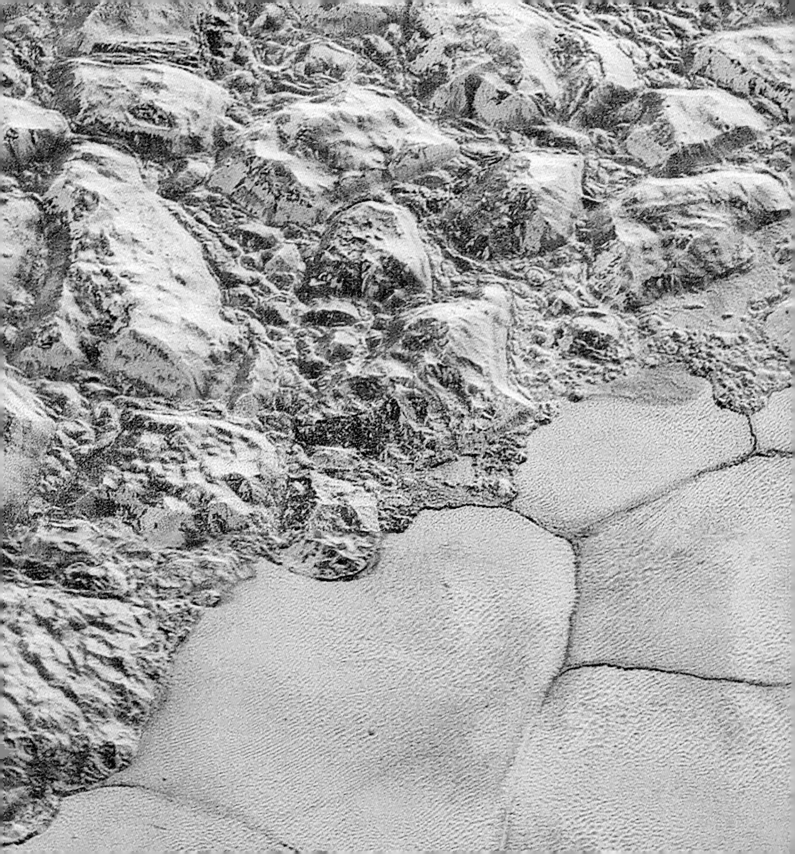

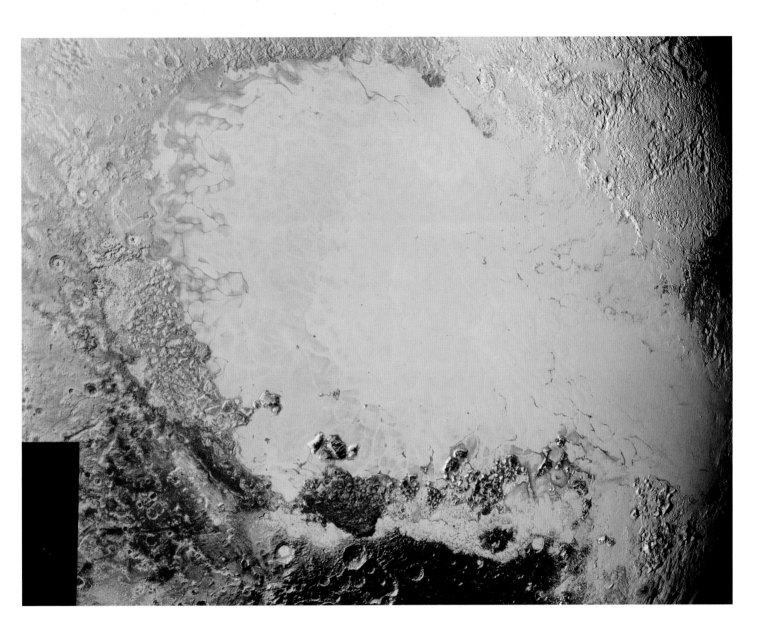

[opposite]

PLUTO'S ICY CRUST

New Horizons captured this image of the al-Idrisi mountains, which
are made up of clusters of Pluto's protuberant water-ice crust. The
area in the image is 50 miles (80 kilometers) wide, and where the
mountains end, Sputnik Planum's icy plains begin.

[above]

MOSAIC OF PLUTO

This series of composite images was taken between September 5
and 7, 2015, and it features the topographically smooth Sputnik
Planum at the center, flanked by rough mountainous regions.

A CLOSE APPROACH

This mosaic comes from images taken during *New Horizons'* closest approach to Pluto in July 2015. It features a snapshot of Pluto's geological diversity, from icy craters to glacial plains. The strip seen here is roughly 50 miles (80 kilometers) wide, and also encompasses the image of the al-Idrisi mountains, on page 220.

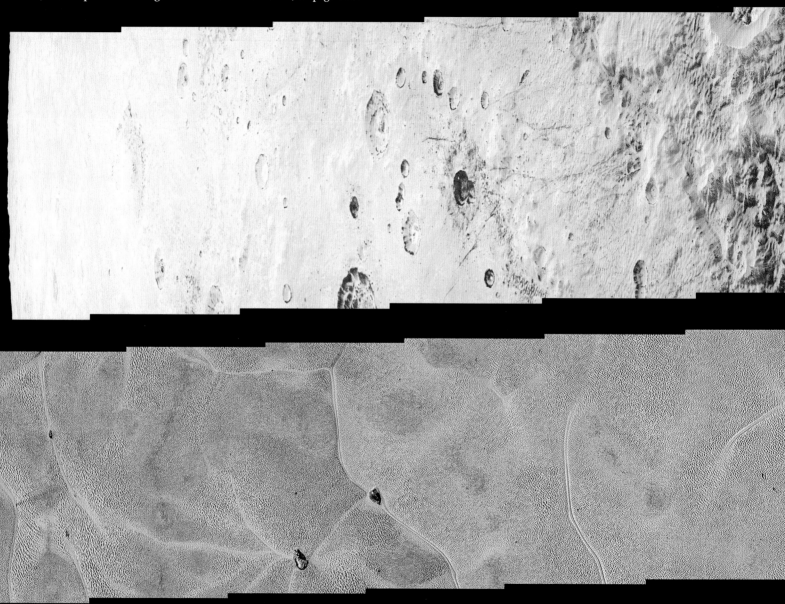

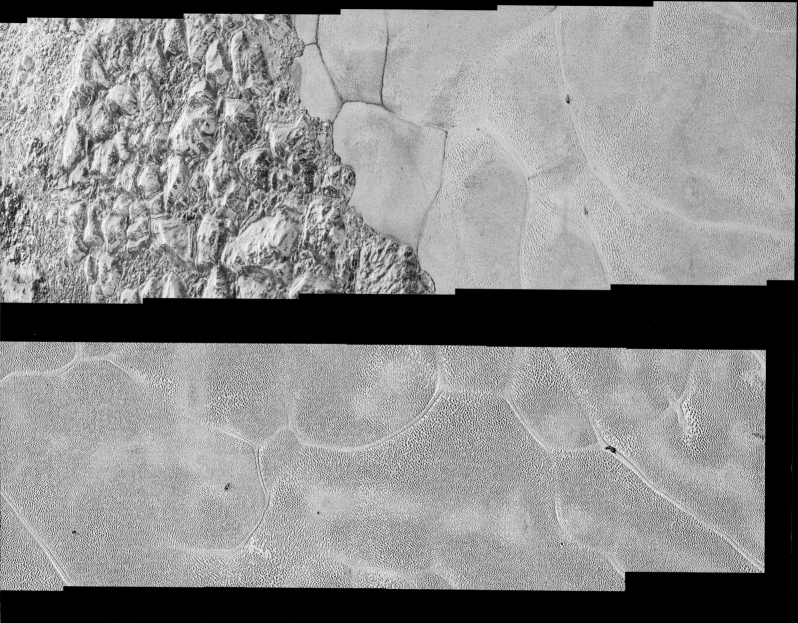

THE CENTER OF SPUTNIK PLANUM

New Horizons' high-resolution mosaic of Pluto features images covering areas smaller than a city block. Starting at the left, this strip of images extends from the northwestern edge of Sputnik Planum and progresses east across its slightly textured plains for over 400 miles (644 kilometers).

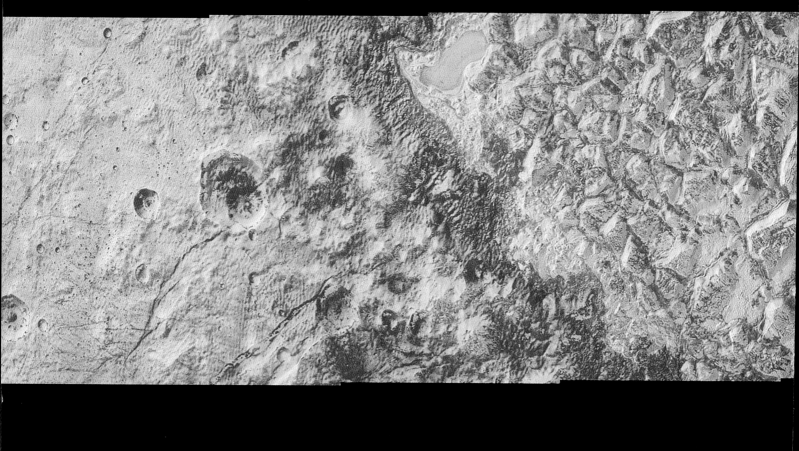

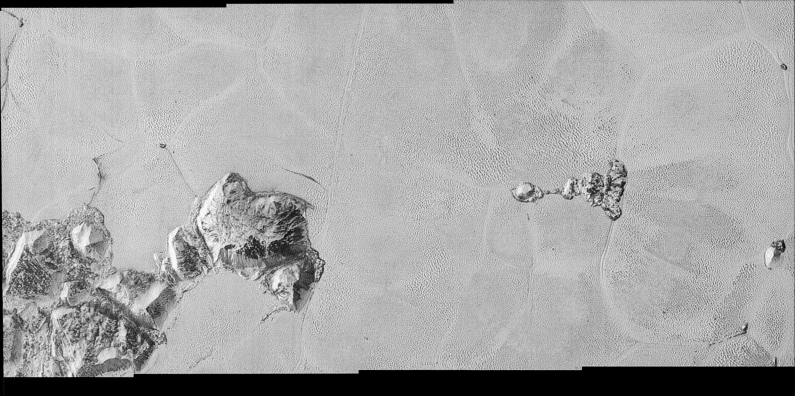

SPUTNIK PLANUM

New Horizons took this image moments before its closest approach to Pluto on July 14, 2015. This enhanced-color photograph displays approximately 330 miles (531 kilometers) of Pluto's surface, and in it, topographical features as small as 800 feet (244 meters) across can be seen. This image is one piece of the vast, textured, heart-shaped Sputnik Planum, whose surface is covered in welt-like cells of ice ranging from 10 to 30 miles (16 to 48 kilometers) across. The pattern of the cells comes from the thermal convection of the region's solid nitrogen ice. As the nitrogen is warmed by the dwarf planet's heat, it rises up in enormous blobs, cools off, sinks back down again, and repeats the process.

PLUTO AND CHARON

This enhanced-color composite of Pluto and its largest moon, Charon, was taken by *New Horizons* on July 14, 2015. The Pluto-Charon system comprises the only binary planet system in our solar system, as the two bodies orbit each other similar to the way binary stars do. Though only half the diameter of Pluto, Charon's topography is just as diverse – containing mountains, canyons, and surface-color variations. The same red speckles can be seen in Pluto's equatorial terrain and Charon's polar region. The deep red of Charon's polar cap stems from methane gas released by Pluto's atmosphere and captured by the moon's surface environment.

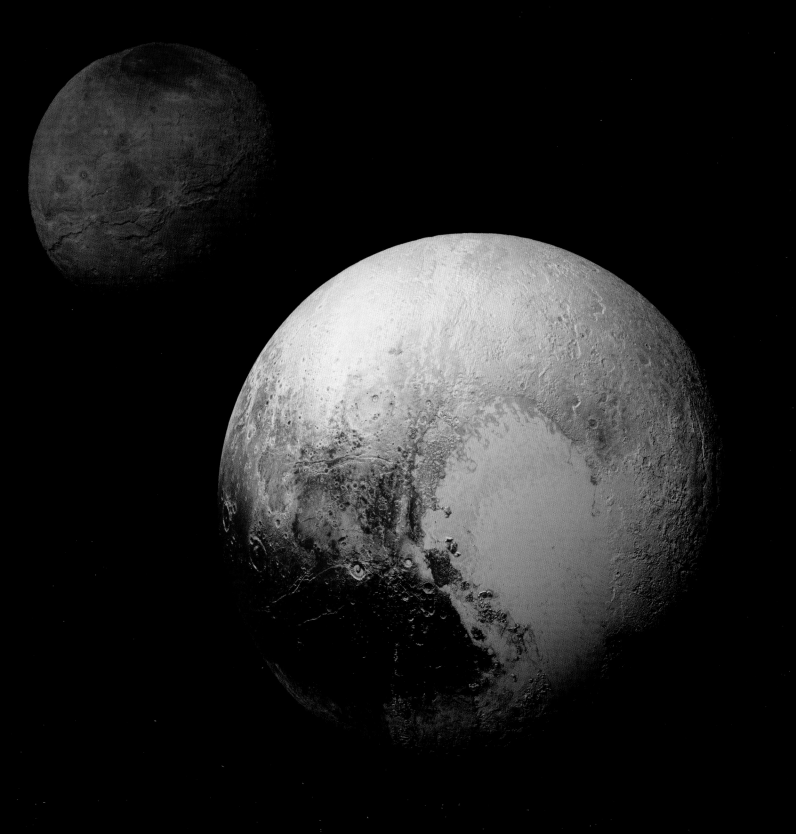

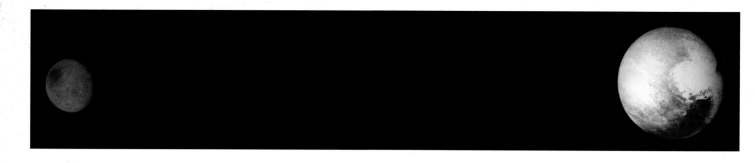

THE TERRAIN OF PLUTO AND CHARON

This enhanced-color *New Horizons* composite image, from July 2015, shows the diverse terrains of both Pluto and Charon, in their relative actual position to each other. Charon is the solar system's largest moon relative to its planet.

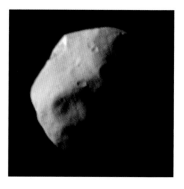

TWO VIEWS OF PLUTO AND CHARON

This 2015 side-by-side color image from *New Horizons* features two different photographs with two distinct views of Pluto and Charon, and it illustrates that their "barycenter" – which refers to the center of mass of two bodies that orbit each other – lies outside of and between both bodies. The barycenter is 12,241 miles (19,700 kilometers) from the center of Charon, and 250 miles (400 kilometers) from the center of Pluto; at this point, the gravitational effects of either body cancels out, which is the reason Pluto appears to wobble in space. Since the common center of mass for the Pluto-Charon system is not located within the interior region of either body, scientists have suggested that it is not a true planet-satellite system.

NIX

Pluto's third-largest moon, Nix, is featured in this luminous image, taken from roughly 14,000 miles (22,500 kilometers) away.

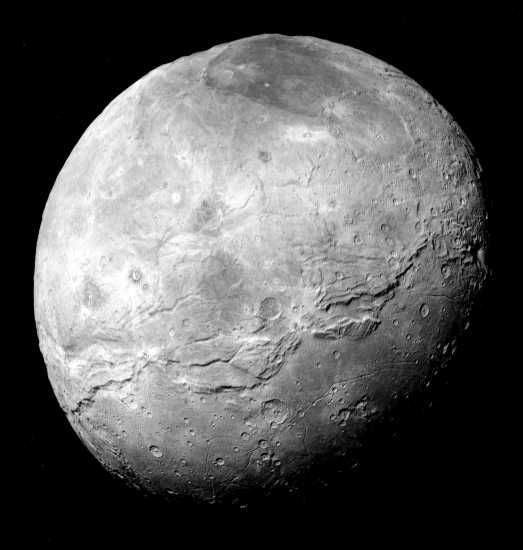

CHARON

This *New Horizons* image of Charon, taken on July 14, 2015, reveals the splotchy red north pole region known as the Mordor Macula (named after the black terrain in J. R. R. Tolkien's *Lord of the Rings*), which covers an area roughly the size of New Mexico. Although Charon's topography is diverse, its color palette appears more monochromatic than Pluto's, with the exception of this singular striking feature. It takes Charon and Pluto, which are locked in a binary orbit, about 6.4 Earth days to make a full revolution around each other. Since one full Pluto rotation around its own axis is approximately just as long, Charon always hovers over the same area of Pluto's surface and is tidal locking — meaning that the same side of the moon always faces the dwarf planet.

CERES

NASA's *Dawn* spacecraft captured this mosaic image of Ceres between April 24 and 26, 2015, from roughly 8,400 miles (13,520 kilometers) away. Ceres is the largest body in the asteroid belt between Mars and Jupiter, and it is the nearest dwarf planet to Earth. Ceres was considered a planet shortly after its discovery in 1801 by Sicilian astronomer Giuseppe Piazzi. Eventually, it was deemed an asteroid, and then in 2006, it was upgraded to a dwarf planet – the smallest that we know of. It is 590 miles (950 kilometers) in diameter. Ceres seems to have had an active geological history. By measuring changes in the dwarf planet's gravitational impact on the *Dawn* spacecraft, which offered insight into Ceres's thermal and geological history, scientists found that its interior shows evidence of dramatic change over millions of years.

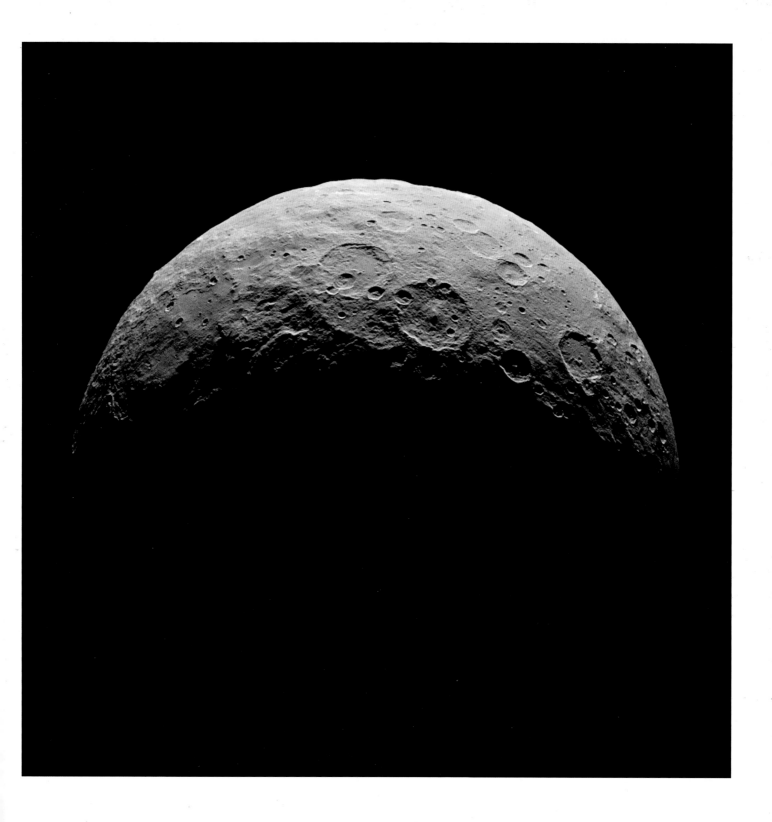

TWO CRATERS ON CERES

NASA's *Dawn* spacecraft captured this close, low-altitude image of the Dada Crater (top center) and the larger Roskva Crater (left).

A VOLCANO IN THE SOUTHERN HEMISPHERE OF CERES

This image from the *Dawn* spacecraft shows a massive volcano with a distinctive crater in Ceres's southern hemisphere.

CLOSE-UP OF CERES

This close-up view of Ceres comes from an image sequence taken by *Dawn* on May 4, 2015, at 8,400 miles (13,520) kilometers from the dwarf planet. Ceres harbors a number of unusual features, including a water-vapor plume that may be emerging from cryovolcanoes (not visible in this image). Ceres has a distinctly round shape, since it is massive enough to be molded into a sphere by gravitational forces. Ceres's many bright spots may be the product of reflective material such as water ice or salts; the brightest spots are within the Occator Crater. Studies of Ceres's crater morphology suggest that the dwarf planet's crust is a mixture of roughly 60 percent rock and 40 percent ice. Ceres's surface contains ammonia-laden clays — an unusual feature. Ammonia is abundant in the outer solar system, so scientists have theorized that Ceres may have formed close to Neptune and, over time, migrated inward.

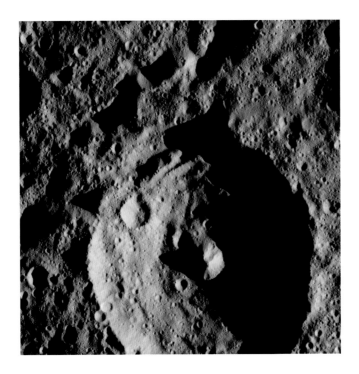

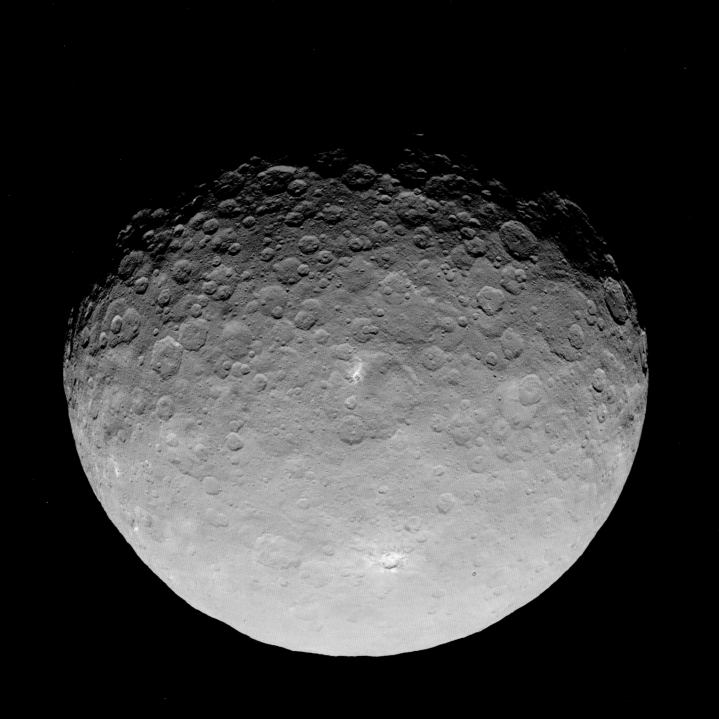

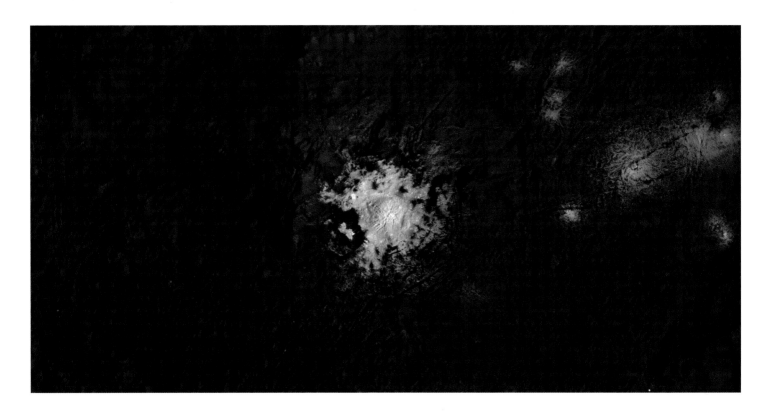

[above]

OCCATOR CRATER

This is an enhanced-color view of Ceres's Occator Crater, the brightest
spot on the dwarf planet. The crater has the highest concentration of
carbonate minerals that scientists have observed beyond Earth. The
eighty-million-year-old Occator is a dome-centered crater (a crater with a
dome within it that is usually formed when layers of rock are broken up
beneath the ground, pushing the surface upward over thousands of years).
It is relatively young and is swathed in reflective material, including salt
deposits. Scientists conjecture that the salt deposits could be remnants
of a subterranean liquid ocean that, through deep hydrothermal activity,
pushed the minerals up through the surface of the dwarf planet.

[opposite]

THE LIMB OF CERES

This October 2016 image taken by *Dawn*
reveals the northern hemisphere of Ceres
giving way to the blackness of space. At the
top left of the image is the Occator Crater, an
impact crater that is 57 miles (92 kilometers)
wide and 2.5 miles (4 kilometers) deep
and features a prominent, bright interior
composed of salts.

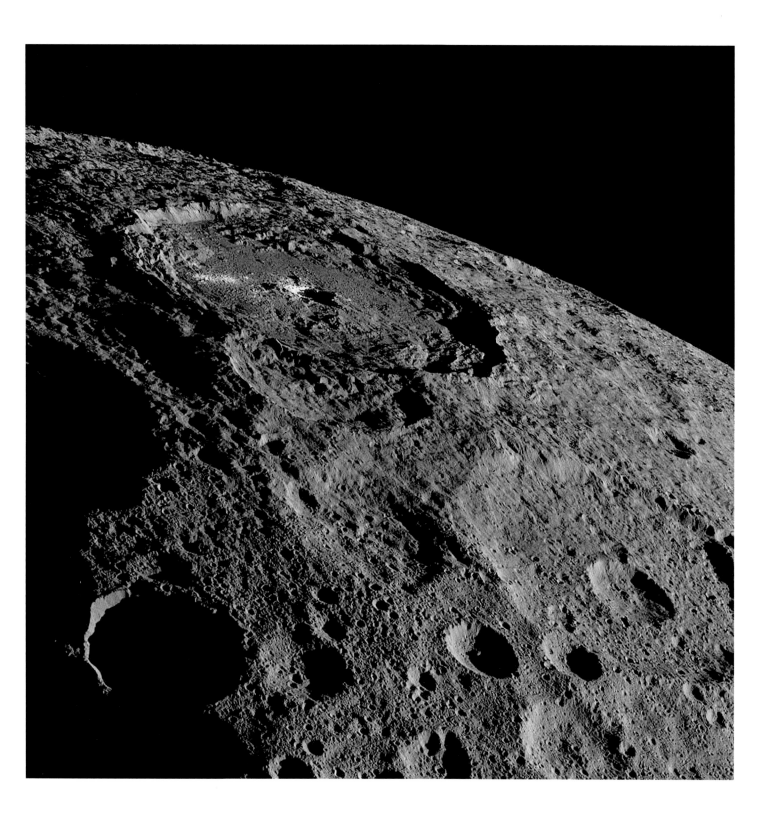

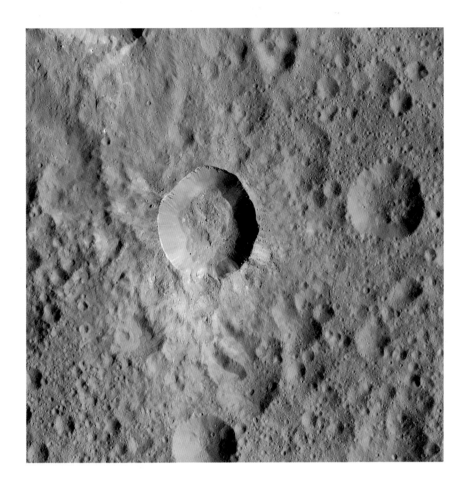

A CRATER ON CERES

Dawn captured this domed crater (center) in the northern hemisphere of Ceres in early 2016; the surrounding region comprises a blanket of ejected rock and includes bright, reflective material (most likely salt deposits).

BRIGHT OCCATOR CRATER

Ceres's Occator Crater, featured in this false-color image, appears as a luminous spot in the center of the dwarf planet. The crater itself has a strange mixture of landforms, including a shiny reflective dome centered within a comparatively smooth pit, neither of which are immediately visible in the image. The dome is covered in cracks and fissures that suggest active interior processes. Although Occator Crater is Ceres's most prominent bright spot, there are at least a hundred other reflective areas strewn across the dwarf planet.

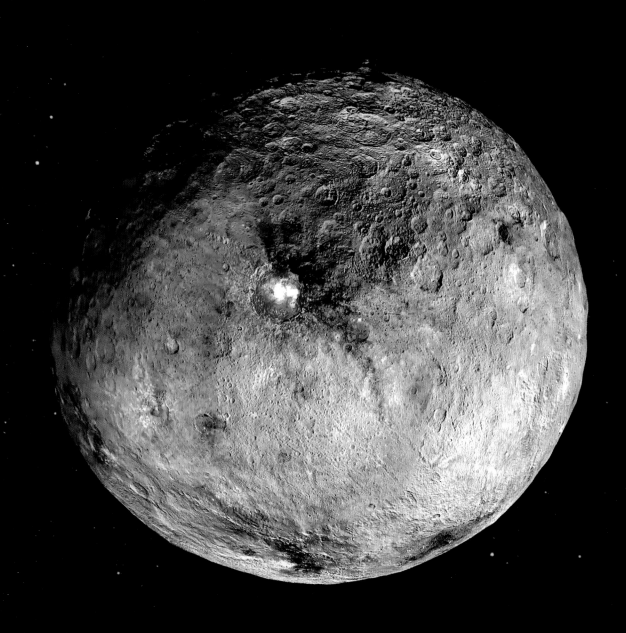

COMET 67P/ CHURYUMOV-GERASIMENKO

A COMET ILLUMINATED IN SPACE

Comet 67P/Churyumov-Gerasimenko most likely comes from the Kuiper Belt; however, as a Jupiter-family comet, its orbit is determined by the gas giant's gravitational influences. The comet travels through the solar system within and just beyond the orbit of Jupiter. The European Space Agency's *Rosetta* spacecraft synched up with and observed the comet, and on July 14, 2015, *Rosetta*'s navigation camera (NavCam) captured this image of Comet 67P from roughly 100 miles (161 kilometers) away. Comet 67P has a short orbital period of less than twenty years around the Sun. Like other comets that originated in the Kuiper Belt, Comet 67P was likely flung out of the belt and toward the Sun due to collisions or gravitational disturbances. The gravitational pull of massive planets like Jupiter can change a comet's orbit over time, and eventually, comets can be ejected out of the solar system altogether – that is, if they don't collide with another body first.

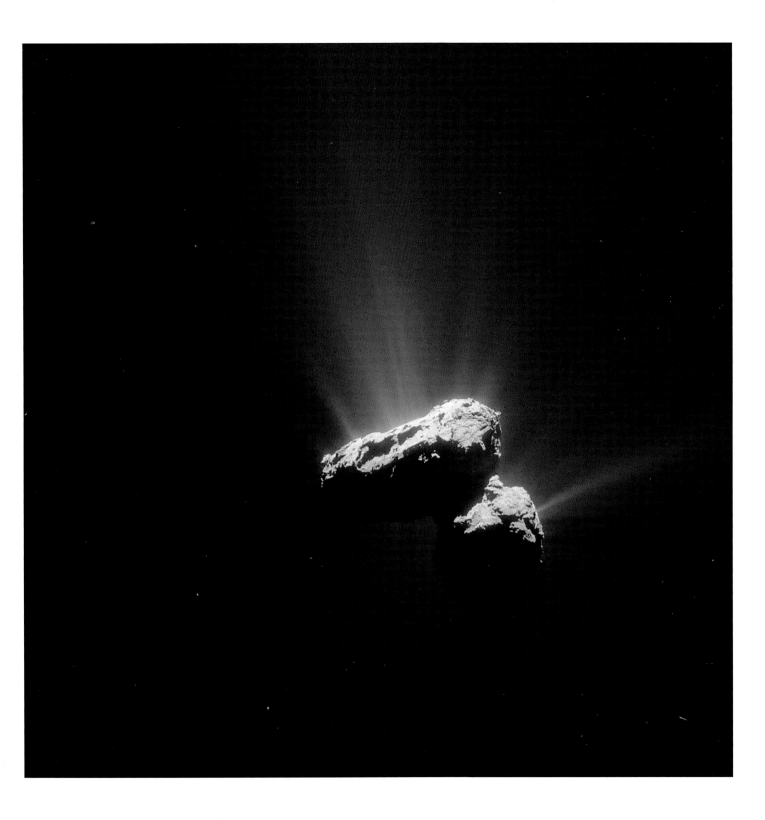

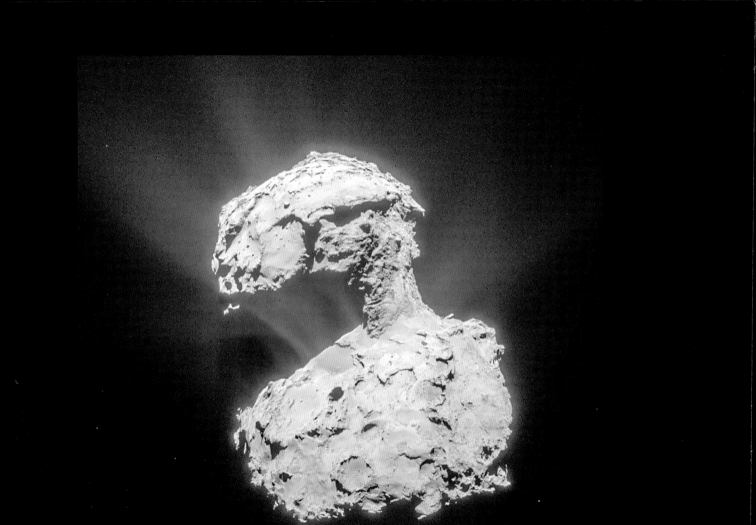

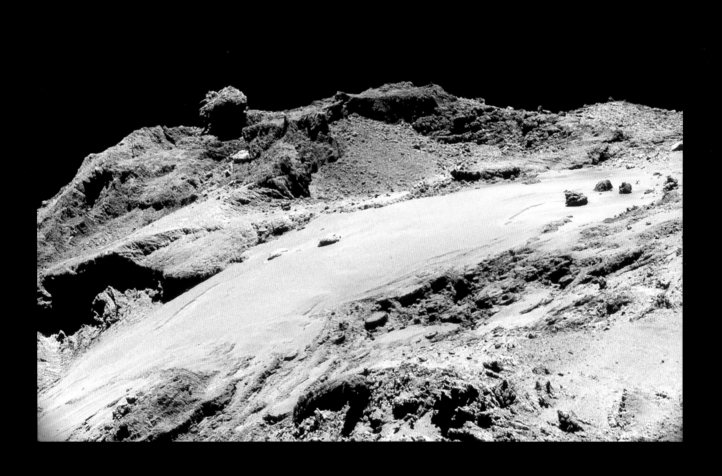

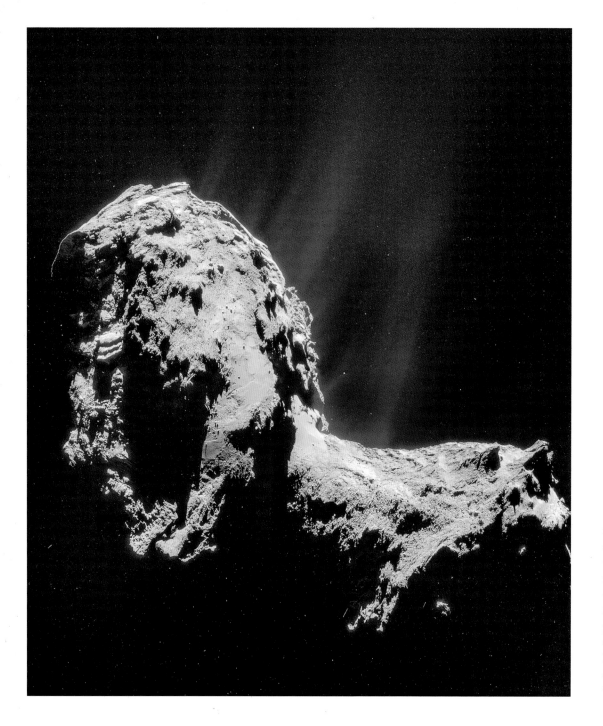

[*left*]

A COMPOSITE OF COMET 67P/ CHURYUMOV-GERASIMENKO

This composite image is made up of four NavCam photographs taken by *Rosetta* from a mere 19 miles (31 kilometers) away.

[*opposite*]

THE SURFACE OF COMET 67P/ CHURYUMOV-GERASIMENKO

In this April 2016 image— taken by *Rosetta*'s narrow-angle camera OSIRIS (for Optical, Spectroscopic, and Infrared Remote Imaging System)—Comet 67P appears like a mammoth landscape full of crags, fissures, and curves. However, the comet is a mere 1.86 miles (3 kilometers) in length. Although Comet 67P will never find itself in Earth's orbital path, the asteroid that once struck Earth and may have contributed to the extinction of the dinosaurs was about this size.

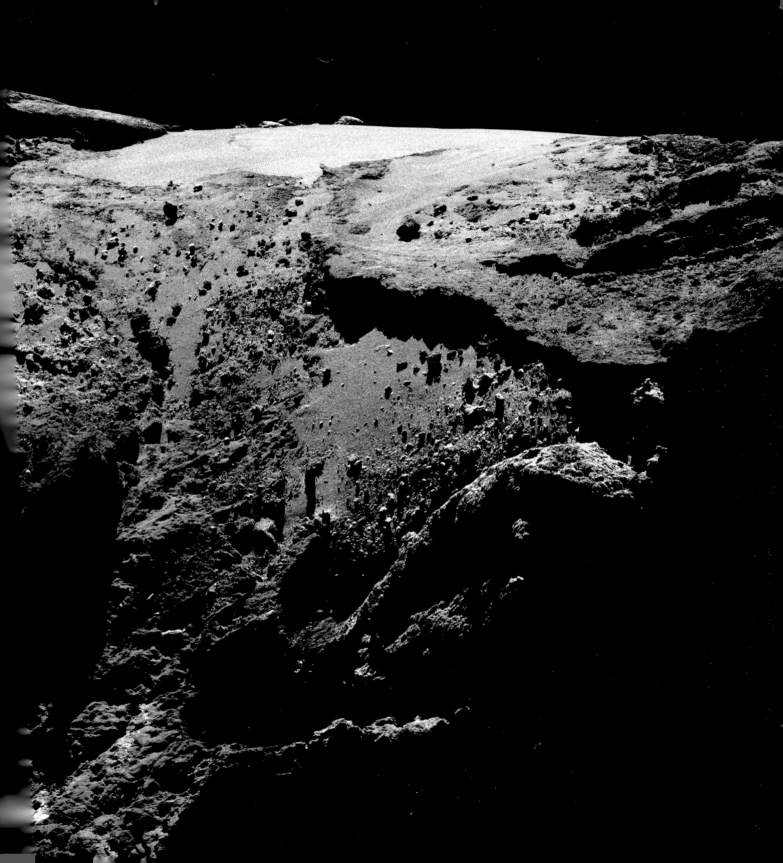

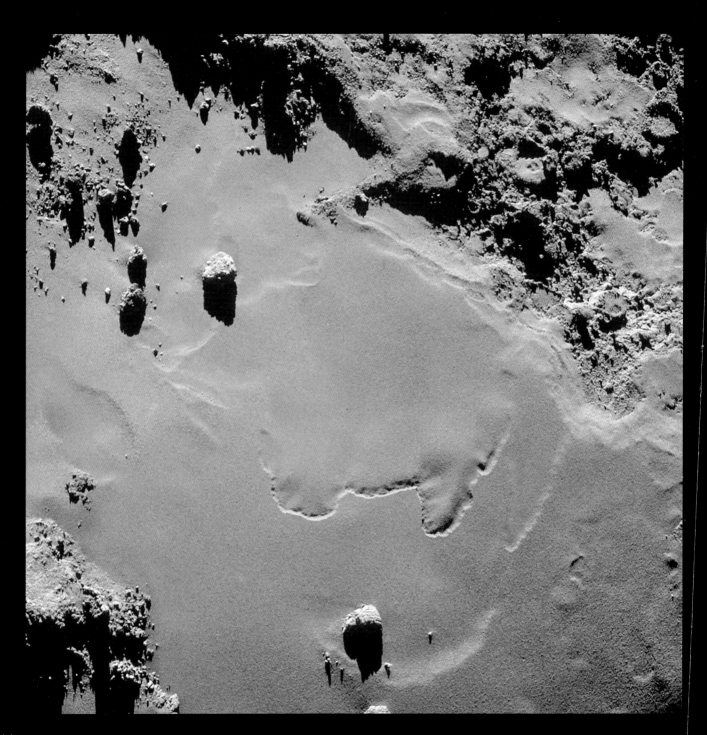

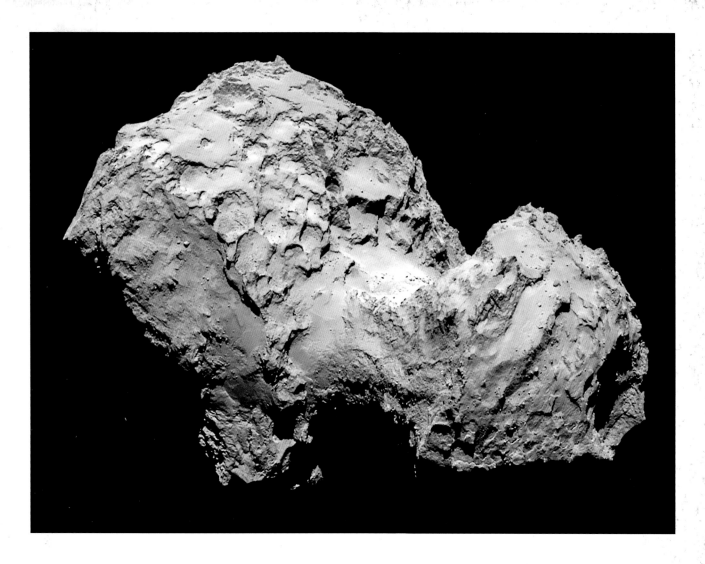

posite]

SMOOTH PATCH OF COMET

2014 image by *Rosetta* shows the center of the
et, at the middle of its two lobes. The ancient
ace material comprises water ice and rock
aining at least sixteen organic compounds
uding acetamide, acetone, methyl isocyanate,
propionaldehyde, which had never before been
cted on a comet).

[above]

A DRAMATIC VIEW

This extraordinary image of Comet 67P was taken
by *Rosetta*'s OSIRIS narrow-angle camera from
approximately 177 miles (285 kilometers) away.

ASTEROID VESTA

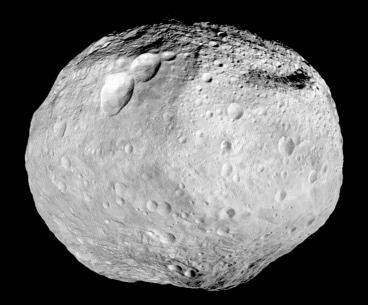

[*above*]

THE BUMPY TERRAIN
OF VESTA

In 2012, NASA's *Dawn* spacecraft
captured this high-resolution mosaic
of the massive asteroid Vesta, which
much like our Moon, is characterized
by bright and dark patches.

[*opposite*]

VESTA'S NORTH POLE

Dawn captured this close-up image of Vesta's north pole in 2012. *Dawn*
arrived close to Vesta in July 2011, but for at least a year, Vesta's north pole
was shrouded in darkness. Vesta is the second most massive object in the
asteroid belt between Mars and Jupiter (after the dwarf planet Ceres), and it
considered a long-surviving protoplanet. A protoplanet is a celestial body th
developed early in the solar system's formation (within the first few millior
years) and combined with other protoplanets to form the rocky terrestrial
planets. Vesta is also the brightest asteroid in the sky and the first to be visi
by a space probe. Vesta made its closest approach to Earth in 1996, though
remained about 110 million miles (177 million kilometers) away.

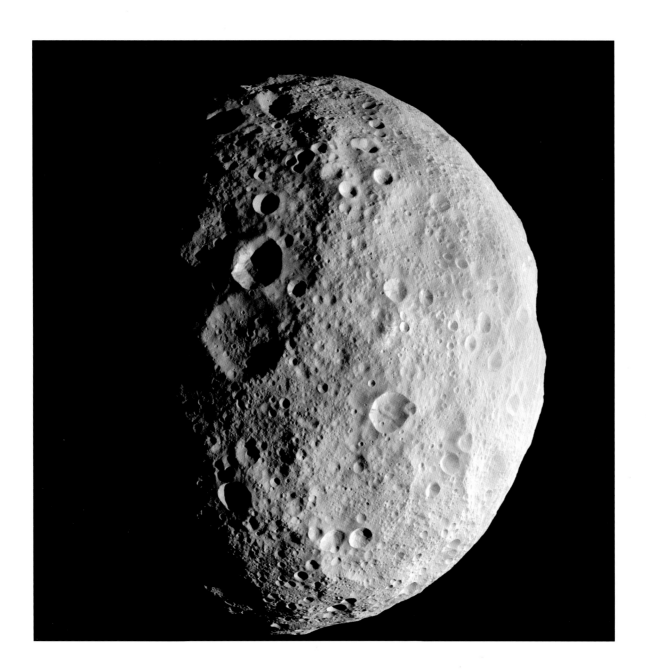

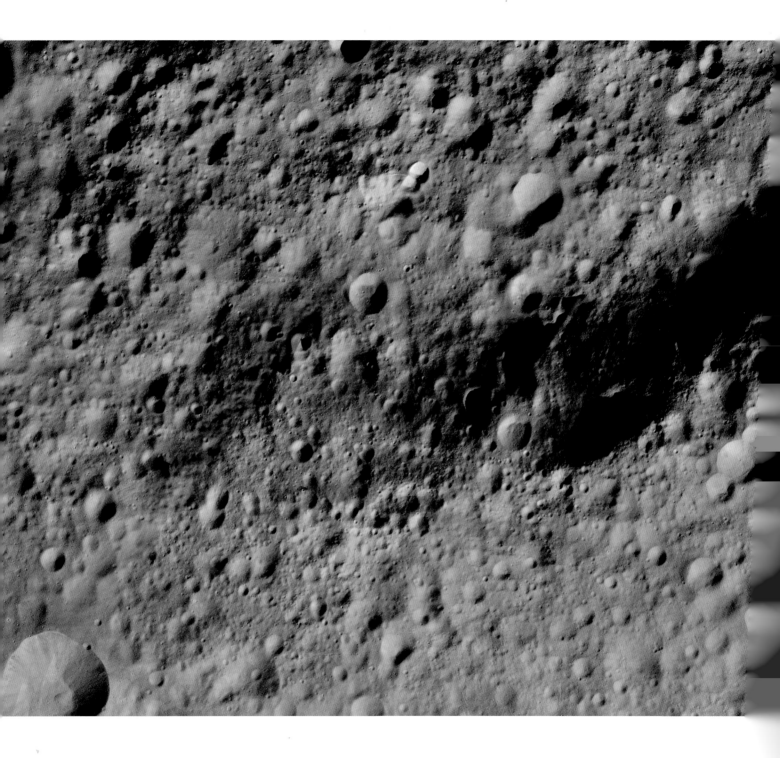

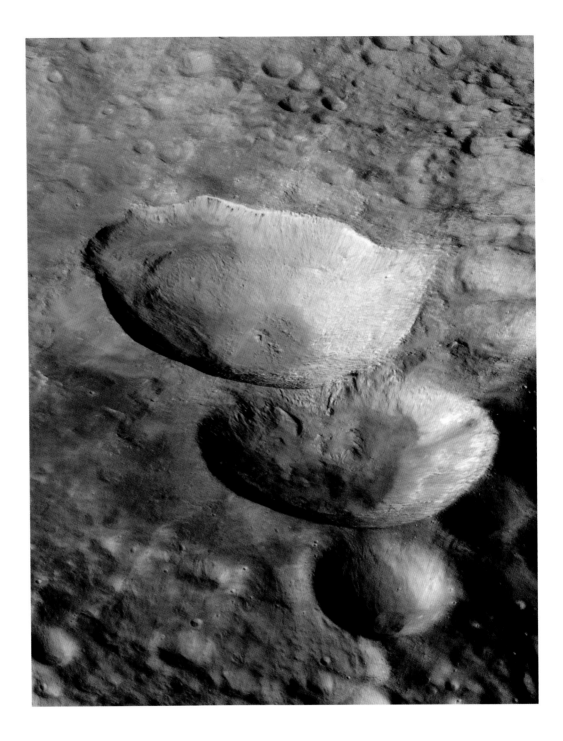

[*opposite*]

AN ATLAS OF VESTA

This mosaic is made up of
approximately ten thousand
images captured by *Dawn* from
130 miles (209 kilometers)
away.

right]

"NOWMAN"
RATERS

his colorized image of three
pact craters – likely the
sult of impacts with other
eroids – is made up of
eral photographs taken by
wn from roughly 420 miles
6 kilometers) above Vesta's
face.

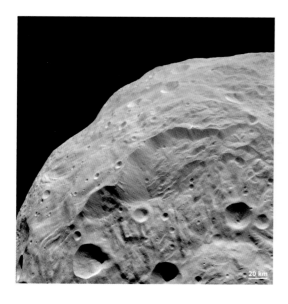

VESTA'S IRREGULAR TERRAIN

This 2011 *Dawn* image shows a steep bank dotted with landslides and craters that were probably formed early in the protoplanet's history.

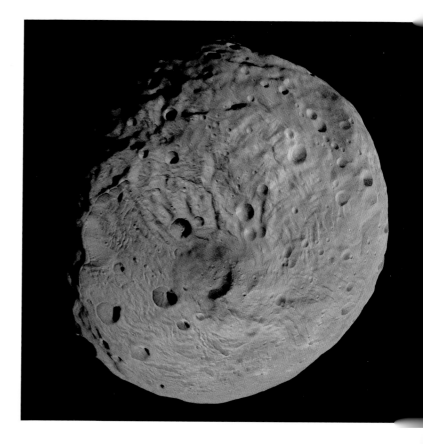

SOUTH POLE OF VESTA

Many scientists believe that the circular structure of Vesta's south pole is actually a massive crater that's the result of a collision with another asteroid. This image was taken by *Dawn* in 2011, but in 1996, the Hubble Space Telescope first revealed and measured the crater, which is 286 miles (460 kilometers) in diameter—a remarkable size considering that the asteroid itself is a mere 329 miles (530 kilometers) across.

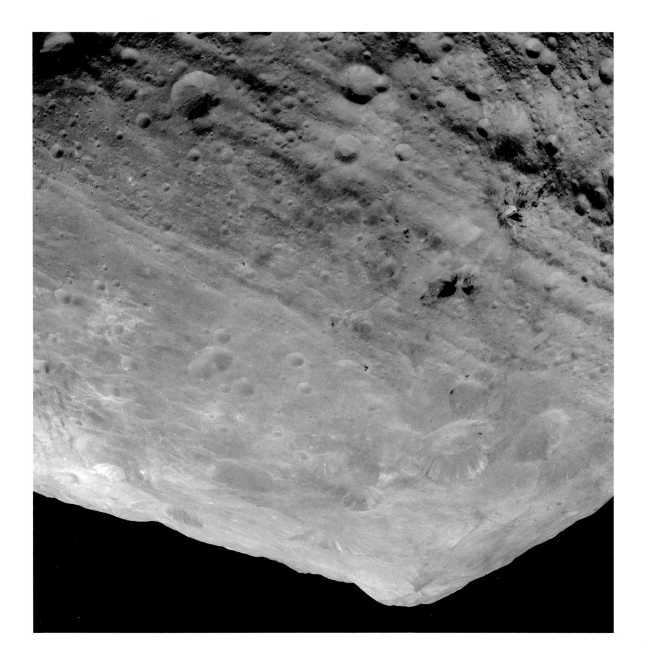

MASSIVE MOUNTAIN ON VESTA

This *Dawn* image features a massive mountain rising from the vast crater in Vesta's south pole. Though it's hard to appreciate in this image, which lacks a visual scale, this giant mountain is more than twice the height of Mount Everest and one of the highest recorded elevations on a solid-surface body in our solar system.

ACS = Advanced Camera for Surveys
AIA = Atmospheric Imaging Assembly
ASI = Italian Space Agency
ASTER = Advanced Spaceborne Thermal Emission and Reflection Radiometer
AURA = Association of Universities for Research in Astronomy
BBSO = Big Bear Solar Observatory
CEA/Irfu = Alternative Energies and Atomic Energy Commission/ Research Institute of the Fundamental Laws of the Universe, France
CNRS/INSU = French National Centre for Scientific Research/ Institute for Earth Sciences and Astronomy
CXC = Chandra X-ray Center
DASP = distributed aerodynamic sensing and processing
DLR = German Space Agency
DOD = Department of Defense
ERSDAC = Earth Remote Sensing Data Analysis Center
ESA = European Space Agency
ESO = European Southern Observatory
GRC = Glenn Research Center
GSFC = Goddard Space Flight Center
HEIC = Hubble European Space Agency Information Centre
IAA = International Aerospace Abstracts
IDA = International Docking Adapter
INAF = National Institute for Astrophysics, Italy
INTA = National Institute of Aeronautics, Spain
IPHAS = INT Photometric H-Alpha Survey
ISS = International Space Station
JAROS = Japanese Resource Observation System Organization
JAXA = Japan Aerospace Exploration Agency
JHUAPL = Johns Hopkins University Applied Physics Laboratory
JIRAM = Jovian Infrared Auroral Mapper

JPL-Caltech = Jet Propulsion Laboratory/California Institute of Technology
JSC = Johnson Space Center
LAM = low-altitude mission
LMSAL = Lockheed Martin Solar and Astrophysics Laboratory
LPI = Lunar and Planetary Institute
METI = Ministry of Economy, Trade, and Industry, Japan
MPS = Max Planck Institute for Solar System Research
MSSS = Main Space Science Systems
NASA = National Aeronautics and Space Administration
NAVCAM = navigation camera
NJIT = New Jersey Institue of Technology
NOAA = National Oceanic and Atmospheric Administration
NOAA GOES = National Oceanic and Atmospheric Administration geostationary operational environment satellite
PACS = Photoconductor Array Camera and Spectrometer
PSI = Physical Sciences Informatics
SDO = Solar Dynamics Observatory
SOHO = Solar and Heliospheric Observatory
SSI = Space Science Institute
SSO = Spacial Standard Observer
STSCI = Space Telescope Science Institute
SWRI = Southwest Research Institute
UKATC/STFC = United Kingdom Astronomy Technology Centre Science and Technology Facilities Council
UPD = University of Padova
UPM = Polytechnic University of Madrid
USGS = US Geological Survey
VLT = Very Large Telescope (European Southern Observatory)

BIBLIOGRAPHY

Boss, Alan. *The Race to Find New Solar Systems.* Hoboken, NJ: Wiley, 2000.

Cox, Brian. *The Wonders of the Solar System.* New York, NY: HarperCollins Reference Hardbacks, 2010.

David, Leonard. *Mars: Our Future on the Red Planet.* Washington, DC: National Geographic, 2016.

Hadfield, Chris. *You Are Here: Around the World in 92 Minutes.* New York, NY: Little, Brown, 2014.

Meltzer, Michael. *The Cassini-Huygens Visit to Saturn: An Historic Mission to the Ringed Planet.* New York, NY: Springer Praxis Books, 2015.

Ridpath, Ian, and Will Tirion. *Stars and Planets: The Most Complete Guide to the Stars, Planets, Galaxies, and the Solar System.* Princeton, NJ; Princeton Field Guides, 2008.

Ward, Peter D., and Donald Brownlee. *Rare Earth: Why Complex Life Is Uncommon in the Universe.* New York, NY: Copernicus, 2000.

WEB RESOURCES

NASA Solar System Exploration, solarsystem.nasa.gov/galleries/

Jet Propulsion Laboratory/California Institute of Technology, photojournal.jpl.nasa.gov

Arizona State University Apollo Image Archive, apollo.sese.asu.edu

Gateway to Astronaut Photography of Earth, eol.jsc.nasa.gov

IMAGE CREDITS

Front cover: NASA, JPL-Caltech, SSI
Back cover: NASA, USGS
Page 4: NASA, M. Justin Wilkinson, Texas State University, Jacobs Contract at NASA-JSC
Page 13: NASA, JHUAPL, Carnegie Institution of Washington
Page 14–15: NASA, JHUAPL, Carnegie Institution of Washington
Page 16: NASA, JHUAPL, Carnegie Institution of Washington
Page 17: NASA, JHUAPL, Carnegie Institution of Washington
Page 18: NASA, JHUAPL, Carnegie Institution of Washington
Page 19: NASA, JPL-Caltech
Page 20: NASA, JHUAPL, Carnegie Institution of Washington
Page 21: NASA, JHUAPL, Carnegie Institution of Washington
Page 22: NASA, JHUAPL, Carnegie Institution of Washington
Page 23: NASA, JHUAPL
Page 24, top: NASA, JHUAPL, Carnegie Institution of Washington
Page 24, bottom: NASA, JHUAPL, Carnegie Institution of Washington
Page 25: NASA, JHUAPL, Carnegie Institution of Washington
Page 26: NASA, JHUAPL, Carnegie Institution of Washington
Page 27: NASA, JHUAPL, Carnegie Institution of Washington
Page 28: NASA, JHUAPL, Carnegie Institution of Washington
Page 29: NASA, JHUAPL, Carnegie Institution of Washington
Page 30: NASA, JHUAPL, Carnegie Institution of Washington
Page 31, top: NASA, JHUAPL, Carnegie Institution of Washington
Page 31, bottom: NASA, JHUAPL, Carnegie Institution of Washington
Page 35: NASA, SDO, AIA
Page 36: NASA, SDO, AIA
Page 37: JAXA, NASA, Lockheed Martin
Page 38: NASA, JPL-Caltech

Page 39: NASA, JHUAPL, Carnegie Institution of Washington
Page 40: NASA, NSSDC
Page 41: NASA, JPL-Caltech
Page 43: NASA, JPL-Caltech
Page 45: NASA, JPL-Caltech
Page 46: NASA, JPL-Caltech
Page 47: NASA, JPL, USGS
Page 48: NASA, JPL-Caltech
Page 49: NASA, JPL-Caltech
Page 50: NASA, JPL-Caltech
Page 51: NASA, JPL-Caltech
Page 52: NASA, JPL-Caltech
Page 57: NASA, Project Apollo Archive
Page 58–59: NASA, ISS
Page 60–61: NASA, ISS
Page 62: NASA, ISS
Page 63: NASA, ISS
Page 64–65: NASA, ISS
Page 66, top: ISS Crew Earth Observations experiment and Image Science & Analysis Laboratory, JSC
Page 66, bottom: NASA
Page 67: NASA, ESA, Alexander Gerst
Page 68–69: NASA, ISS
Page 70–71: NASA, GSFC, Jeff Schmaltz, Moderate Resolution Imaging Spectroradiometer Land Rapid Response Team
Page 73: USGS Earth Resources Observation and Science Center Data Center Satellite Systems Branch
Page 74: NASA, GSFC, METI, ERSDAC, JAROS, and US, Japan ASTERScience Team
Page 75, top: NASA, ISS
Page 75, bottom: NASA, ISS
Page 76–77: Norman Kuring of NASA's GSFC
Page 78: NASA, NOAAGOES Project
Page 79: Norman Kuring and NASA's GSFC
Page 80: ESA, NASA
Page 81: NASA
Page 82: NASA
Page 83: NASA
Page 85: NASA
Page 86–87: NASA, Lunar Orbiter Image Recovery Project
Page 88: NASA
Page 89: NASA, GSFC, Arizona State University
Page 90, top: Anaxagoras

Page 90, bottom: NASA
Page 91: NASA, GSFC, Arizona State University
Page 95: NASA, USGS
Page 96: NASA, JPL, USGS
Page 97: NASA, JPL-Caltech, USGS
Page 98: NASA
Page 99: NASA, JPL-Caltech, University of Arizona
Page 100–101: NASA, JPL-Caltech, MSSS
Page 102–103, top: NASA, JPL-Caltech, Cornell University, Arizona State University; NASA, JPL-Caltech, MSSS
Page 102–103, bottom: NASA, JPL-Caltech, Cornell University, Arizona State University NASA, JPL-Caltech, MSSS
Page 104, top: NASA, JPL-Caltech, MSSS
Page 104, bottom: NASA, JPL-Caltech, MSSS
Page 105: NASA, JPL-Caltech, Cornell University
Page 106: NASA, JPL-Caltech
Page 107: NASA, JPL-Caltech, University of Arizona
Page 108, top: NASA, JPL-Caltech, University of Arizona
Page 108, bottom: NASA, JPL-Caltech, University of Arizona
Page 109: NASA, JPL-Caltech, University of Arizona
Page 110: NASA, JPL-Caltech, University of Arizona
Page 111: NASA, JPL-Caltech, University of Arizona
Page 115: NASA, JPL, SSI
Page 116: NASA
Page 117, top: John Clarke (University of Michigan) and NASA
Page 117, bottom: NASA, JPL-Caltech, SWR ASI, INAF, JIRAM
Page 118: NASA, JPL-Caltech
Page 119: NASA, JPL-Caltech, Solaris. Composite image courtesy of Alexis Tranchandon.
Page 120: NASA, JPL-Caltech, SWRI, MSSS
Page 121: NASA, JPL-Caltech, SWRI, MSSS
Page 122: NASA, JPL-Caltech, SWRI, MSSS
Page 123: NASA, JPL, University of Arizona
Page 124: NASA, ESA, and A. Simon (GSFC
Page 125: NASA, JHUAPL, SWRI
Page 126: NASA, JHU-APL, SWRI

Page 127: NASA, JHUAPL, SWRI
Page 128: NASA, JPL-Caltech, SETI Institute
Page 129: NASA, JPL-Caltech, SETI Institute
Page 130: NASA, JPL-Caltech, University of Arizona
Page 132: NASA, JPL-Caltech, University of Arizona
Page 133: NASA, JPL, University of Arizona
Page 134–135: NASA, JPL-Caltech, SSI
Page 136–137: NASA, ESA, GSFC, UC Berkeley, JPL-Caltech, STSCI
Page 140–141: NASA, JPL, SSI
Page 142: NASA, JPL-Caltech, SSI
Page 143: NASA, JPL-Caltech, SSI
Page 144: NASA, JPL-Caltech, SSI
Page 145: NASA, JPL-Caltech, SSI
Page 146: NASA, JPL-Caltech, SSI
Page 147: NASA, JPL-Caltech, SSI
Page 148: NASA, JPL-Caltech, SSI
Page 149, top: NASA, JPL-Caltech, SSI
Page 149, bottom: NASA, JPL-Caltech, SSI
Page 150–151: NASA, JPL-Caltech, SSI
Page 152: NASA, JPL-Caltech, SSI
Page 153: NASA, JPL-Caltech, SSI
Page 154: NASA, JPL-Caltech, SSI
Page 155: NASA, JPL-Caltech, SSI
Page 156: NASA, JPL-Caltech, SSI
Page 157, top: NASA, JPL-Caltech, SSI
Page 157, bottom: NASA, JPL-Caltech, SSI
Page 158: NASA, JPL-Caltech, SSI
Page 159: NASA, JPL-Caltech, SSI
Page 160: NASA, JPL, University of Arizona, University of Idaho
Page 161: NASA, JPL-Caltech, ASI, Cornell University
Page 162, top: NASA, JPL-Caltech, SSI
Page 162, bottom: NASA, JPL-Caltech, SSI
Page 163: NASA, JPL-Caltech, SSI
Page 164: NASA, JPL-Caltech, SSI
Page 165: NASA, JPL-Caltech, SSI
Page 166: NASA, JPL-Caltech, SSI
Page 167: NASA, JPL-Caltech, SSI
Page 168, top: NASA, JPL-Caltech, SSI
Page 168, bottom: NASA, JPL-Caltech, SSI
Page 169: NASA, JPL, SSI
Page 170: NASA, JPL, SSI
Page 171, top: NASA, JPL-Caltech, SSI
Page 171, bottom: NASA, JPL-Caltech, SSI
Page 172: NASA, JPL-Caltech, SSI
Page 173: NASA, JPL-Caltech, SSI
Page 174: NASA, JPL-Caltech, SSI
Page 175, left: NASA, JPL-Caltech, SSI
Page 175, right: NASA, JPL-Caltech, SSI
Page 179: NASA, JPL
Page 180: NASA, W.M. Keck Observatory (Marcos van Dam)
Page 181: NASA, JPL-Caltech
Page 182: NASA, Lawrence Sromovsky, University of Wisconsin-Madison, Keck Observatory

Page 183: NASA and Erich Karkoschka, University of Arizona
Page 183, top: NASA, Keck Observatory
Page 183, middle: NASA and Erich Karkoschka, University of Arizona
Page 183, bottom: NASA and Erich Karkoschka, University of Arizona
Page 184: NASA, Lawrence Sromovsky, Pat Fry, Heidi Hammel, Imke de Pater, University of Wisconsin-Madison; Keck Observatory
Page 185, top: NASA, STSCI
Page 185, bottom: NASA, STSCI
Page 186: NASA, JPL-Caltech
Page 187, left: NASA, ESA, and M. Showalter (SETI Institute)
Page 187, right: NASA, ESA, STSCI
Page 190: NASA, JPL-Caltech
Page 191: NASA, JPL-Caltech
Page 192: NASA, JPL-Caltech
Page 193, top: NASA, JPL-Caltech
Page 193, bottom: NASA, JPL-Caltech
Page 194, top: NASA, JPL
Page 194, bottom: NASA, JPL
Page 195: NASA, JPL
Page 196, top: NASA, JPL
Page 196, bottom: NASA, JPL
Page 197: NASA, JPL, USGS
Page 198: NASA, JPL-Caltech, Ted Stryk Roane State Community College
Page 199, top: NASA, JPL
Page 199, bottom: NASA, JPL
Page 200, all: NASA, JPL, Planetary Data System
Page 201, all: NASA, JPL, Planetary Data System
Page 205: ESA, NASA, SOHO
Page 206: BBSO, NJIT
Page 207: NASA, SDO
Page 208: BBSO, NJIT
Page 209: Nathalia Alzate, University of Aberystwyth, and SDO
Page 210: NASA, SDO, AIA, LMSAL
Page 211: NASA, SDO
Page 213: NASA, JHUAPL, SWRI
Page 214: NASA, JHUAPL, SWRI
Page 215: NASA, JHUAPL, SWRI
Page 216: NASA, JHUAPL, SWRI
Page 217, top: NASA, JHUAPL, SWRI
Page 217, bottom: NASA, JHUAPL, SWRI
Page 218, top: NASA, JHUAPL, SWRI
Page 218, bottom: NASA, JHUAPL, SWRI
Page 219: NASA, JHUAPL, SWRI
Page 220: NASA, JHUAPL, SWRI
Page 221: NASA, JHUAPL, SWRI
Page 222–223, top: NASA, JHUAPL, SWRI
Page 222–223, bottom: NASA, JHUAPL, SWRI
Page 224–225: NASA, JHUAPL, SWRI
Page 227: NASA, JHUAPL, SWRI
Page 228, top: NASA, JHUAPL, SWRI
Page 228, bottom left: NASA, JHUAPL, SWRI
Page 228, bottom right: NASA, JHUAPL, SWRI
Page 229: NASA, JHUAPL, SWRI

Page 231: NASA, JPL-Caltech, UC Los Angeles, MPS, DLR, IDA, PSI
Page 232, top: NASA, JPL-Caltech, UC Los Angeles, MPS, DLR, IDA
Page 232, bottom: NASA, JPL-Caltech, UC Los Angeles, MPS, DLR, IDA
Page 233: NASA, JPL-Caltech, UC Los Angeles, MPS, DLR, IDA
Page 234: NASA, JPL-Caltech, UC Los Angeles, MPS, DLR, IDA, PSI, LPI
Page 235: NASA, JPL-Caltech, UC Los Angeles, MPS, DLR, IDA
Page 236: NASA, JPL-Caltech, UC Los Angeles, MPS, DLR, IDA
Page 237: NASA, JPL-Caltech, UC Los Angeles, MPS, DLR, IDA
Page 239: ESA, Rosetta, NAVCAM
Page 240: ESA, Rosetta, NAVCAM
Page 241: ESA, Rosetta, NAVCAM
Page 242: ESA, Rosetta, NAVCAM
Page 243: ESA, Rosetta, MPS for OSIRIS Team MPS, UPD, LAM, IAA, SSO, INTA, UPM, DASP, IDA
Page 244: ESA, Rosetta, NAVCAM
Page 245: ESA, Rosetta, MPS for OSIRIS Team MPS, UPD, LAM, IAA, SSO, INTA, UPM, DASP, IDA
Page 246: NASA, JPL-Caltech, UC Los Angeles, MPS, DLR, IDA
Page 247: NASA, JPL-Caltech, UC Los Angeles, MPS, DLR, IDA
Page 248: NASA, JPL-Caltech, UC Los Angeles, MPS, DLR, IDA
Page 249: NASA, JPL-Caltech, UC Los Angeles, MPS, DLR, IDA
Page 250, left: NASA, JPL-Caltech, UC Los Angeles, MPS, DLR, IDA
Page 250, right: NASA, JPL-Caltech, UC Los Angeles, MPS, DLR, IDA
Page 251: NASA, JPL-Caltech, UC Los Angeles, MPS, DLR, IDA

BILL NYE (the Science Guy) is a science educator, actor, writer, and the host of the Netflix science show "Bill Nye Saves the World." Nye serves as CEO of the Planetary Society, an organization founded by Carl Sagan. The Society engages citizens to advance space science, exploration, and effective space policy.

NIRMALA NATARAJ is a New York–based writer and editor with a background in science writing – particularly cosmology, ecology, and molecular biology – and a focus on the visual and performing arts. She is the author of *Earth + Space*.